Voices of Fire
Art, Rage, Power, and the State

On 7 March 1990 the National Gallery of Canada issued a press release announcing its purchase of a large abstract painting by the American artist Barnett Newman for $1.8 million. Within 72 hours the gallery was under attack both for its selection of *Voice of Fire* and for the price tag attached to it. Objections came from across Canada and from all quarters.

The *Voice of Fire* controversy was the most extensive and heated debate over visual art ever to have taken place in Canada. This anthology can be seen as a case-study, providing both a historical account of the outcome of the National Gallery's purchase of the painting and an understanding of why the gallery's actions provoked such strong opinions and feelings. In this volume the editors also address the peculiar and paradoxical character of abstract art in general, and the problems it consistently poses for viewers. Newman's work is presented as the focus of these concerns.

The attack on the gallery by the press, the general public, Canadian artists, and politicians is documented in the first section by a broad selection of cartoons satirizing the painting, press photographs, news releases, editorials, letters to the editor, and public exchanges. In the second section three essays offer contrasting accounts of the controversy and its significance. The first considers the social processes by which art becomes art; the second focuses on the role of the media in shaping public opinion about art; and the third compares the reception of *Voice of Fire* in two distinctive frameworks, first at Expo 67 in Montreal, and then in Ottawa in 1990. In the final section, four papers given at a symposium of *Voice of Fire* organized by the gallery in October 1990 (a combined effort at damage control and art criticism) are presented, as well as a transcription of the public dialogue between speakers and audience that followed.

BRUCE BARBER is an associate professor at the Nova Scotia College of Art and Design. He is an artist and cultural historian, and author of *Reading Rooms* and *Modern Art, Cartoons, Comics and Class Conflict: Cultural Hegemony and the Contest of Power* (forthcoming).

JOHN O'BRIAN teaches art history at the University of British Columbia. He is author of *David Milne: The Flat Side of the Landscape* and *Degas to Matisse: The Maurice Wertheim Collection,* and editor of *Clement Greenberg: The Collected Essays and Criticism.*

SERGE GUILBAUT is a professor in the Department of Fine Arts at the University of British Columbia. He is editor of *Modernism and Modernity* and *Reconstructing Modernism,* and author of *How New York Stole the Idea of Modern Art* and *Voir, Ne Pas Voir, Faut Voir.*

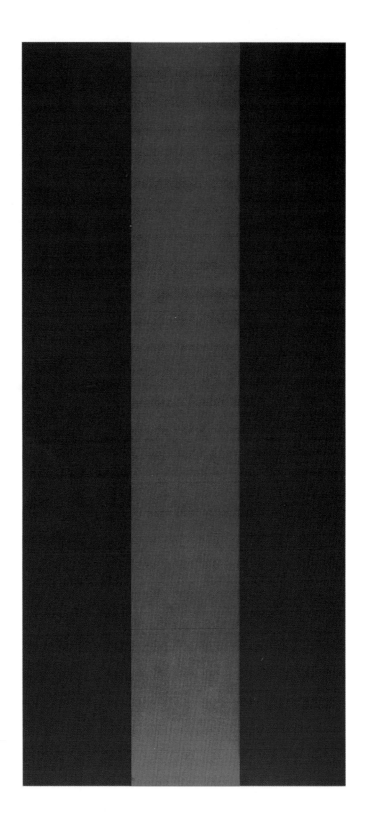

Voices of Fire

ART, RAGE, POWER, AND THE STATE

Edited by BRUCE BARBER,
SERGE GUILBAUT, and
JOHN O'BRIAN

Introduction by John O'Brian

UNIVERSITY OF TORONTO PRESS
Toronto Buffalo London

© University of Toronto Press Incorporated 1996
Toronto Buffalo London
Printed in Canada

ISBN 0-8020-0754-6 (cloth)
ISBN 0-8020-7803-6 (paper)

∞

Printed on acid-free paper

THEORY/CULTURE

Editors:
Linda Hutcheon, Gary Leonard
Janet Paterson, and Paul Perron

Canadian Cataloguing in Publication Data

Main entry under title:

Voices of fire : art, rage, power, and the state

(Theory/culture)
Includes index.
ISBN 0-8020-0754-6 (bound) ISBN 0-8020-7803-6 (pbk.)

1. Newman, Barnett, 1905–1970. Voice of Fire.
2. National Gallery of Canada – Appropriations and
expenditures. 3. Painting, American – Political aspects –
Canada. 4. Painting, Abstract – Political aspects –
Canada. 5. Art and state – Canada – Case studies.
6. Painting, Abstract – Public opinion. 7. Public
opinion – Canada. I. Barber, Bruce. II. Guilbaut, Serge.
III. O'Brian, John, 1944 – . IV. Series

ND237.N49A78 1996 759.13 C96-930573-3

FRONTISPIECE: Barnett Newman, *Voice of Fire*, 1967. Acrylic on canvas,
543.6 × 243.8 cm. National Gallery of Canada, Ottawa

Design: William Rueter

University of Toronto Press acknowledges the financial assistance to its
publishing program of the Canada Council and the Ontario Arts Council.

Contents

Preface

Visual art, especially abstract art, functions a little like a time bomb. It explodes under the pressure of changing social circumstances, scattering the old meanings that once defined it and reassembling new ones not imagined at the moment of production. These metaphoric detonations and reconstitutions of art, though unpredictable in their timing, occur with a certain inevitability. By drawing on the case-study of a particularly notorious explosion, and by investigating what triggered it, we endeavour in this book to show that no aspect of visual culture can escape such discharges or the collateral damage that follows them.

The book contains media documents, press photographs, editorials, articles, cartoons, letters, public exchanges, symposium papers, and critical essays. Most of the material collected was produced within a span of eight months, from March to October 1990. The earliest dated item is a press communiqué distributed by the National Gallery of Canada on 7 March 1990, announcing that the gallery had acquired a number of new works of art for its permanent collection. In the communiqué Dr Shirley Thomson, director of the gallery, observed that 'the generally very high prices still prevalent in the international fine-art market mean that we [the gallery] simply cannot compete for a Picasso or a Pontormo. However,' she continued, 'we can and do make sound and outstanding purchases in less overheated areas.' She cited a major painting by the American abstract artist Barnett Newman – *Voice of Fire* – recently acquired for the price of $1.76 million.

The National Gallery's announcement of the Newman acquisition drew an immediate response from across Canada. Within seventy-two hours the gallery was under attack, both for its selection of *Voice of Fire*

and for the price tag attached to it. Objections came from all quarters. The general public voiced its disapproval in on-the-street interviews with the broadcast media and in letters to the editors of daily newspapers; Canadian artists condemned the gallery through a statement issued by a national artists' lobby group (CARFAC); and members of the Conservative party, the political party in power, threatened to rescind the purchase. MP Felix Holtmann, chair of the House of Commons Standing Committee on Communications and Culture, stated famously on a Winnipeg open-line radio program: 'It looks like two cans of paint and two rollers and about ten minutes would do the trick.'

The public uproar over *Voice of Fire* lasted for two months before subsiding. This represented an unusually long stretch of time for a work of art to command widespread media attention, in Canada or any other place. As we shall try to demonstrate, the prolonged media attention in part reflected a political climate in which social anxieties about governmental intransigence and a failing economy were projected onto art. In the United States there were also anxieties at the time, but they played themselves out differently. The Contemporary Art Center in Cincinnati found itself under attack for mounting an exhibition of photographs by Robert Mapplethorpe at exactly the same moment that the National Gallery was drawn into the media spotlight north of the border. Although the social and aesthetic issues raised by the two cases were not comparable – the Contemporary Art Center was being called to account for promoting supposedly obscene images, the National Gallery for fiscal irresponsibility at a time of impending national crisis – the rush of politicians and the public to criticize art, and the institutions that collect and exhibit art, was the same.

The *Voice of Fire* controversy was the most extensive and heated debate over visual art ever to have taken place in Canada. Our intention in this anthology is to describe the controversy as fully as possible, providing both a historical account of the outcome of the National Gallery's purchase of the painting and an understanding of why the gallery's actions provoked such strong opinions and feelings. We also intend to address the peculiar and paradoxical character of abstract art in general and the problems it consistently poses for viewers. The work of Barnett Newman is presented as the focus of these concerns.

The Introduction to this volume situates the *Voice of Fire* controversy historically. On the one hand, the imbroglio must be seen as one in a

continuum of art controversies that have centred on modern art during the twentieth century. On the other hand, the *Voice of Fire* dispute should be recognized as the product of a particular place and time – Canada in 1990 – and therefore unlike other art controversies. The mentalities and institutional structures that shaped it are found to be differently constituted from those shaping art controversies elsewhere.

The twists and turns evident in the reception of *Voice of Fire* are tracked in the Documents section of this book. It pulls together a chronology of events; a compilation of cartoons satirizing the painting; and a selection of reports, letters, articles, and public exchanges that appeared in the media during March and April 1990.

The documentary material provides the necessary background for the critical essays that constitute the following section. Each of the three essayists locates his arguments within a separate discourse on modernist culture, thereby offering a very different account of the controversy and its significance. In 'Vox Ignis Vox Populi,' Thierry de Duve reflects on the social processes by which art becomes art, and considers two pastiches made after *Voice of Fire*, one by an artist, the other by a non-artist. He argues that the pastiches are important not only for what they can tell us about *Voice of Fire*, but also for what they say about the aesthetics of modernity. In 'Thalia Meets Melpomene,' Bruce Barber focuses on the role of the print media – writers, editors, cartoonists – in shaping public opinion about art – how, for example, they can productively (or not so productively) contaminate institutional discourses about aesthetic matters. In addition to the media response to *Voice of Fire*, he also examines the *Flesh Dress* controversy that followed it. In 'Who's Afraid of Barnett Newman?' John O'Brian considers the demonization of *Voice of Fire* in 1990 against the backdrop of the world's fair in Montreal, Expo 67, for which Newman produced the painting. He argues that the different cultural frames established for the painting in Montreal and Ottawa were paramount in determining the gazes levelled at the work.

The final section of the anthology consists of four papers given at a symposium on *Voice of Fire* organized by the National Gallery in October 1990 and a transcription of a public dialogue between the speakers and the capacity audience that came to hear them. Each of the four speakers investigates value systems that are articulated by *Voice of Fire*, arriving at markedly different conclusions. Serge Guilbaut points out in

his paper, 'Voicing the Fire of the Fierce Father,' that Newman wanted his work to be seen as the carrier of a modern virility and all that this connotes about male dominance after the Second World War, thus pinpointing gender as a matter for debate. Nicole Dubreuil-Blondin, in 'Tightrope Metaphysics,' examines the radical hermeticism of Newman's formal means in his paintings. She argues that such hermeticism does not preclude the paintings from having a subject, but it does result in the circulation of meanings around the subject being much freer than with figurative art. Robert Murray is a Canadian artist who met Newman at an artists' workshop held at Emma Lake, Saskatchewan, in 1959 and worked closely with him on a number of sculptural and architectural projects in New York City. His paper addresses Newman's sculptures. Brydon Smith, then assistant director of the National Gallery, who has been responsible for helping to shape and expand the gallery's permanent collection of American postwar art since the 1960s, negotiated the acquisition of *Voice of Fire* for the gallery. In his paper, he focuses on the physical and formal properties of the painting, and on the work's significance as a medium for personal liberation.

There is a sense in which the National Gallery's decision to organize a symposium on *Voice of Fire* six months after the denouement of the controversy can be seen as an idiosyncratic gesture. Museums and galleries have traditionally shied away from criticism and adverse publicity, and by mounting the symposium the gallery risked reopening a wound that had only recently begun to heal. The gallery was obviously attempting to repair some of the damage it had undergone, to alter its image as an élite institution distanced from its public, but it was also attempting to add to the critical investigation of *Voice of Fire*. This book is underwritten by a more general desire – to advance the discourse on modernism and abstraction. As we see it, such a discourse does not stop with *Voice of Fire* and other instances of modernist practice but extends to the role of museums in legitimating modernist art. The *Voice of Fire* controversy engaged a wide range of publics in Canada, each with an ideological stake in the outcome. As editors, we admit to having a stake; so, as readers, do you.

The Editors

Acknowledgments

This book has grown by fits and starts since 1990. The idea was first discussed by the editors in October 1990, at a conference in Montreal organized by the Universities Art Association of Canada. At the time, Thierry de Duve's article 'Vox Ignis Vox Populi' had recently appeared in *Parachute*, Bruce Barber had completed a paper examining cartoons and caricatures related to the *Voice of Fire* controversy, and Serge Guilbaut and John O'Brian were on their way to Ottawa to participate in a symposium on *Voice of Fire* organized by Brydon Smith for the National Gallery of Canada. Here was the incipient core of a book. The incentive to build around it and to produce a finished volume occurred when Linda Hutcheon encouraged its publication for the Theory/ Culture series she was editing at the University of Toronto Press.

We owe our first debt to the other contributing authors of the volume: Thierry de Duve, Nicole Dubreuil-Blondin, Robert Murray, and Brydon Smith. We would also like to thank those writers whose articles, dating from the days and weeks immediately following the purchase announcement of *Voice of Fire*, are republished under the heading 'Texts.' Detailed acknowledgments of copyright permissions are provided on a separate page.

Our second debt is to the National Gallery of Canada. Brydon Smith provided us with information and documentation, including audiotapes of the symposium. Meva Hockley and the photographic services department provided us with photographs and technical assistance. And Dr Shirley Thomson, director of the gallery, supported the book's publication by providing a subvention to cover the cost of printing the illustrations. We also wish to thank Pauline Labelle, Diana Nemiroff, Serge Thériault, Murray Waddington, and the staff of the library for their

assistance. John O'Brian would particularly like to thank Gyde Shepherd and the gallery's Canadian Centre for the Visual Arts for offering him a research fellowship in 1992–3 to work on the project in Ottawa. The fellowship enabled him to gather material for the chronology, to locate (with the help of John Collins) graphic satires on *Voice of Fire*, and to select texts for the Documents section of the book. It also enabled him to edit the symposium material that makes up the final section of the volume.

In addition, we would like to acknowledge the following organizations and individuals for their help in producing the book: the Nova Scotia College of Art and Design, and Roxanna Boers, Bob Hackett, David Howard, Jane Mothersell, and Joann Reynolds-Farmer; the University of British Columbia, and Grant Arnold, Robert Bos, Nancy Cuthbert, Ellen Grande, and Alison Walker; and the University of Toronto Press, especially Joan Bulger.

Other friends and colleagues who have facilitated our endeavours include Guy Bardeaux, Iain Boal, Yve-Alain Bois, Mark Cheetham, Chris Creighton-Kelly, James B. Cuno, David Diao, Carol Doyon, Janice Helland, David Lemon, Linda Milrod, Annalee Newman, Matthew Teitelbaum, Charlotte Townsend-Gault, William Withrow, William Wood, Dennis Young, and Henri Zerner.

We are grateful for financial support provided by the Canada Council, the National Gallery of Canada, the Nova Scotia College of Art and Design, the Social Sciences and Humanities Research Council of Canada, and the University of British Columbia.

The Editors

Credits

John Bentley Mays, 'National Gallery Should Tune Out Static Over Painting'; Stephen Godfrey, 'Can This Voice Put Out the Fire?'; Jane Martin, 'Letter to the Editor'; Allan Gotlieb, 'A Dream of Albania of the North, Safe from Foreign Art'; Brydon Smith, 'Letter to the Editor'; and Bronwyn Drainie, 'Voice of Fire's Elitist Message Sure to Make Canadians Burn,' are reprinted with permission of the *The Globe and Mail* (Toronto).

Nancy Baele, 'The Gallery's $1.8M Painting'; 'MP Wants Art Gallery to Explain 1.8M Choice'; and Graham Parley, 'Cabinet to Review $1.8M Art Purchase,' are reprinted with the permission of the *The Citizen* (Ottawa).

'Voice of Fire Still a Hot Topic' is reprinted with permission of the *Ottawa Sun.*

Christopher Hume, 'National Gallery Criticized for Buying U.S. Work'; and Gerald Scully, 'Letter to the Editor,' are reprinted with permission of the *Toronto Star.*

'All in the Eye of the Taxpayer' is reprinted with permission of the *Kamloops Daily News.*

Robert Fulford, 'Holtmann Opens a Political Barn Door,' is reprinted with permission of the *Financial Times of Canada.*

Janet Hitchings, 'Letter to the Editor,' is reprinted with permission of the *Star-Phoenix* (Saskatoon).

'Transcript of Global Television Network News Report' is reprinted with permission of Global Communications.

'"Voice of Fires": L'oeuvre de Newman au grand pouvoir de provocation' is reprinted with permission of *Le Droit* (Montreal).

Jocelyne Lepage, 'Le gouvernement se penche sur l'achat à 1,8 million $ de Voice of Fire,' is reprinted with permisssion of *La Presse* (Montreal). All other texts are reprinted with permission of their authors.

Photographs of works of art have been supplied, in the majority of cases, by the owners or custodians of the works; photographs of reference illustrations and graphic satires have been, with a few exceptions, taken from the publications in which they first appeared. All illustrations are reprinted with the permission of the organizations and individuals mentioned in the accompanying captions.

xiv
Credits

Voices
of Fire

JOHN O'BRIAN

Introduction
BRUISING THE PUBLIC EYE

In the spring of 1990, with the Canadian economy heading into a tailspin and the Meech Lake constitutional accord unravelling, one of the longest-running news stories in Canada featured a painting. The painting was *Voice of Fire*, a tall abstract canvas measuring 5.4 by 2.4 metres, executed in 1967 by the American artist Barnett Newman – a work which the National Gallery of Canada announced on 7 March that it had purchased for $1.76 million. The merits and demerits of the painting and its acquisition were debated on open-line radio programs, on television news shows like CBC's *The Journal*, in the editorial pages of the daily press across Canada, and not least by Members of Parliament and the House of Commons Standing Committee on Communications and Culture. MP Felix Holtmann, then chair of the standing committee, suggested on a Winnipeg radio talk show that, if the painting was 'as valuable as some people have purported it to be, maybe it can be put up for public auction,' and Don Mazankowski, then deputy prime minister, responded to the broad backlash against the painting and its price tag by threatening to rescind the purchase, stating through a spokesperson that he and his fellow ministers did not 'like the way the money was spent.'[1] The extent and duration of the ensuing controversy, which lasted from March until June, attested to the passions aroused by the National Gallery's decision, at a time of national predicament, to acquire the painting for its permanent collection.

In some respects, the controversy over *Voice of Fire* was a tempest in a cultural teapot, a squall that provided relief from the more violent storms that were troubling Canada's economic and political future in 1990. But it would be a mistake to underestimate what was at stake for those embroiled in the controversy, as well as for the public at large. In

ways that were sharply symbolic, the controversy reflected the larger themes and debates disquieting Canadians: federal budget deficits and perceived misuses of the taxpayers' money; growing threats to the nation's social safety net; the country's cultural and political agendas and who should control them; the relationship of Quebec to the rest of the country; and the relationship of the whole country to the international community. At a time of pending national crisis, the purchase of *Voice of Fire* seemed to many an economically and morally irresponsible act. 'It's not hard to understand why interest rates are high [and] economists are forecasting recession,' a letter to the editor of the Ottawa *Citizen* asserted, 'when this type of ludicrous spending of taxpayers, money is allowed to go on.'[2]

When, to state the matter bluntly, has a single work of art ever held the attention of the Canadian populace for so long a period of time? Whether we like it or not, because of the controversy *Voice of Fire* has become as much a part of the crazy quilt of Canadian culture as the work of Tom Thomson and the Group of Seven (see fig. 1) or Paul-Emile Borduas and the Automatistes. The same is true of Mark Rothko's *No. 16* (fig. 2), which triggered a second nation-wide debate when the National Gallery added it to its permanent collection in the summer of 1993.

In what follows, I want to try and make sense of what nerves were being touched by these expensive works of postwar American art, especially *Voice of Fire*, and to ask why curators and critics, to say nothing of the press and broadcast media, did not do more to intervene with pertinent questions and observations. I also want to try to situate the outrage over *Voice of Fire* by distinguishing historically between various types of art controversy in the modern era. It is important to remember that many controversies about modern art have been caused by calculated affronts to viewing publics by artists resisting bourgeois norms. Such artists are generally identified as members of an avant-garde, as a group contesting the dominant cultural forms of their time and the institutional structures supporting them.[3] Newman certainly thought of himself as a member of an avant-garde formation and regularly engaged in affronts to the public. During his lifetime (1905–1970) he was no stranger to controversy; anyone daring to contradict his idiosyncratically anarchist view of the world, or the place his art occupied in it, was almost certainly guaranteed a fight.[4]

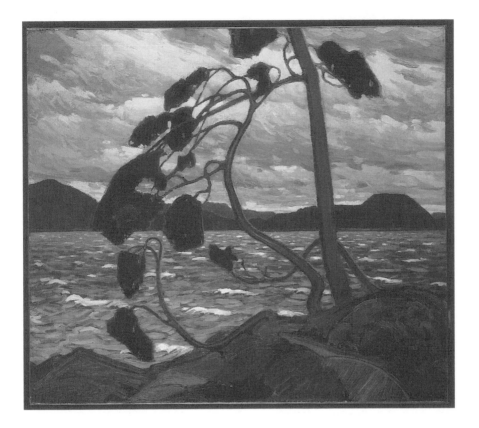

1 Tom Thomson, *The West Wind*, 1917. Oil on canvas, 120.7 × 137.5 cm. Art
Gallery of Ontario, Toronto. Gift of the Canadian Club of Toronto, 1926

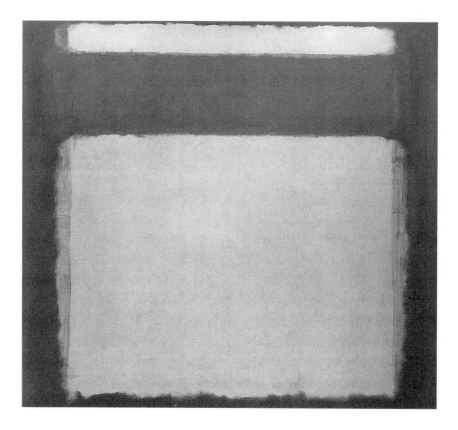

2 Mark Rothko, *No. 16*, 1957. Oil on canvas, 265.5 × 293.0 cm. National Gallery of Canada, Ottawa

The *Voice of Fire* controversy would never have occurred at all had the National Gallery not paid almost $2 million in public funds for the painting. Or, rather, the controversy would never have occurred had the National Gallery not paid such a large sum for art to which the media and the general public so strenuously objected. When Dr Shirley Thomson, director of the National Gallery, was questioned about how she would justify the acquisition to her home town of St Marys, Ontario, she replied: 'We need something to take us away from the devastating cares of everyday life.'[5] The response signalled a misunderstanding about the kind of anger being generated by the acquisition. Far from offering a pleasurable escape from the cares of everyday life, much of the public thought the painting was directly contributing to those cares. Admonitions to enjoy *Voice of Fire* served only to strenghten the view that the gallery functioned as a bureaucratic enclave, an institution less interested in public service than in its own regimes of specialization. (When the gallery purchased an 'old master' painting by Guido Reni one year later, however, at nearly double the price of *Voice of Fire* [$3.3 million], there were no objections. The mythological subject-matter, Jupiter and Europa, clearly accorded with general expectations of what an expensive work of art should represent and of how it should look.)

The cost of *Voice of Fire* figured in all the early news reports of the acquisition – '$1.8 Million Painting Has Artists Seeing Red' was the headline in the *Toronto Star* and 'All in the Eye of the Taxpayer' that of the *Kamloops Daily News* – and continued to fuel the controversy long after the debate had broadened to engage non-monetary discontents. In short, it was the monetary transaction and the 'difficulty' of the painting, rather than the exhibition of it, that provoked such strong public reaction. The painting had been on exhibition as an extended loan from the artist's widow, Annalee Newman, ever since the National Gallery opened the doors to its new building in Ottawa in May 1988, but not a word of criticism was heard in the media. It was only two years later, when the gallery announced it had actually *purchased* the painting, that the controversy erupted.

There is a long and noisy history in the modern era of attacks against art. Attacks have been mounted against: (a) the exhibition of art, (b) the acquisition of art with public funds, (c) the placement of art in public settings, and (d) the right of certain kinds of art to exist at all (censor-

ship). The vociferousness of the attacks has generally been loudest when the gap between art élites, as represented by the National Gallery of Canada (and, it must be said, by individuals with credentials not dissimilar to those of the contributors to this volume),[6] and the public became wider than the public could bear – or, to follow the German sociologist Max Weber, when the idea systems and structures of power around state-supported art no longer seemed legitimate to a large section of society.[7]

II Initially, attacks against modern art were mostly directed against the exhibition of works. In Paris, the Impressionists were ridiculed in the 1870s and 1880s for a series of self-organized exhibitions that were seen to contravene the accepted norms and conventions of academic representation. In New York, Marcel Duchamp, Henri Matisse, and other 'extremists' were caricatured and lampooned during the Armory Show of 1913 for offending public decorum with works such as Duchamp's *Nude Descending a Staircase* (1912) and Matisse's *Blue Nude* (1907). And, in Toronto, Thomson and the Group of Seven were accused in the teens and early 1920s of executing incomprehensible landscapes painted in wilfully crude and shocking 'spasms' of colour. Most recently, in 1991, as Bruce Barber discusses in his essay in this volume, Jana Sterbak and the National Gallery were excoriated for exhibiting Sterbak's *Vanitas: Flesh Dress for an Albino Anorectic* (1987). In all instances, and with greater or lesser degrees of justification, the artists were accused of contravening public sensibilities, of bruising the public eye.[8]

As soon as public institutions began to acquire the works of these artists for their permanent collections, they too became subject to attack. When Gustave Caillebotte died in 1894, bequeathing sixty-five Impressionist paintings to the French state, the gift was blocked until the public and the press joined forces in a counter-campaign for its acceptance. Thirty-eight paintings were eventually chosen for the collection, but not hung in the Louvre until 1928. Canada, like any other country, has its own list of confrontations. In 1922, the critic Hector Charlesworth, writing in *Saturday Night*, castigated the National Gallery for purchasing paintings by Thomson and the Group of Seven instead of works by members of the Royal Canadian Academy. 'To hold that artists,' wrote Charlesworth, 'like the Homer Watson of his prime, Carl

Ahrens, Archibald Browne and Suzor-Coté, who interpret with poetic truth the moods of the older and more pastoral sections of Canada, are the less worthy and the less national in spirit because they do not camp out in the late autumn and paint the wilds in a harsh, strident mood is to talk nonsense and very misleading nonsense at that.'[9] In the period leading up to Charlesworth's criticism, the National Gallery had acquired more than fifty major paintings by Thomson and the Group – and, notwithstanding the controversy generated by Charlesworth, it has continued to purchase works by these artists. In 1993, at the same time that the gallery announced the acquisition of Rothko's *No. 16*, it also announced that it had purchased Lawren Harris's *Decorative Landscape* (1916–17) for $410,000, a record sum for a work of Canadian art acquired by the gallery.

Prior to the *Voice of Fire* and *No. 16* conflagrations, the most prolonged and heated controversy in Canada over a work of art occurred in 1966 and involved a public sculpture, Henry Moore's bronze *The Archer* (fig. 3). The Finnish architect of Toronto's new city hall, Viljo Revell, an acquaintance of Moore's, wanted *The Archer* to stand in the civic square fronting the new building. He had seen a plaster model of the sculpture and was impressed with the way the curvilinear forms of the piece complemented the curved towers of the city hall. There was an allowance in the overall budget to cover the $120,000 price of the finished bronze, but it had to be approved by the city council's board of control before the commission could proceed.

In March 1966, following a debate widely covered in all the media, the council voted down the proposal. 'How much art and culture can we stand?' shouted one opponent of *The Archer* during the discussions. Another argued that 'standards of what constitutes art should be guided basically by what the most people enjoy and take pleasure in.'[10] At the time, 'most people' (which is to say, the Toronto public) agreed with the council. However, Philip Givens, mayor of Toronto, was not one of them, and rather than see Revell's proposal die he formed a committee to raise the funds privately. The committee found the money and Toronto got its Moore, whether a majority of citizens wanted the sculpture or not. (A famous inverse situation, involving a public sculpture that was already installed, was the forced removal under public protest of Richard Serra's *Tilted Arc* from Federal Plaza, New York City, in 1989. Seven thousand workers in the vicinity of the plaza petitioned against

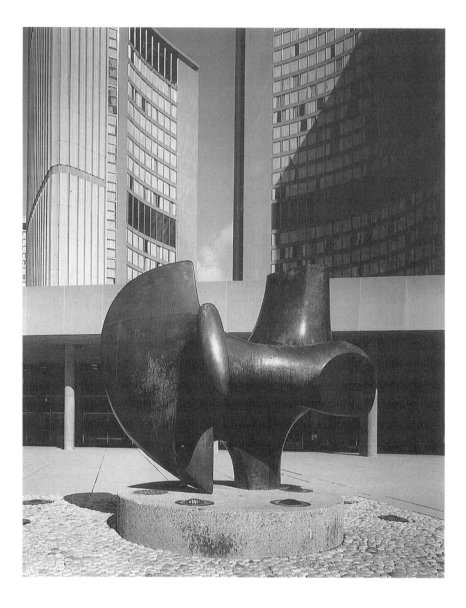

3 Henry Moore's *The Archer* in front of Toronto's City Hall. Photograph courtesy of The Art Gallery of Ontario, Toronto

the sculpture.) Not many years later, it seems worth noting, the Art Gallery of Ontario, supported by sizeable grants from the public purse, opened the Henry Moore Sculpture Centre, now the largest extant public collection of the artist's work.

Most of the time, confrontations about possible acquisitions by public institutions occur behind closed doors and out of the public eye. They are not any the less acrimonious for being *in camera*. By coincidence (or perhaps not?), one such confrontation in Canada also featured a work by Barnett Newman. In 1960, the volunteer committee of the Art Gallery of Toronto, as the Art Gallery of Ontario was then called, set out to raise funds expressly for the gallery to purchase contemporary American art, and asked the American collector Ben Heller for advice about what to buy. Mistakenly, Heller took this as a *carte blanche* invitation to act on the gallery's behalf. Instead of consulting with the committee, he told Newman the gallery intended to buy one of his paintings and had *Day One* (fig. 4) shipped to Toronto without advance warning.

William Withrow, then assistant director of the gallery, can still remember the general puzzlement when the shipping crate arrived.[11] The puzzlement was not lessened when the crate was opened and the volunteer committee was introduced to *Day One*. Given the committee's relative unfamiliarity with American art and the drastically reduced formal structure of the work, it is not surprising the committee decided to turn it down.[12] The painting was returned to New York, and Newman was furious – he was notorious for protecting his work against hostile interpretations – thinking that the gallery had reneged on a firm purchase commitment. According to Annalee Newman, he never forgave the gallery (or Toronto) for seeming to go back on its word.[13]

During the *Voice of Fire* controversy, no one argued that the painting should be censored or confiscated. Nevertheless, the debate over the painting took place in a climate in which censorship had become a point of confrontation in Canada, another major category of art controversy. In 1984, the Vancouver Art Gallery cancelled its own exhibition of videotapes, *Confused: Sexual Views*, by artists Paul Wong, Gary Bourgeois, Gina Daniels, and Jeannette Reinhardt. The director of the gallery, Luke Rombout, concluded that the work was not art, adding that he feared adverse public and media reaction to the exhibition. Despite widespread protests and a libel suit by Paul Wong, the exhibition was

4 Barnett Newman, *Day One*, 1951–2. Oil on canvas, 335.3 × 127.6 cm.
Collection of Whitney Museum of American Art, New York. Photograph by
Geoffrey Clements

not reinstated. Later in the same year, a regulatory arm of the Ontario government confiscated videotapes from A Space, a Toronto artist-run collective, without explanation. A Toronto court subsequently ruled that the videotapes must be returned, since the seizures contravened constitutional rights to freedom of expression guaranteed by the 1982 Canadian Charter of Rights and Freedoms.[14] In 1994, five canvases and thirty-five sketches by Eli Langer, shown the previous year at the Mercer Union gallery in Toronto and representing the sexual engagement of children and adults, went on trial to determine whether or not they should be destroyed. The judge hearing the case first reserved judgement and then, in 1995, ruled that the works should be returned to the artist because they did not pose 'a realistic threat to children' and were 'entitled to the defence of artistic merit.' 'In other words,' the judge wrote, 'the purpose of the work is not to condone child sexual abuse, but to lament the reality of it.'[15]

In a case that did not come to trial, the Mendel Art Gallery in Saskatoon came under fire in 1990 for exhibiting work by the Canadian photographer Evergon. Several of his large-scale images represented figures of uncertain gender wrapped in sheets of plastic and submerged upside down in water. A public letter of complaint, calling the works offensive and stating that they promoted homosexuality, sparked a debate that resulted in the Saskatoon city council reviewing the Mendel's exhibition and management policies. Several councillors wanted to censor 'offensive' exhibitions and to cut the gallery's budget. Linda Milrod, then director of the gallery, defended the gallery's exhibition policies by stating: 'It's not our job to judge what the community needs protection from ... It is our job to allow a free exchange of ideas about sometimes controversial matters.'[16] In the end, the gallery managed to retain control of its exhibition policies and hold on to most of its budget.

III The foregoing recitation of modern-art controversies, and the categories into which they may be divided, serves to frame the *Voice of Fire* debate. The objections to *Voice of Fire*, I want to emphasize, heralded nothing new or unprecedented in the history of art controversies – in Canada or any other place. Mention *Voice of Fire* to an Australian and you will get an earful about *their* national gallery's purchase of Jackson Pollock's *Blue Poles* for $2 million in 1973, and the

scandal it precipitated; discuss Moore's *The Archer* with a Londoner and you will get chapter and verse on the exhibition of Carl Andre's 'bricks' (*Untitled*, 1965) by the Tate Gallery in 1976, and the public denunciation and vandalism that followed.[17]

But it would be wrong to suppose that each new art controversy is simply a carbon copy of those preceding. That would be to reckon without the local demons of history that pursue each incident, demons as different from one another as one war is from the next. The Armory Show, for example, which took place shortly before the outbreak of the First World War, coincided with widespread anxiety about the collapse of the political and social order in Europe. An editorial in the *New York Times* accused Matisse, Duchamp, and the modern movement in general of nothing less than fomenting political insurrection. They were part of an insane effort 'discernible all the world over, to disrupt and degrade, if not to destroy, not only art, but literature and society, too.'[18] The *New York Times* was accurate in observing that artists wished to overthrow the established order for art but wrong in insisting that they were political revolutionaries as well.

Seventy-five years later, in the United States, conservative cultural warriors who signed up in the fight to overturn liberalism in the 1980s did not go so far as to claim that contemporary art might bring down the government – that would have seemed ludicrous – but they did charge it with maliciously undermining 'traditional American family values.' Although modern and contemporary art initially occupied a relatively minor position on the conservative moral agenda, the period was characterized by attacks on left-wing critics and the liberal establishment by such organs as Hilton Kramer's *The New Criterion*. Then, in April 1989, the Reverend Donald Wildmon brought to the attention of Congress and the media Andres Serrano's *Piss Christ*, a large colour photograph of a plastic crucifix submerged in the artist's urine. Aside from wanting to damn Serrano and damn the image, Wildmon wished to vilify a government agency, the National Endowment for the Arts (NEA), for granting monetary support to Serrano.

Wildmon's attack on Serrano and the NEA opened a new chapter in the so-called American culture wars. In their widest form, the culture wars have ranged over territory stretching from the depredations of popular culture to the diversification of the educational curriculum in

the United States. Conservatives who have taken up arms over these matters have been adamant. They want popular culture to provide 'decent' family entertainment and they want the educational curriculum to teach the old canons that constitute great ideas, great literature, and great art, much as they prevailed before the social revolutions of the 1960s. Their line of attack against the arts has been to try to force the curtailment of government funding for them, especially for artists like Serrano and Robert Mapplethorpe (the latter's widely discussed exhibition *The Perfect Moment* also received NEA support).

The most prominent public figure in the anti-art/anti-NEA campaign has been Senator Jesse Helms. The sweep of his animus can be judged from a 1991 letter to the Reverend Jerry Falwell, in which he warned that 'the homosexual "community," the feminists, the civil libertarians, the pro-abortionists, the flag burners and many other fringe political groups are more active than ever in promoting their dangerous anti-family and anti-American agendas.'[19] From time to time, Helms has had some odd bedfellows, for example, the feminist anti-pornographers Catharine MacKinnon and Andrea Dworkin, whose ideas and campaigns have intersected with his.

Given the tenor of the debate about subsidized culture south of the border, it is important to recognize that the *Voice of Fire* controversy, which was also about the public funding of 'high' culture in a time of public discontent, produced a different kind of rhetoric and debate. One opponent of the *Voice of Fire* acquisition called the painting 'a refugee flag in search of a country'[20] – which is not a bad definition, as Thierry de Duve says in his essay for this volume, 'Vox Ignis Vox Populi' – but that is a far cry from accusing advocates of the painting of being unpatriotic flag-burners. Another opponent, speaking on behalf of the artists' lobby group CARFAC, argued that the National Gallery's priorities were 'pretty backward' and that it should not have used 'such a big chunk of the budget ... to purchase a work by an American artist'[21] when it could have bought more work by Canadian artists. Once again the charge falls well short of a blanket condemnation of the gallery for espousing a dangerous 'anti-Canadian' agenda, even if the reaction reflects a certain kind of feather-bedding Canadian nationalism, an appeal to national identity as a self-serving means of promoting its members' interests. CARFAC and related organizations have generally

escaped criticism in Canada, Dot Tuer has observed, because of the sanctified aura that has surrounded federal support of the arts as a guarantor of national identity since the Second World War.[22]

This is not to say that the rhetoric generated by *Voice of Fire* lacked intensity – there was heat enough in it – but it is to suggest that the mentalities and institutional structures that shaped it were different in Canada and in the United States. Unlike the American adversaries of the NEA, Canadian opponents of *Voice of Fire* refrained from trying to slash the National Gallery's budget. In Canada, there is a stronger tradition of public support for the arts than in the United States, where a system of private patronage has been firmly entrenched since the nineteenth century. The Canadian patron state, as it might be called, has been responsible for initiating some of the country's most enduring cultural institutions: the National Film Board, the CBC, the Canada Council, the National Gallery of Canada itself, to name just four. The clash over *Voice of Fire*, therefore, centred less on whether government should be funding the arts – the consensus in 1990 remained that it should (though five years later that consensus is less uniform and showing signs of strain)[23] – than on whether the National Gallery used the funds at its disposal in a responsible way.

IV In order to determine whether the gallery did act responsibly, it is important to understand the scope and terms of the gallery's mandate. Much of the anger directed at *Voice of Fire*, it seems to me, arose from a sincere ignorance, both inside and outside government, about the legislation governing the gallery's activities. To confuse matters, this legislation was in the process of changing at the precise moment the controversy broke. Since 1968 the gallery had operated under the National Museums Act, which placed it under the same organizational umbrella as the Canadian Museum of Civilization, the National Museum of Natural Sciences, and the National Museum of Science and Technology. On 30 January 1990, a little more than a month before the announcement of the acquisition, a parliamentary bill (C-12) turning the National Gallery into an autonomous Crown corporation was given Royal Assent.[24] Under the terms of the new Museums Act, the gallery was given its own board of trustees and independent management of its financial affairs. It was also given responsibility, as before, to collect and present works of art as it saw fit 'for the benefit and enjoy-

ment of Canadians.' The act specifically stated that no directives were to be imposed on the gallery with regard to administrative and artistic matters. Moreover, the traditional 'arm's-length principle' of independence from political interference would regulate the gallery's relationship with the federal government.

By the time Dr Shirley Thomson appeared to report on the gallery's affairs before MP Felix Holtmann and the Standing Committee on Communications and Culture on 10 April 1990, there had already been widespread public debate on the arm's-length principle and what it meant for the *Voice of Fire* purchase. On the morning of 10 April, Holtmann published a letter in the *Globe and Mail* in which he argued against a defence of the principle by Allan Gotlieb, then chair of the Canada Council. 'Contrary to what Mr. Gotlieb asserts,' he stated, 'the gallery is responsible to Parliament, as are other federal institutions. In spite of Mr. Gotlieb's belief, there is no divine right of curators. The gallery is spending public money. Parliament and citizens have every right to ask what it is spending it for.'[25]

In her opening statement to the committee, Dr Thomson (fig. 5) responded to Holtmann's challenge to the arm's-length principle by observing that the principle had been reaffirmed in the new act giving the gallery Crown corporation status. In a politically roundabout way, she was saying that government – whether in the form of Holtmann and his committee or Don Mazankowski and the Cabinet – had no business threatening to rescind the purchase. In acquiring *Voice of Fire*, the gallery was only carrying out its mandate according to terms that had been established by Parliament itself. Dr Thomson did acknowledge, however, Parliament's right to question the gallery: 'I assure you that we respect the accountability our new status entails and we are always ready to appear here to continue our dialogue and to open the gallery to you.'[26] Which is to say, she acknowledged there is no 'divine right of curators' protecting their activities from government scrutiny.

The Italian Marxist Antonio Gramsci once observed that intellectuals are experts in legitimation. Although the gallery's curators unquestionably fall into the category of intellectuals, and the gallery itself can be categorized as a legitimating institution, during the *Voice of Fire* controversy neither the curators nor the gallery seemed at ease in accounting for what they were busy legitimating. Most of all, they did not seem to recognize that their devoted efforts in the cause of modern art

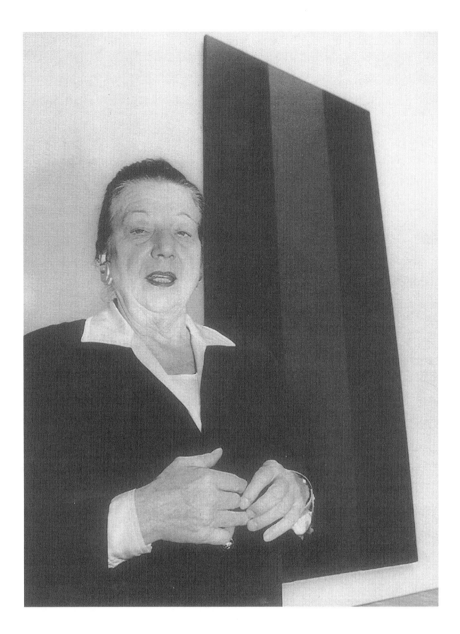

5 'Director Shirley Thomson with $1.76-million *Voice of Fire*: frustrations.' *Globe and Mail*, 14 March 1990. Photograph courtesy of CANAPRESS

might not be appreciated by the Canadian public. Nor did they seem to recognize that the negative reaction to the purchase deeply implicated the Conservative government, making it look fiscally irresponsible. The gallery's misunderstanding about the source and direction of the public's anger was apparent in its press statements about the painting. Its first pronouncement, prepared by then assistant director Brydon Smith (fig. 6), who was responsible for advancing and negotiating the acquisition, read: '*Voice of Fire*'s soaring height, strengthened by the deep cadmium-red centre between dark blue sides, is for many visitors an exhilarating affirmation of their being wholly in the world and in a special place where art and architecture complement each other.'[27]

By using such a defence, Smith reckoned without the public's aversion to abstraction in general and the paintings of Newman in particular. The public saw Newman's work as bewildering in its reductiveness and extreme in its assertiveness. As the controversy demonstrated, the painting had a capacity to repel viewers that was more than equal to its ability to attract them. Newman, as a member of a self-conscious avant-garde, was not unaware of these qualities in his work. Smith assumed, however, that *Voice of Fire* could be understood and appreciated by anyone who looked at it hard enough.[28] His explanation, a resolutely 'formalist' one, insisted that the visual pleasures of abstraction were open to any viewers, regardless of their background, who would take the trouble to let the force of abstract representation and its moral probity penetrate through them. His recommendation to viewers was a little like D.H. Lawrence's description of masturbation: 'an attempt to make the body react to some cerebral formula.'[29] What got left out in Smith's and the gallery's account of *Voice of Fire* was an admission that the painting is difficult, to say nothing of its flesh-and-blood history, the circumstances of its making and use, and the successive meanings that have accrued to it over time.

What remained unexamined during the controversy is, in part, the subject of this book. One of the principal themes in what follows is that the privileges claimed by formalism and its adherents are not easily reconciled to the interests of the general public. At the heart of the *Voice of Fire* controversy was a profound questioning of élite accountability in the public sphere. The National Gallery came under intense scrutiny for its purchase decision, not only from the federal government, to which it reports under the legislative terms of its mandate, but also from the

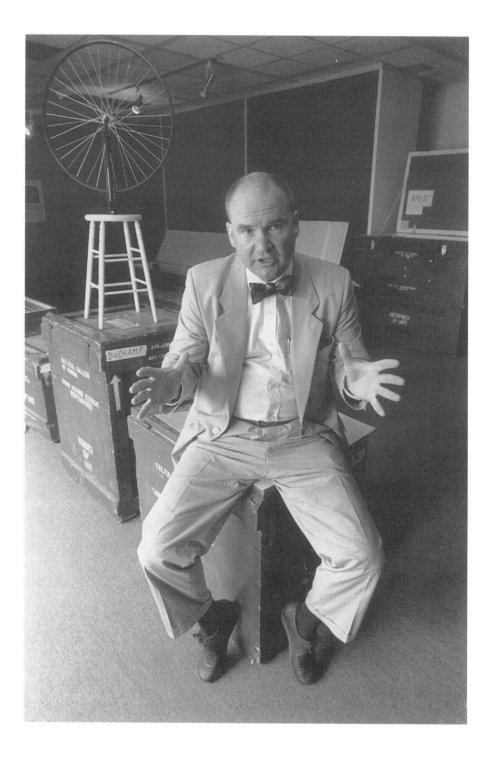

6 'Brydon Smith: "I've been agonizing over a way to deal with this." ' *Globe and Mail*, 30 March 1990. Photograph by Ron Poling, courtesy of CANAPRESS

general public and the media. At issue was the gallery's seeming disre-
gard for the national interest at a time of pending economic crisis and
deepening uncertainty about the constitutional future of the country.
From March until June 1990, the connotations conjured up by the
National Gallery of Canada as an institution were strongly negative. The
gallery projected an image of aloofness, of a place governed more by
bureaucratic protocol than by a concern for the public it was charged
with serving. In the minds of audiences, the high arrogance of Barnett
Newman's *Voice of Fire* was matched by the high arrogance of the insti-
tution that had purchased the painting.

Documents

The material collected in this section provides the basic documentary background for understanding the *Voice of Fire* controversy. The Chronology is a point-by-point chronicle of events, detailing Barnett Newman's commission to execute a painting for the 1967 world's fair in Montreal, Expo 67, and extending to the media scrutiny of March and April 1990. The Graphic Satires subsection brings together newspaper and magazine cartoons that address the painting and its purchase by the National Gallery of Canada. And the Texts portion comprises a selection of news reports, letters, articles, and public exchanges that appeared in the media during the controversy.

Chronology

1966 Barnett Newman is approached about participating in an exhibition of contemporary American painting to be mounted at Expo 67, the upcoming world's fair in Montreal. The United States Information Agency (USIA) is coordinating the exhibition; it is also constructing the pavilion in which the exhibition will be installed. Alan Solomon, art critic and historian, is in charge of selecting work for the exhibition.

Solomon invites twenty-two artists to participate, requesting that they contribute paintings that are (a) large in scale and (b) vertical in format. The exhibition is called *American Painting Now*.

1967 Winter. Newman paints *Voice of Fire* in his studio at 100 Front Street, New York. The canvas measures 5.4 metres high by 2.4 metres wide and is executed using acrylic paint in two colours, cadmium red and ultramarine blue. Newman had previously executed four horizontal paintings with similar dimensions; several of these paintings also use red and blue as their dominant colours.

11 April. *Voice of Fire* is shipped by Newman from his New York studio to Montreal.

28 April. Expo 67 opens. *American Painting Now* is installed in the United States pavilion, Buckminster Fuller's geodesic dome, along with an Apollo space capsule, close-up photographs of the moon, blow-ups of movie stars, and three huge red-and-white-striped Apollo parachutes that encircle the paintings. The paintings are floated against sailcloth panels suspended on stainless steel cables hung from the roof. Fuller's dome, dubbed 'Bucky's Bubble,' quickly becomes the fair's principal icon; the exhibitions inside generate substantially less media commentary than does the building.

11 June. Newman mails Solomon an invoice for the cost of his materials in preparing *Voice of Fire*. The invoice amounts to $423.60. Even though the USIA has not expressed an interest in buying the painting, Newman clarifies his contractual arrangement in an accompanying letter: 'I understand that [my reimbursement for materials] does not give anyone an equity in my work.'

Midsummer. Newman and his wife, Annalee, travel from New York to Montreal to visit the fair. They approve of Solomon's installation of the paintings in the exhibition.

27 October. Expo 67 closes. Along with other paintings from Solomon's exhibition, *Voice of Fire* is shipped to Boston.

15 December. *American Painting Now* opens at its second (and only other) venue: Horticultural Hall, Boston. The exhibition in Boston is sponsored by the Institute of Contemporary Art and is accompanied by a catalogue written for the occasion by Solomon.

1968 27 June. *Documenta 4*, a quadrennial exhibition of international art, opens in Kassel, Germany. *Voice of Fire* is among the works included in the show.

1969 12 September. Newman travels to Ottawa for a retrospective exhibition of Dan Flavin's works at the National Gallery of Canada. Newman has been invited by Flavin and the gallery to introduce the exhibition at its official opening. Brydon Smith is curator of the exhibition.

1970 4 July. Newman dies of a heart attack at age sixty-five. *Voice of Fire* becomes part of his estate, which is left to his wife, Annalee.

1987 Late fall. The National Gallery of Canada, Ottawa, negotiates the purchase of *Voice of Fire* from the artist's widow, Annalee Newman, for $1.5 million (U.S.). The purchase is subject to a lengthy process of approval by various boards and committees, both within the gallery and outside it. The acquisition is not formally concluded until August 1989 and is not officially announced until March 1990.

1988 May. The National Gallery celebrates the completion and opening of its new building in Ottawa. *Voice of Fire*, on loan to the gallery from Annalee Newman, is given a prominent position in the galleries devoted to postwar art.

17 September. Brydon Smith, assistant director of the gallery, is quoted by the *Globe and Mail* as saying that he expects approval of the proposed acquisition of *Voice of Fire* to be 'tough sailing.' Smith continues: 'It's about [the gallery's] freedom to choose, to defend that choice publicly, and hopefully to have it understood and supported.'

18 September. The gallery recommends purchase of *Voice of Fire* to the board of the National Museums of Canada Corporation, the organization which oversees its activities. The acquisition meets with board approval.

10 October. The *Globe and Mail* publishes a letter from Jim Parr, Toronto, who is critical of the proposed purchase. Parr writes that 'museum directors should know that the public will not be fooled by claptrap – not for long anyway.' This is the first public denunciation of the painting and its proposed acquisition.

25 October. Jean Sutherland Boggs, a former director of the gallery and the former chair of the Canadian Museums Construction Corporation, responsible for building the gallery, responds to Parr's letter: 'I should like to say that as an art historian and a retired museum professional, and as a Canadian, I support the purchase ... I hope that in Canada we are ready to support the acquisition of this masterpiece of universal rather than regional meaning.' The exchange between Boggs and Parr about *Voice of Fire* is the first of many to appear in the pages of Canadian newspapers.

1989 August. *Voice of Fire* is acquired by the National Gallery of Canada at a price of $1.5 million (U.S.) (approximately $1.76 million [Cdn]). No public announcement of the purchase is made at this time.

1990 7 March. The National Gallery announces that it has purchased *Voice of Fire* in a routine news release providing information about the Newman painting as well as other works acquired during the previous year. The gallery also announces that its

annual budget for acquisitions, set at $1.5 million since 1972, has been doubled to $3 million by the Minister of Communications, Marcel Masse. In a news interview Dr Shirley Thomson, director of the gallery, states: 'We rarely have the chance in today's overheated art market to purchase works of the scale and historical significance of *Voice of Fire*.' This opinion is supported by then assistant director Brydon Smith, who describes the painting as ideally suited to the new building: 'In the spacious, sunlit gallery where the work is presently installed, *Voice of Fire*'s soaring height, strengthened by the deep cadmium-red centre between dark blue sides, is for many visitors an exhilarating affirmation of their being wholly in the world and in a special place where art and architecture complement each other.'

The purchase announcement generates swift response. Global Television in Ottawa produces a special report on the evening news, cutting from Dr Thomson's observations about the painting to observations by the general public. Some of the comments by the public are that *Voice of Fire* looks like 'the ribbon of a military medal,' 'a flag of a country somewhere,' and 'something my son'll do in daycare.' Still others say they 'wouldn't pay a dollar' for it, and that it should be 'put in the garbage.' Radio station Q-101 FM, Ottawa, also conducts an evening interview with Dr Thomson on its program 'Insight.' CBC-FM, on 'Arts Tonight,' runs a report by Robert Enright. When Enright is asked if 'this [is] going to upset a lot of people who think the National Gallery of Canada should be buying mainly at home,' he replies that it will.

8 March. The gallery is criticized for purchasing *Voice of Fire* by Greg Graham, director of Canadian Artists' Representation/ Front des artistes canadiens (CARFAC), a national lobby group of artists: 'We think the National Gallery's priorities are pretty backward ... It bothers us that such a big chunk of the budget is going to purchase work by an American artist.' A headline in the *Toronto Star* reads: '$1.8 Million Painting Has Artists Seeing Red.' A photograph of the painting is reproduced in colour.

9 March. Member of Parliament Felix Holtmann, chair of the House of Commons Standing Committee on Communications and Culture, announces plans to question gallery officials about *Voice of Fire*. On an open-line radio program in Winnipeg, Holtmann states that, if the painting 'is as valuable as some people have purported it to be, maybe it can be put up for public auction.' He also states, famously, that

'it looks like two cans of paint and two rollers and about ten minutes would do the trick.'

A parody of *Voice of Fire*, painted by Louis Lesosky and Dave Trendle of Victoria, B.C., and titled *Echo of Fire*, is reproduced in the Victoria *Times-Colonist*. It is the first parody (or copy) of the painting to be reproduced in a Canadian newspaper. It has 'a firesale price of $3.2 million.'

10 March. Deputy prime minister Don Mazankowski announces through a spokesperson that the Cabinet's expenditure review committee 'will discuss next week whether the purchase can be stopped ... It's a question of the appropriateness of buying this painting.' Helen Murphy, speaking on behalf of the gallery, responds that *Voice of Fire* was acquired and paid for in August 1989, which means that the purchase cannot be reversed. The Ottawa *Citizen* publishes an editorial stating that the painting represents 'good value,' but the gallery would have been better advised to spend its money on Canadian art. The Moncton *Times–Transcript* denounces the purchase as 'a shocking waste of public monies.' The Saskatoon *Star–Phoenix* compares it to wallpaper. On the whole, coverage is negative.

The first editorial cartoon related to *Voice of Fire*, by David Beresford in the Ottawa *Citizen*, is published.

12 March. The furore over *Voice of Fire* gathers force, attracting strongly differing opinions from both experts and the general public. Montreal artist Yves Gaucher says in an interview that it 'is a fabulous painting and when a good purchase like this is made, it is cause for celebration'; Montreal art dealer Serge Vaisman disagrees, saying that 'buying the painting 23 years after it was done is a bit late ... It's frittering away taxpayers' money.'

15 March. Brydon Smith is interviewed on the CBC radio program 'Morningside' by Peter Gzowski. When Gzowski points that there seems to be a lot of heat on the gallery over the acquisition, Smith responds that 'the first reporters who were put on the case were firetruck chasers, and they certainly fanned the fires of *Voice of Fire*.'

16 March. The *Ottawa Sun* publishes photographs of several *Voice of Fire* copyists with their copies: John and Joan Czupryniak standing in front of a 4.8-metre-high by 1.8-metre-wide version of the painting on their Nepean farm, and John Beland wearing a 'T-shirt of Fire' that he is selling for '$20,000 (price negotiable).'

18 March. Press secretary Tom Van Dusen, speaking for deputy prime minister Don Mazankowski, reiterates that the Cabinet's expenditure review committee intends to discuss the purchase. 'The review [is] prompted by a negative public reaction to the purchase that include[s] phone calls and letters,' he says. This is the last statement on the purchase to be issued by Mazankowski's office.

20 March. An editorial in the *Globe and Mail* endorses the gallery's purchase of *Voice of Fire*, arguing that making decisions about 'what belongs in the National Gallery's collection is not the job of Commons or cabinet committees.' Marjorie Nichols, writing in the Ottawa *Citizen*, thinks that the proposed governmental review 'is a sop to the yahoos on the Tory backbench who haven't had many victories lately, what with their government's renewed commitment to bilingualism and the decision to allow Mounties to wear turbans.'

21 March. The Royal Canadian Academy of Arts comes out in support of the National Gallery.

23 March. The Canadian Conference of the Arts, the country's largest arts lobby group, accuses the government of violating 'the arm's-length principle between government and its autonomous agencies' with regard to the National Gallery and *Voice of Fire*.

24 March. Ian MacLeod, writing for the Ottawa *Citizen*, compares recent prices recorded for Newman's work: *Anna's Light* (1968) was bought in 1988 by the Kawamura Memorial Museum, Tokyo, for $2.5 million (U.S.); *The Promise* (1949) was bought at auction in 1988 by an anonymous buyer for $1.65 million (U.S.); and other works are said to have changed hands for at least twice the price paid by the National Gallery. MacLeod quotes Annalee Newman as saying, 'I felt Canada was the right place for the painting. I kept the price very low because I wanted Canada to have it.'

26 March. Allan Gotlieb, chairman of the Canada Council, warns of the need to resist political interference in the arts.

28 March. Marcel Masse, Minister of Communications, defends the arm's-length principle in relationships between cultural institutions and the federal government.

29 March–9 April. The public debate over *Voice of Fire* is conducted across all regions of the country, with continuous commentary in magazines, newspapers, and the broadcast media. Attend-

ance at the gallery climbs by more than 20 per cent compared with that of the previous year.

A pamphlet on the painting written by Brydon Smith, *'Voice of Fire': Barnett Newman 1905–1970*, is circulated free of charge to gallery visitors. Fifty thousand copies are printed.

10 April. A letter from MP Felix Holtmann responding to the article by Allan Gotlieb appears in the *Globe and Mail*. Holtmann argues that it is the responsibility of government to question the gallery about its activities: 'Contrary to what Mr. Gotlieb asserts, the gallery is responsible to Parliament, as are other federal institutions. In spite of Mr. Gotlieb's belief, there is no divine right of curators. The gallery is spending public money. Parliament and citizens have every right to ask what it is spending it for.'

At 9:00 A.M., in Room 269, West Block, Parliament Buildings, Ottawa, a capacity audience gathers to hear representatives of the National Gallery speak before the House of Commons Standing Committee on Communications and Culture, chaired by Felix Holtmann. The hearing constitutes part of an annual review of the gallery's spending estimates, though *Voice of Fire* is the primary topic of discussion. The gallery is represented by Dr Shirley Thomson, Brydon Smith, and Yves Dagenais, deputy director. After a full day of testimony and questions, little emerges from the hearing that has not already been aired in the media. Proposed motions regarding *Voice of Fire* are deferred until the committee meets at a later date.

CBC television runs a special program about the *Voice of Fire* controversy on *The Journal*. The program includes archival footage of the artist himself, a panel discussion with art-world professionals, and a lengthy interview with the Canadian sculptor Robert Murray, who worked with Newman during the 1960s.

26 April. A motion by Conservative MP Larry Schneider that the National Gallery consider selling *Voice of Fire* and that it use the funds to buy Canadian art is defeated by the House of Commons Standing Committee on Communications and Culture by a vote of eight to five. Liberal MP Sheila Finestone opposes the resolution on the grounds that it violates the government's own arm's-length policy against interference in the arts bodies it funds. She cautioned the committee about looking 'like a bunch of philistines ... cultural ignora-

muses.' The defeat of the motion concludes the government's public involvement in the controversy.

May. The press keeps the controversy alive by encouraging guest writers, letters to the editor, and its own columnists. Published views about the acquisition remain predominantly negative.

June. Press commentary on *Voice of Fire* dries up.

20 September. Seventeen-year old Kyle Brown of Edmonton notices that the cover photograph of *Voice of Fire* on the National Gallery's pamphlet is flopped. He arrives at his conclusion by observing that the label on the jeans of the figure shown standing beside the painting appears on the wrong rear pocket. The gallery admits its error.

28 October. The National Gallery hosts a symposium and public forum on *Voice of Fire* in its auditorium. More than 400 people turn out for the event.

Graphic Satires

The nineteen cartoons in this section appeared in the pages of Canadian newspapers and magazines in 1990–1. Seventeen of them were published in the six-week period from 10 March and 21 April 1990; one was published in November 1990; and the final cartoon appeared five months later, in April 1991, at the time of the *Flesh Dress* controversy.

7 David Beresford, *The Citizen* (Ottawa), 10 March 1990

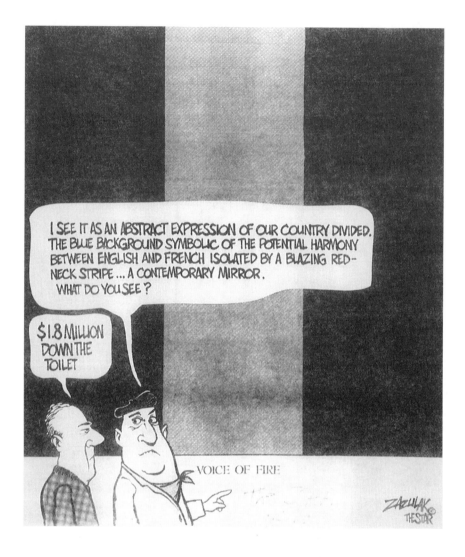

8 Zazulak [Peter Zazulak], *Toronto Star*, 14 March 1990

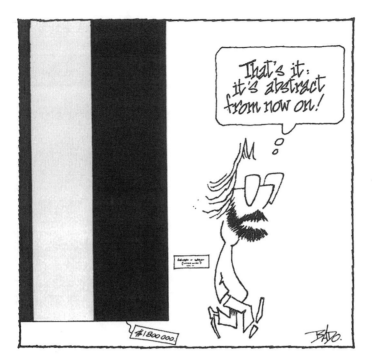

9 Bado [Guy Badeaux], *Le Droit* (Montreal), 15 March 1990

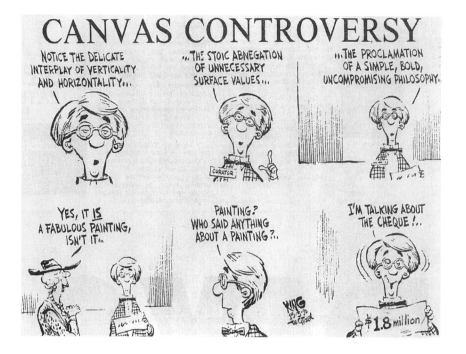

10 King [Alan King], *The Citizen* (Ottawa), 15 March 1990

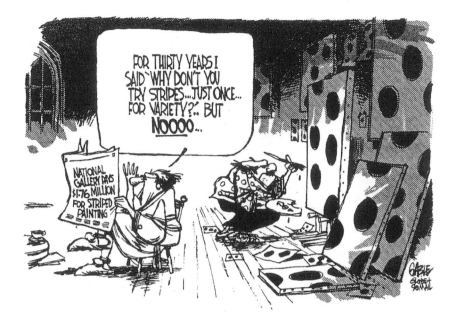

11 Gable [Brian Gable], *Globe and Mail,* 17 March 1990

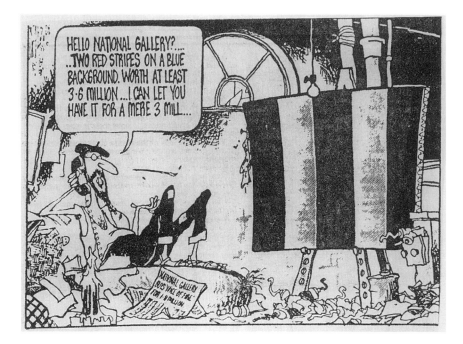

12 Adrian Raeside, *Sudbury Star,* 17 March 1990

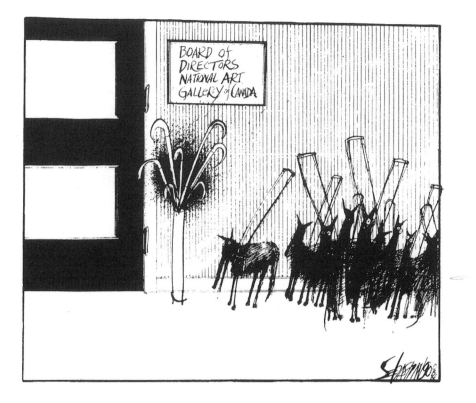

13 Sebastian [Fred Sebastian], *Ottawa Business News,* 24 March–6 April 1990

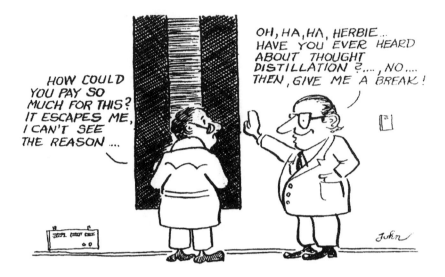

14 John, *Edmonton Bullet*, 28 March 1990

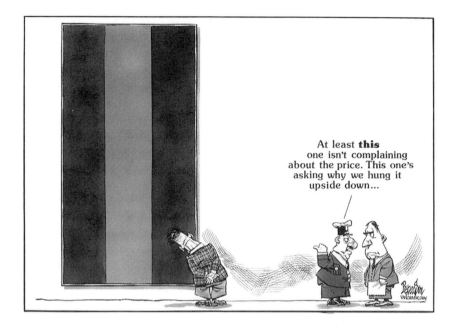

15 Peterson [Roy Peterson], *Vancouver Sun*, 28 March 1990

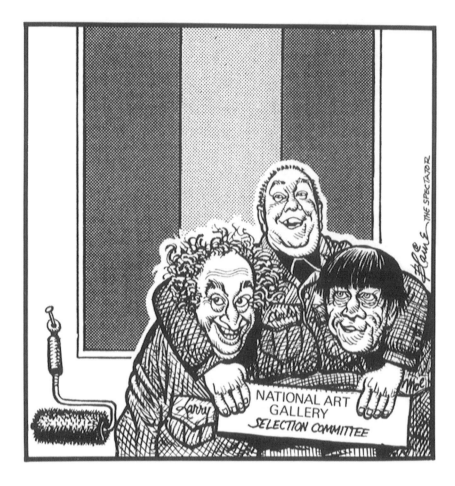

16 Blaine, *Hamilton Spectator*, 29 March 1990

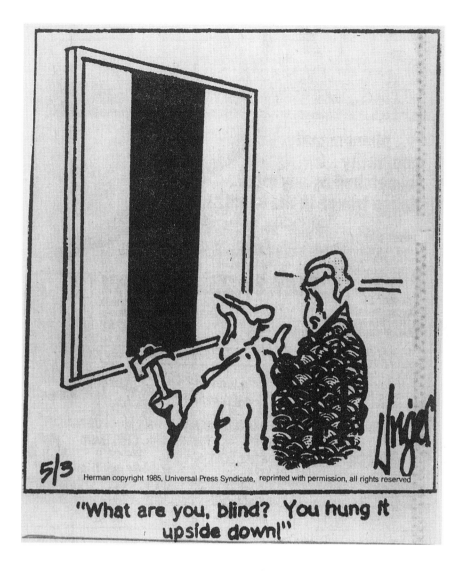

17 Unger [Tommy Unger], 'Herman,' *Globe and Mail,* 7 April 1990

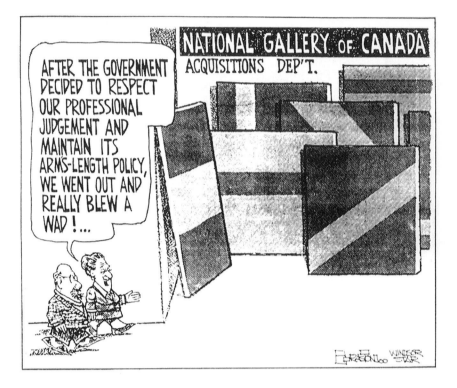

18 Graston [Mike Graston], *Windsor Star*, 12 April 1990

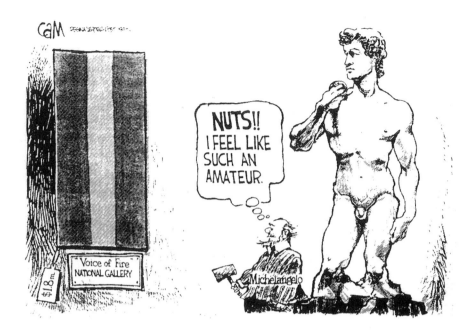

19 Cam [Cameron Cardow], *The Leader–Post* (Regina), 14 April 1990

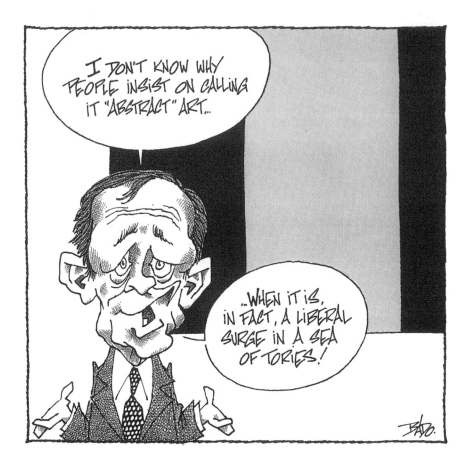

20 Bado [Guy Badeaux], *Le Droit* (Montreal), 18 April 1990

HUTCH

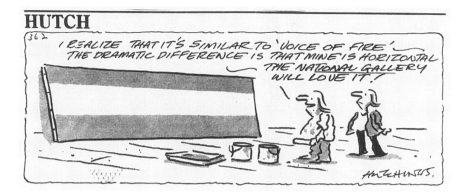

21 Hutch [Hutchings], *Financial Post,* 19 April 1990

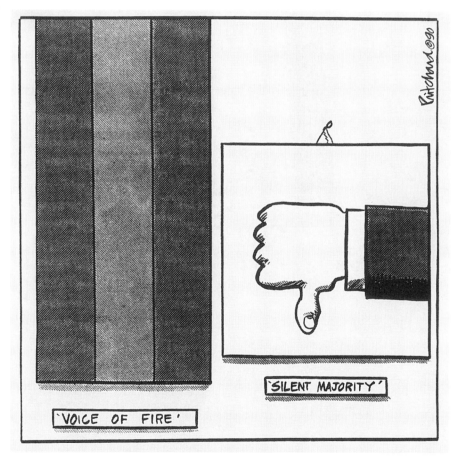

22 Pritchard, *The Leader–Post* (Regina), 21 April 1990

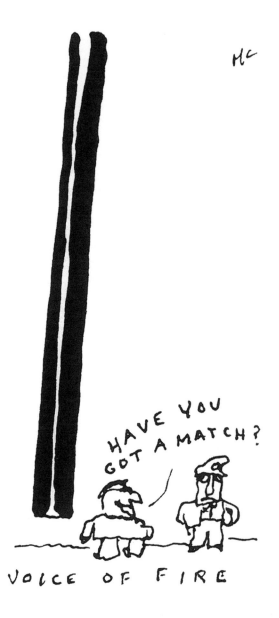

23 MC [Mike Constable], *TO Magazine*, April–May 1990

24 Ben Lafontaine, *Ottawa Magazine*, November 1990

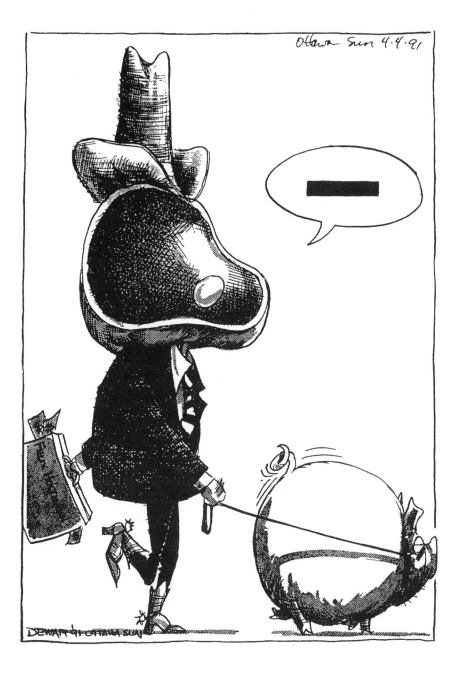

25 Dewar [Susan Dewar], *Ottawa Sun,* 4 April 1991

Texts

**National Gallery of Canada
News Release, 7 March**

In 1989 the National Gallery of Canada continued its active acquisitions program of works of art for its collections. From January to December 1989, 411 acquisitions were made, including 226 purchases and 185 gifts.

The gallery's acquisitions budget, which had been set at $1.5 million a year in 1972, this year was doubled by the Minister of Communications, the Hon. Marcel Masse, to $3 million as of 1 April 1989. Dr Shirley Thomson, director of the gallery, acknowledges this increase gratefully as a vote of confidence in the institution and its curators. 'It will greatly help the gallery in its acquisitions program,' Dr Thomson noted. 'The generally very high prices still prevalent in the international fine-art market mean that we simply cannot compete for a Picasso or a Pontormo. However we can and do make sound and outstanding purchases in less overheated areas, and thanks to our astute curators and their research we continue to acquire important works.'

One such work is Barnett Newman's *Voice of Fire*, a magnificent painting and a major work in this American abstract painter's career, first shown in Canada at the U.S. Pavilion for Expo '67. Newman's personal contact with the Canadian art world began in 1959 during his workshops at Emma Lake in Saskatchewan, and he has had a strong and positive influence on many Canadian artists, including Robert Murray and Guido Molinari. *Voice of Fire* hangs in the European and American galleries.

Another significant purchase, this time for the prints and drawings collection, is William Morris' *Design for a full-page border for the Kelmscott Press 'Chaucer'*. Morris, whose accomplishments as a poet, draftsman, designer, and

critic make him one of the Great Victorians, founded the Kelmscott Press in 1888, and he and his collaborators produced 53 exquisitely designed and illustrated books under its imprint. The outstanding work by the Kelmscott Press was Morris' masterpiece, the *Chaucer*. It is lavishly illustrated, and Morris produced over 60 new designs for the book, including seven matching pairs of full folio borders. The drawing now in the gallery's collection is a full-scale drawing for one of these pairs, of very high quality and in good condition.

The collection of later Canadian paintings, sculpture and decorative arts was enriched by the addition of three pieces by George A. Reid. Best known as a painter, he was also a catalyst in the Arts and Crafts Movement in Canada. The gallery aquired Reid's piano, music cabinet, and piano stool, the piano and cabinet being designed and painted by the artist, and they illustrate Reid's commitment to an ideal fusion of the arts. These are unique works in the Canadian context and without peer, essential to the history of the Arts and Crafts Movement in Canada.

Among the many works acquired in the field of contemporary Canadian art, of particular interest is a work by Martha Fleming and Lyne Lapointe, *A Kidnaper and I have been abandoned by the world*, a mixed media installation which was a key element in their recent project *La Donna Deliquenta*. Their work, which has been called 'urban archaeology,' is a feminist critique of received notions on sexuality and women's place in the world, an effort to break out of traditional art-historical roles and to develop collaboration instead of individual expression, inclusiveness rather than exclusivity.

Another superb acquisition was by gift: the G. Blair Laing gift of 84 works by the Canadian Post-Impressionist painter James Wilson Morrice. Mr. Laing, well-known dealer and collector, has with this magnanimous gesture doubled the gallery's holdings of Morrice; the works are in excellent condition and of splendid quality, and will be exhibited at the gallery from 30 March to 21 May 1990. The works will later tour Canada.

Nancy Baele, 'The Gallery's $1.8M Painting,' Ottawa *Citizen*, 7 March
The National Gallery has paid $1.8 million for *Voice of Fire*, a blue-and-red painting by American abstract expressionist Barnett Newman, gallery director Dr Shirley Thomson announced Tuesday.

'We rarely have the chance in

today's overheated art market to purchase works of the scale and historical significance of *Voice of Fire,*' said Thomson.

She said she had been supported in the acquisition by Canadian artists, museum directors, critics and professors of visual art.

The gallery's annual acquisition budget was raised in April to $3 million from $1.5 million. Also purchased during the year were two photographs by Ottawa artist Lynne Cohen and 223 smaller purchases.

The Newman painting, which is 18 feet high and eight feet wide, is a red stripe on a blue background. First shown at the U.S. Pavilion at Expo '67, the painting has been on loan to the gallery since the new building opened in May, 1988, and has been on display in the European and American galleries.

It was purchased from the artist's widow, Annalee Newman.

The gallery also owns an early Newman painting *The Way I* and a sculpture *Here II.* Newman only produced 125 paintings in his lifetime.

Newman belonged to the abstract expressionism art movement that developed in the 1940s in New York. It was based on a spirit of revolt against traditional styles and a demand for spontaneous expressionism, seen most famously in Jackson Pollock's style of action painting. But Newman went his own way, developing his own austere style of abstraction.

Newman, who died in 1970 at 65, painted five large-format works. The Museum of Modern Art in New York and the Stedelijk Museum in Amsterdam also own them.

Brydon Smith, head of collections and research at the National Gallery, said, 'In the spacious, sunlit gallery where the work is presently installed, *Voice of Fire*'s soaring height, strengthened by the deep cadmium red centre between dark blue sides, is for many visitors an exhilarating affirmation of their being wholly in the world and in a special space where art and architecture complement each other.'

Transcript of Global Television Network News Report, 7 March
Global: Art officials in Ottawa today defended a decision by the National Gallery to spend nearly two-thirds of its annual acquisition budget on a controversial abstract painting. Ottawa bureau chief Doug Small has the story.
Reporter: It's big, 5.4 metres by 2.4. It's bright, but is this painting by American abstract expressionist Barnett Newman, is it worth 1.8 million dollars?
Shirley Thomson: There's no doubt about it, but that's not our concern.

We're interested in important works of art and great works of art.

Reporter: Ordinary Ottawans say they are not so sure this particular purchase – it made the front page here – falls into the 'great art' category.

Unidentified: It's just three stripes, painted on a board. I could do that.

Unidentified: It looks like the ribbon on a military medal.

Unidentified: A flag.

Reporter: What does it say to you?

Unidentified: A flag of some country somewhere.

Unidentified: Looks like something my son'll do in daycare.

Reporter: Would you pay 1.8 million dollars for it?

Unidentified: I wouldn't pay a dollar.

Reporter: But 1.8 million spent on *Voice of Fire* – that's what it's called – represents nearly two-thirds of the gallery's yearly acquisition budget. [The] gallery's director says the purchase is neither more expensive nor more controversial than other works bought in the past.

Thomson: Why don't you look at the newspapers in 1912 when we bought Tom Thomson and A.Y. Jackson. They were horrified. Imagine those badly painted canvases, but those are now magnificent treasures of the Canadian national collection, and this painting is too.

Reporter: There are those who agree.

Unidentified: Why not?

Unidentified: Yeah, I agree.

Unidentified: It's a gallery. It's not just little photos or little pictures. It's big things that are supposed to say something, so ...

Unidentified: And it's not geared to one person's taste. It's, you know, a nation's taste.

Unidentified: That's right.

Unidentified: Newman is so right in American artists now deceased that I think our money is well spent.

Reporter: *Voice of Fire* was first shown in the American pavilion at Expo 67, the year it was painted. It's now in a room with another painting by the same artist and one of his sculptures.

Thomson: It's part of the continual investigation of painters and intellectuals into the nature of reality, if you wish.

Reporter: In this case it seems the nature of that reality is a little different out here in the streets.

Unidentified: I would put it in the garbage.

Reporter: Thanks very much.

Christopher Hume, 'National Gallery Criticized for Buying U.S. Work,' *Toronto Star*, 8 March

The National Gallery of Canada has spent nearly two-thirds of its $3

million annual acquisitions budget on a canvas by an American painter, and some Canadian artists don't like what they see.

The work, *Voice of Fire*, was painted by Barnett Newman, a major figure in 20th-century art. It cost $1.8 million.

'We think the National Gallery's priorities are pretty backward,' said Greg Graham, director of a national artists' lobby group called Canadian Artists' Representation/ Front des artists canadiens (CARFAC).

'It bothers us that such a big chunk of the budget is going to purchase a work by an American artist,' Graham said in an interview from Ottawa.

Voice of Fire, which measures 5.4 metres by 2.4 metres (18 feet by 8 feet), consists of a deep red stripe against a blue background.

'We're part of an international world,' said Shirley Thomson, director of the national gallery.

'Nobody has demanded that we take away our Rembrandts ... This painting has a place in Canada.'

'All in the Eye of the Taxpayer,' *Kamloops Daily News*, 9 March

The experts say it's worth it, the general public is bound to disagree. The National Gallery of Canada announced this week it will spend $1.8 million of its $3 million acquisition budget for a painting by an American abstract expressionist.

The work of – uhm – art, *Voice of Fire*, is a giant striped panel. It looks pretty simplistic, but for those in the know it's no doubt a significant piece of art.

Most Canadians, however, aren't in the artistic know. They've also just been hit with a federal budget screaming with cost-cutting proposals. On top of that, Canadians are looking at a goods and services tax that will add seven per-cent to almost anything they buy.

To think the National Gallery of Canada, which is funded by the federal government, could pay almost two million dollars for any painting, and particularly that painting, is incomprehensible to most people.

They will look at that 5.4-metre-high by 2.4-metre-wide red stripe on a blue background and think of P.T. Barnum.

'There's a sucker born every minute and they saw us coming.'

'MP Wants Art Gallery to Explain $1.8M Choice,' Ottawa *Citizen*, 10 March

The National Gallery of Canada will be called before the House of Commons culture committee to defend the spending of $1.8 million

on a painting by a U.S. artist, committee chairman Felix Holtmann said Friday.

Holtmann said during an open line radio program that he has had many calls complaining about the spending of public funds on the painting by abstract expressionist Barnett Newman.

The work, called *Voice of Fire*, depicts a red stripe on a blue background stretched over a canvas 5.4 metres high and 2.4 metres wide.

'Well I'm not exactly impressed,' said the Conservative MP for Portage–Interlake in Manitoba. 'It looks like two cans of paint and two rollers and about ten minutes would do the trick.'

Holtmann said the amount paid for the painting is more than half the gallery's $3 million acquisition budget and could have been better used to support many Canadian artists.

Graham Parley, 'Cabinet to Review $1.8M Art Purchase,' Ottawa *Citizen*, 10 March

A powerful cabinet committee will review the National Gallery's $1.8 million purchase of the abstract painting *Voice of Fire*.

A spokesman for Deputy Prime Minister Don Mazankowski confirmed Friday that the expenditure review committee will discuss next week whether the purchase can be stopped.

'It's a possibility,' said Tom Van Dusen.

But a baffled gallery spokesman said the painting was bought last August. 'So it can't be stopped. It's acquired,' said Helen Murphy.

The purchase sparked a protest from many Canadians who saw the giant Barnett Newman painting as a simple red stripe on a blue background. Some Canadian artists were critical the gallery had spent so much to acquire an American painting.

The expenditure review committee will study the spending authority of the gallery because ministers 'don't like the way the money was spent,' said Van Dusen. 'It's a question of the appropriateness of buying this painting.'

Toronto artist Jane Martin, the head of Canadian Artists' Representation, said government should stay at arm's length.

'Curators are professionals and they are the ones who should do the shopping, not MP's.'

Until last year, the gallery's annual acquisition budget was only $1.5 million. But Murphy said the gallery buys on a three-year cycle so that it can compete for more expensive works and had $4.5 million saved when it bought *Voice of Fire*. Since last April, the annual budget

has been increased to $3 million.

The Commons culture committee has already announced plans to question gallery officials and its chairman, Manitoba MP Felix Holtmann, said Friday it's unlikely the sale can be rolled back.

'But if it's as valuable as some people have purported it to be, maybe it can be put up for public auction.'

'Voice of Fire Still a Hot Topic,'
Ottawa Sun, 13 March
The furor over _Voice of Fire_ won't die.

Yesterday, after a week of outrage from taxpayers and praise from the art community, the National Gallery of Canada brought a group of journalists to the foot of the huge $1.8 million painting to show them what the fuss is all about.

The 1967 work by U.S. artist Barnett Newman is nothing but a brilliant red stripe down the centre of a deep blue background.

But the simplicity is deceptive, said gallery director Shirley Thomson.

'It's simple and it's powerful. It's a strong image and it's a provocative image,' she said.

The work's ability to provoke has been the only thing people can agree on since the purchase was announced last week.

Even the head of the Commons culture committee, Manitoba pig farmer Felix Holtmann, [said] it looks more like it was painted with two rollers and a couple of cans of paint.

Thomson said the painting is the talk of the town, but, she maintains, most people support the purchase.

It's time to raise your voice about the National Gallery's latest acquisition. What do you think of _Voice of Fire_, the huge red-and-blue abstract bought by the Gallery this month with a cool $1.8 million of taxpayers' money? You don't have to know anything about art – as long as you know what you like – and what you like paying for. Is _Voice of Fire_ worth $1.8 million? _The Sun_ wants to hear from you. Call Nancy Gummow at 739-5175 between noon and 2 p.m. today and tell us what you think.

Presse Canadienne, '"Voice of Fire": L'oeuvre de Newman au grand pouvoir de provocation,'
Le Droit, 14 March
Si la marque d'une grande oeuvre d'art réside dans son pouvoir de provocation, alors la nouvelle acquisition du Musée des beaux-arts du Canada, _Voice of Fire_, est sans contredit un chef-d'oeuvre.

Ce tableau du peintre américain Barnett Newman, acheté par le

Musée des beaux-arts au prix de 1,8 million $, semble avoir été 'peint en dix minutes avec deux rouleaux et deux seaux de peinture,' estime le président du comité de la culture de la Chambre des communes, Felix Holtmann. Les critiques du dimanche, quant à eux, lancent les hauts cris devant le prix élevé de l'oeuvre.

Mais le musée essaie tant bien que mal de faire comprendre au public tout le trésor que constitue le tableau de Newman. Lundi, le service des relations publiques a dû composer avec une armada de journalistes, qui voulaient en savoir plus à propos du tableau et de la décision controversée prise par le musée.

L'oeuvre, haute de 5,4 et large de 2,4 mètres, est composée d'une simple bande rouge vif appliquée sur un fond bleu foncé. Mais selon la directrice du musée, Mme Shirley Thomson, cette simplicité est trompeuse. 'Il s'agit du produit de la pensée d'un homme, après une période de 62 ans,' explique-t-elle.

C'est l'age qu'avait Barnett Newman au moment où il a peint *Voice of Fire*, en 1967. Il est mort trois ans plus tard.

'Il faut s'asseoir calmement devant le tableau pour voir jusqu'à image forte, provocante. Et pensez donc! Cette oeuvre a un quart de siècle et possède encore le pouvoir de provoquer. Et ça, ça fait partie de l'art.'

La décision d'aquérir le tableau de cet expressioniste américain n'a cependant pas été prise spontanément. 'Nous avons consulté nos collègues du monde des galeries d'art et des musées un peu partout au Canada et nous en avons discuté,' explique Mme Thomson. 'Nous savions que ce serait difficile (de le faire accepter). C'est ça l'art abstrait.'

Par ailleurs, la directrice du musée rejette les accusations de certains, qui prétendent que l'acquisition égrènera le budget consacré aux oeuvres de peintres canadiens. En fait, le budget d'acquisition est étalé sur une période de trois ans. Mais depuis trois ans, justement, le musée met de coté une somme de 600 000 $ par année pour l'aquisition d'une oeuvre d'un grand maître américain du 20e siècle. La somme de ces trois ans d'économie (1,8 million $) aura servi acquérir *Voice of Fire*.

Loin d'être ennuyée par la mini-tempête qu'au suscitée l'aquisition du Newman, Mme Thomson semble plutôt s'en réjouir. 'L'histoire de l'art a toujours été une histoire de tensions et de défis. Plus on parle d'art, mieux c'est. Et plus on en parlera, mieux ce sera pour les artistes canadiens.'

John Bentley Mays, 'National Gallery Should Tune Out Static Over Painting,' *Globe and Mail*, **14 March**

Barnett Newman always loved a good fight. Growing up in New York's Bronx before the First World War, the U.S. painter learned how to use his fists in street slug-outs between local Jewish kids (his gang) and Irish kids. Years later, when he visited London for the first time, the thing he got the biggest kick out of wasn't the Tate Gallery or the British Museum. It was a boxing match.

Given his life-long taste for two-fisted action, Newman would probably be bored to death by the current flap over the National Gallery of Canada's purchase of his magnificent 1967 abstract painting, *Voice of Fire*.

In one corner, we have the foes of the $1.76 million buy. Felix Holtmann, for example. He's the Tory MP for the Manitoba riding of Portage–Interlake, chairman of the House of Commons culture committee and self-appointed expert on what's good for Canadian art, who has decided to haul up NGC officials to account for the purchase. Last week, Holtmann declared that he could do as well as Barnett Newman, given 'two cans of paint and two rollers and about 10 minutes.'

Also in Holtmann's corner: Canadian Artists' Representation (CAR), other artists' organizations and some artists. It may seem strange that artists would be lining up against Canada's capture of a great artwork by a distinguished colleague – until you recall that, of late, artists and artists' groups in this country have taken to griping automatically whenever public money is spent on anything other than them.

In the other corner, we have the National Gallery of Canada, in the persons of director Shirley Thomson, and assistant director Brydon Smith, whose idea this purchase was.

The NGC seems to be shocked by the attack that was bound to come, once the acquisition was made public. As everyone surely knows – everyone outside Ottawa, that is – the national mood is grouchy and touchy, about language, taxes, and most other matters. The gallery should have known that spending $1.76 million on a big abstract painting by an American would bring down the roof. But instead of hitting back hard with solid arguments, the gallery is drawing up the robes of high principle about its chin, and affecting bewilderment. The official line being trotted out is, by and large, lame and very ad-hoc. Asked

this week in Ottawa how she would justify the purchase to the folks back in her hometown of St. Marys, Ont., Thomson answered, in part: 'We need something to take us away from the devastating cares of everyday life.' So what can *Voice of Fire* do for the people of St. Marys that a week in Orlando couldn't do, for a heck of a lot less money?

The national tizzy over *Voice of Fire* will eventually peter out. But for now, as the fur and fancies fly, it's worthwhile to keep some facts in mind.

Contrary to what CAR and artists are saying, for instance, art museums do not exist to subsidize artists and dealers through pur-chases, and donors through tax write-offs. They exist to serve the life of the mind, principally in the creation, study and celebration of distinguished collections of visual art. In terms of creation, anyway – the institution should be organizing more and better critical shows of postwar art – the National Gallery can hardly be accused of shirking. In the three-year cycle of acquisi-tions that ended in the spring of 1989, says Thomson, the NGC spent 42 per cent of its $4.5 million budget on methodically gathering artworks by the best Canadian artists, including General Idea and Jocelyne Alloucherie, Mary Scott, and Robin Collyer, Ian

Wallace and Barbara Steinman.

The purchase of *Voice of Fire* should be seen similarly in the context of the National Gallery's long-term collecting strategy. It's no pricey fluke, bought just so the museum can say it 'has a Newman.' This very tall, immensely handsome painting – which features a broad vertical band of strong red flanked by two parallel bands of deep blue – crowns the group of four Newman works already in the collection. Brydon Smith's installation of the work in the neighborhood of the large sculpture *Here II* (1965), and the painting *Yellow Edge* (1968), a promised gift from the artist's widow, constitutes a brilliant, concise statement on what is most arresting about Newman's art at its best – the vivid conviction about art's ability to convince, the forceful argument against the futile speedi-ness and fretfulness of contempo-rary society, the summons to training for larger spiritual and intellectual life.

If Newman's work must be called 'abstract,' let that be a designation of its visual style only. In the ensemble of Newman works on view at the National Gallery, we are given a vision of the human life worth living as profound as any this century has had to offer.

In addition to filling out the Newman collection, *Voice of Fire*

marvelously enhances the collection of some 70 postwar U.S. sculptures, paintings and installations that Brydon Smith has been patiently putting together since he joined the National Gallery in 1967. As Smith explains, he's wanted this picture ever since he first saw it in Montreal 23 years ago, in the U.S. pavilion at Expo '67. The construction of the new National Gallery building in the 1980s at last gave him the ceiling height needed to display the very large (544 cm x 245 cm) canvas, which, he discovered, was still unsold and in the keeping of Annalee Newman, the artist's widow.

By late 1987, the purchase price had been negotiated, and the slow process of approval – by NGC curators and art historians throughout the country, the museum's advisory board, the board of National Museums of Canada – was underway. The deal was concluded last summer; the announcement was delayed by the gallery, for no good reason, until last week.

Much of the grumbling over *Voice of Fire* has had to do with the price paid to Mrs. Newman. But given the international art market nowadays, it's hard to get excited. In 1988, a Newman picture only slightly larger than the NGC's painting was sold to a Japanese buyer for about $3 million, while

one smaller was sold the same year to a Zurich museum for the same price as *Voice of Fire*. Much international art is now beyond the reach of the National Gallery, and modern U.S. art is rapidly getting there. Which is, by the way, nothing new. Smith says the gallery learned a lesson about procrastination in 1968, when NGC brass squashed his bid to buy a major Claes Oldenburg installation for about $25,000. In 1974, Smith finally got his Oldenburg – for $110,000.

Given the long-term prospects of art prices – up and up – the National Gallery has surely made a shrewd move in buying *Voice of Fire* now. But the purchase could also send an important message to the international art world: that Canada is serious about its commitment to the life of the mind, and to the most rigorous, intelligent, and humane visual art of the modern era. The National Gallery would do well to stop dithering over the domestic static, and start pushing that message out to the world at large.

Janet Hitchings, Letter to the Editor, *Saskatoon Star-Phoenix*, 16 March
P.T. Barnum was certainly right when he said, 'There's one born every minute.' But how come so many of them get to spend our tax

dollars (Gallery pays $1.8 million for *Voice of Fire*)?

Oh, well, if you can't beat them … I've got a major work of art I'll part with for the right price as soon as the paint is dry.

Description: One deep, pure white stripe centred between two ebony stripes, complete with 'sensaround.' Title: Le Phew? L'Odour? Something Rotten?

Picasso never spoke a truer word than when he said that modern art was the biggest hoax ever inflicted upon mankind.

Gerald Scully, Letter to the Editor, *Toronto Star*, 16 March
Brian Mulroney can raise his popularity by 5 to 10 points by simply firing whoever is responsible for the purchase of *Voice of Fire* for the National Gallery of Canada.

Jocelyne Lepage, 'Le gouvernement se penche sur l'achat 1,8 million $ de Voice of Fire,' *La Presse*, 22 March
L'achat, par le Musée des beaux-arts du Canada, d'une toile de Barnett Newman pour la somme de 1,8 million de dollars, a été inscrit à l'ordre du jour de la prochaine réunion du Comité d'examen des dépenses du gouvernement canadien. C'est ce q'au confirmé hier Tom Van Dusen, un adjoint au ministre Don Mazankowski.

'Le gouvernement a reçu beaucoup de plaintes des contribuables canadiens au sujet de cet achat,' a-t-il dit, 'des plaintes venant surtout du Canada anglais. Le Comité d'examen des dépenses se penchera sur la question au cours de sa prochaine réunion. Cela ne veut pas dire qu'il va annuler la décision du Musée. Il étudiera surtout le processus de décision qui a mené à cette dépense. Un autre comité, le comité culturel, pourra étudier la même question, mais de son point de vue.'

La Conférence canadienne des arts, un regroupement d'organismes artistiques canadiens, a vivement réagi à cette décision. Dans un communiqué émis hier, la CCA révèle qu'elle a fait part au Premier ministre et aux membres du Comité d'examen des dépenses 'de sa vive opposition à ce que le Musée des beaux-arts du Canada doive justifier l'acquisition de *Voice of Fire*. La CCA estime qu'il s'agit là d'une bréche dans le principe fondamental de l'autonomie des agences gouvernementals face au gouvernement.'

Barnett Newman est l'un des peintres les plus importants de l'École de New York, une 'école' qui eu une grande influence sur le développement de l'histoire de l'art

dans les années cinquante aussi bien en Europe qu'aux États-Unis et au Canada.

Selon Pierre Théberge, directeur du Musée des beaux-arts de Montréal, il est normal que le gouvernement canadien surveille les dépenses des organismes qui relèvent de lui, comme le Musée des beaux-arts du Canada.

'Mais Barnett Newman est l'un des grands artistes de notre époque,' dit-il. 'Ses oeuvres se retrouvent dans tous les grands musées du monde. La National Gallery de Washington en a 14, le Centre Pompidou, à Paris, en possède un gigantesque, on trouve des Barnett Newman dans les musées allemands, hollandais, etc. Il a eu droit à de grandes rétrospectives partout et on le connait même jusqu'au Japon. On peut ne pas aimer Barnett Newman, mais on ne peut pas dire que c'est un artiste inconnu.'

D'autre part, ajoute-t-il, les oeuvres de Barnett Newman ont déjà atteint des prix supérieurs dans les ventes aux enchères publiques. On ne peut pas accuser le Musée d'avoir payé un prix exagéré par rapport au marché de l'art. Le Musée canadien tient là, selon lui, des arguments solides pour défendre son point de vue.

Si le public québécois réagit très peu à cette affaire qui fait scandale au Canada anglais, c'est, toujours selon Pierre Théberge, parce que depuis Borduas et le *Refus global,* les Québécois ont accepté que l'art puisse être abstrait. 'Ce débat-là, nous l'avons fait il y a longtemps,' dit-il. 'Et nous avons chez nous un artiste qui vend presque aussi cher que Barnett Newman dans les ventes publiques: Jean-Paul Riopelle. La surprise est peut-être moins grande.'

Allan Gotlieb, 'A Dream of Albania of the North, Safe From Foreign Art,' *Globe and Mail,* 26 March

The storytellers of the ancient world were fascinated by the creature with two faces, the being that could look in two directions at once. The Canada of today would provide them with rich new material for their tales.

Our constitutional debates unfold in the shadows of the two-nation theory of Canada. Are we two nations in other ways as well? Are we divided into Canadians who look outward and Canadians who look inward? Or is the Canadian in each of us splintered and pulled in two directions at the same time?

As the past decade drew to its close and changes in the Soviet Union and Europe burst upon the

world, Canada, too, was making a mark for itself.

We entered into the world's largest free-trade agreement. Our growth rates were spectacular. So was the behavior of our entrepreneurs. The world became aware of a people looking for new challenges and ready to build enduring monuments to mark their surging self-confidence.

A new Canadian monument was celebrated in the pages of the foreign press every few months. International critics looked up and noticed.

What did they say?

Arthur Erickson's Canadian embassy was the most beautiful diplomatic compound in Washington; Moshe Safdie's National Gallery in Ottawa was the finest new museum building in a generation; Douglas Cardinal's Museum of Civilization was brilliantly original; the new Canadian Centre of Architecture in Montreal had few rivals in the world; the giant white amoeba that grew alongside Toronto's CN Tower ... well this was – we were pleased to learn – a modern equivalent of Venice's San Marco and Companile.

This was the face of Canada looking out at the world, challenging people to stare back and admire us.

But there is the other face of Canada, the Canada that would like to live and be left alone. 'National Gallery criticized for buying U.S. work,' proclaims our largest-circulation daily, presenting a monster-size color photograph of an abstract painting by Barnett Newman, filling a quarter of its front page.

The capital's biggest newspaper offers a major editorial. Its title: 'We know what we don't like.'

The media inform us confidently that 'Canadian cultural nationalists are going to hate this painting.' Canada's largest artists' lobby declares: 'It bothers us that such a big chunk of the budget is going to purchase a work by an American artist.'

The National Gallery will be called before the House of Commons to defend spending $1.8 million on a painting by a U.S. artist. So states Felix Holtmann, chairman of the committee on culture, adding that the painting 'looks like two cans of paint and about 10 minutes would do the trick.' A cabinet committee will review the expenditure.

This is not the only time we have heard the voices of obscurantism in Canada. Last summer, some prominent Canadians, in a silly, petulant mood, condemned the government for donating a Jean-Paul Riopelle painting to France for its bicentennial. Remember John

Diefenbaker's minister of finance? He vetoed the National Gallery's purchase of a foreign artist's work on the grounds that he was a Communist. The painter was Picasso.

On such occasions Canadian voices valiantly defend our cultural institutions. But they are often drowned in a sea of hostility and ridicule, sensationally reported by our leading media.

What is the argument of the critics? It is that public monies should be spent on Canadian, not foreign paintings. This means that Canadians wishing to see works by the seminal artists of our time will have to go to New York or elsewhere. It means no more Rembrandts, Monets or Matisses, even if the gallery could afford them. It means our institutions should sell the foreign art they now own and use the money to buy more Canadian artists. There is a mysterious gene in some Canadians that drives them to such preposterous conclusions. They dream of a huge Albania on the Canadian tundra, walled up against foreign contamination.

The mysterious gene is not found in all that many Canadians. In a democracy, everyone is entitled to an opinion, even a foolish one. But a large part of the problem is that their voices get magnified by the giant media megaphone. Do some of our journalists search out these anti-foreign comments? Surely our press has a responsibility not to stimulate xenophobic sentiments among Canadians.

Our cultural institutions have been led by far-sighted Canadians who never bowed to populist political or media sentiments. Alan Jarvis purchased European masterpieces for the National Gallery at great cost by the standards of the day before being crucified by the Diefenbaker government for so doing. Jean Sutherland Boggs and the new director, Shirley Thomson, have stood up for the highest quality and international standards of creative accomplishment. Ms. Thomson and courageous curators are committed to ensuring that our public museums contain works of art worthy of their magnificent new homes.

They deserve the support of Canadians, not their ridicule.

Stephen Godfrey, 'Can This Voice Put Out the Fire?' *Globe and Mail*, **30 March**
Beset by controversy over its purchase of the $1.8 million painting *Voice of Fire* by American painter Barnett Newman, the National Gallery of Canada will begin distributing flyers to visitors within the next few days, with a

brief analysis from the man most responsible for the purchase.

The flyer may evoke as much discussion as the painting itself, as it sees in the painting's three colored bands a metaphor for oppression and national identity.

Brydon Smith, assistant director of the gallery and an admirer of the painter for more than 20 years, said this week that 'there's been such a bad reaction in the press, people are coming to look at the work with a negative mindset, and it's not getting a fair chance. I've been agonizing over a way to deal with this, and I felt a physical description might help.'

The gallery is under pressure from two government sources: a cabinet expenditures review committee that is expected to analyze the process by which the painting was bought, and the Standing Committee on Communications and Culture, which is meeting with gallery management on April 10. The committee chairman, Felix Holtmann, has already derided the painting, saying it could have been done by anyone with two cans of paint and a roller.

The gallery's remarks have been terse and, critics say, unhelpful in explaining why the painting is worth the expenditure. Smith's own comments made the painting appear to be chiefly an extension of the gallery architecture, and director Shirley Thomson said the painting helped 'take us away from the devastating cares of everyday life.'

Smith said it was very difficult to put the impact of the painting into words and, for some viewers, the text of the flyer may prove him right. Smith quotes the late artist, who said he hoped the painting's three stripes would give each viewer 'the feeling of his own totality, of his own separateness, of his own individuality, and at the same time of his connection to others who are also separate.'

Smith's two-page description of the 18-by-8 foot painting, which was created for the U.S. pavilion at Expo '67, begins with a thorough description of the color of the stripes – one cadmium-red stripe flanked by two ultra-marine blue bands – and says that the form 'confirms each viewer's own upright stance in the world in a straightforward and comforting manner.' He says that the painting is not an abstraction, but instead 'an objectification of thought, a concrete embodiment of Newman's reflections on his existence and an acting-out of those reflections in paint on canvas.'

Among Smith's observations is the significance of the bands, which remain separate and yet coexist as

a whole. 'As we struggle nationally and internationally with our individual and collective identities,' he writes, 'it is a timely reminder for each of us what it is to be independent and free of oppression while at the same time part of a larger world.'

When questioned whether this was not reading too much into the work, Smith said, 'It is not that this is the only true way to see the painting and I acknowledge it's a bit of a leap. But although this is a very subjective description, I challenge you not to see some of the things that I saw.'

The text of the brochure concludes that *Voice of Fire* is 'about seeing and being. It is a phenomenal painting in which our sensory experience of the work is stripped of all other associations, and through which the emphatic qualities of purely colored form are able to flood our consciousness with a sublime sense of awe and tranquillity. *Voice of Fire*, like all great art, is one artist's gift to the world.'

Smith said he 'had to believe that the painting can touch and move people.'

Responding to various criticisms of the purchase, including the fact that the gallery already has four works by Newman, Smith said, 'In the case of contemporary artists who we feel have been innovative –

such as, in Canadian art, Michael Snow, Guido Molinari, and Greg Curnoe – we have purchased more that one work. Of the four works of Newman we have, two are on paper and cannot be easily exhibited, and none of them are of the scale of this work.'

Noting that a similar work by Newman had recently sold for more than $3 million, Smith said that even critics now seem convinced the painting was 'an exceptionally good deal ... a bargain. No matter what the art market does, I'm not worried about Newman. This painting will not lose value.'

Smith said he hoped people would try to experience the work first-hand, rather than rely on inadequate newspaper reproductions. Of those detractors who have done their own versions of *Voice of Fire* to show how easily it could be imitated, Smith said, 'I'm sure that if they saw this painting, they would be able to appreciate how different it was.'

Jane Martin, Letter to the Editor, *Globe and Mail*, 30 March
By setting up his prize-fight metaphor, John Bentley Mays has posited a world of black trunks versus red and blue trunks, which strikes me as a bit simplistic for one so dedicated to the life of the mind as he (National Gallery Should Tune

Out Static Over Painting – March 14).

The Canadian Artists' Representation (CARFAC) is certainly not in Felix Holtmann's corner. To toss in a few metaphors: we support 'arm's- length' and would certainly rather have curators than members of Parliament drawing up the grocery lists. If curators bring home bad meat too often they can be fired, but until then it's up to them, not politicians, to do the shopping.

What bothers us is the huge gap between the $1.8 million spent on the Barnett Newman painting and the $75,000 spent last year on contemporary Canadian art. Was the Newman too expensive or is the budget for contemporary Canadian art too small? Unlike Mr. Holtmann, we feel that too little, not too much, is being spent, and this should place us firmly in the corner of the curator of contemporary Canadian art.

Brydon Smith, 'Voice of Fire: Barnett Newman, 1905–1970,' National Gallery of Canada Pamphlet, April

Barnett Newman was 62 when he finished painting *Voice of Fire*. He created it as his contribution to an exhibition of art in the American pavilion at Expo '67 in Montreal. It's almost 18 feet high and 8 feet wide. Its form is clear and simple. It consists of three bands of colour which run to the upper and lower edges of the canvas. Each band is 32 inches wide. The red band down the centre was done first and is thickly painted with a number of coats of acrylic. It reflects cadmium-red light very intensely. The red band is flanked by two identically coloured deep ultramarine-blue bands. They are also painted in acrylic, but more thinly, so that the white ground reflects through a bit, giving them added luminosity with a slightly purplish glow. The blue paint has bled slightly onto the edges of the red. On all three bands the final coat of paint is brushed on directly and fairly evenly, giving the whole painting a sustained intensity of colour and surface. The bilateral symmetry of *Voice of Fire* confirms each viewer's own upright stance in the world in a straightforward and comforting manner. Although simple in form, it is a complex painting that can convey a range of meanings for those viewers who are willing to slow down and approach it with an open mind.

Like some Canadian artists whom he inspired, such as Guido Molinari, Robert Murray, and Claude Tousignant, Newman is part of a long 20th-century tradition in art in which colour, line, form, and struc-

ture are used not for representational ends, but to express feelings and thoughts directly. *Voice of Fire* is not an abstraction of something, nor does it refer to anything outside of itself. It is an objectification of thought – a concrete embodiment of Newman's reflections on his existence and an acting-out of those reflections in paint on canvas. Although its presence can induce different responses in each viewer, the resulting experiences will be grounded and focused in the work itself, and will correspond somewhat to Newman's own feelings and thoughts at the time *Voice of Fire* was conceived and painted.

Looking at *Voice of Fire*, it is apparent that there is no hierarchical arrangement or dominance of one part over another: the three equal parts exist alongside each other. The only differences are in their relative position and colour. And while there is twice the quantity of blue, the red band is just as important and distinct as the two blue ones. Each part remains separate and yet all coexist as a whole. As we struggle nationally and internationally with our individual and collective identities, *Voice of Fire* acts as a reminder of what it is to be independent and free of domination while at the same time part of a larger world.

Voice of Fire is a visual call or cry

beckoning the viewer to come closer. Seen from a short distance, as Newman intended it to be seen, its scale and large size break the surrounding space, transforming the room it is in into a place for as pure an act of seeing as is possible – a place where coloured light reflects evenly from a simple structured surface without shadows, constantly asserting itself on the beholder. *Voice of Fire* is about seeing and being. It is a phenomenal painting in which our sensory experience of the work is stripped of external references, and through which the emphatic qualities of purely coloured form are able to flood our consciousness with a sublime sense of awe and tranquility. *Voice of Fire*, like all great art, is one artist's gift to all of us.

An Excerpt from the Minutes of Proceedings of the House of Commons Committee on Communications and Culture, 10 April

The Chairman (MP Felix Holtmann): Mr. Smith, I read somewhere that you have a fixation yourself, personally, about this painting. Is that a true statement?

Mr. Brydon Smith: No. I think it is an exaggeration. I first saw the painting at Expo '67. I thought it to be an outstanding work, very different from the other works in

that exhibition in Buckminster Fuller's dome. I was impressed with it. I certainly found it to be a beacon of sorts.

However, in 1986, when I was at that point project director of the new gallery, I was over alone and they had just finished pouring the concrete in one of the large spaces. I looked at the space and I thought of the kind of art we had in the collection at that point that would actually hold its own.

Architects think they can lord it over everybody else, including artists, and that artists are just there to decorate architecture. I took it as a bit of a challenge. [Moshe] Safdie and I were working closely. I thought of works in our own collection that would hold their own in that space and maybe even diminish the architecture a little bit. *Voice of Fire* popped back into my mind.

The Chairman: You are saying that part of the design of the National Gallery was for the picture and the picture was for the gallery. It was all tied together; is this what you are saying? A quick answer, please.
Mr. Smith: No, because we had large pictures –
The Chairman: Not that large!
Dr. Shirley Thomson: Sure we have.
Mr. Smith: Not quite as large, but we have –
The Chairman: By the way, some-body suggested to me that if you did allow the picture to tour, but you do not have a very high ceiling, can you put it the other way? Would you be inspired the same way?
Mr. Smith: No, that would turn it into a landscape.

Robert Fulford, 'Holtmann Opens a Political Barn Door,' *Financial Times of Canada*, 16 April
Official Ottawa often turns cultural issues into low farce, but the Barnett Newman scandal is outlandish even by Ottawa standards. Since early March, when the National Gallery announced the purchase for $1.8 million of a major Newman painting, *Voice of Fire*, the politicians have been putting on a performance unequaled since the great days of John Diefenbaker's populist demagoguery in the 1950s. Unfortunately, this little comedy has done more than provide innocent amusement for the voters in a grim season. It has also undercut all the federal arts organizations, and put the politicians themselves in a potentially painful situation.

That can't be blamed on the parliamentary culture committee chaired by the noisy Felix Holtmann from Manitoba. Holtmann made the papers a few weeks ago by offering his considered opinion that he

26 'Shirley Thomson and Felix Holtmann attend committee session.' *Globe and Mail*, 11 April 1990. Photograph by Chuck Mitchell, courtesy of CANAPRESS

could paint every bit as good a stripe picture as Newman any day, given a couple of cans of paint and rollers. When he uttered that remark, the annual appearance of National Gallery representatives before his committee was already scheduled, so Holtmann let the gallery people know that he would be against them even before the first question was asked. But he couldn't resist the chance to provide himself with more publicity and his enemies with a fresh occasion for rude laughter.

His committee, fortunately, has little power. The real harm was done by Don Mazankowski, the deputy prime minister, when he announced that the Newman purchase would be put before the expenditure-review committee of cabinet. This bad idea was made worse by Mazankowski's apparent ignorance of its implications. Asked if the cabinet might intervene and stop the purchase, Mazankowski's spokesman, Tom Van Dusen, said:

'It's a possibility.' Well, no, Tom, it's not. The transaction was concluded last summer, when the money went to Barnett Newman's widow in the U.S. and the painting became Canada's property.

Mazankowski's representative not only didn't know that the deal was closed, he apparently didn't know that it was closed with careful legality. It was endorsed first by the curatorial committee of the gallery; then by the gallery's board; then by the trustees of the National Museums of Canada, all of whom are political appointees. The gallery administration is never 'unaccountable,' as its political enemies keep insisting – its every fiscal move is scrutinized in this way.

The gallery people made one political mistake, however, and inadvertently raised the level of hostility against them. Instead of making the announcement last August, they held it back until their fiscal year was ending in March and then released news of 126 purchases made and 715 gifts received over 12 months. Brydon Smith, the assistant director of the gallery and the man most responsible for buying the Newman, has explained: 'We wanted to place it in context. We felt it would be better to report it at year's end along with everything else.' Alas, his hope of burying it was frustrated: all those other items were ignored and an

ocean of publicity splashed over the Newman. Smith's timing was atrocious, presumably because gallery people are too absent-minded to know what time of year budgets come down, citizens pay their taxes, and grouchiness walks the land. The fact that half the country was also furious about the GST didn't help.

But even with public anger behind it the cabinet can't alter a deal legally completed eight months earlier. The cabinet could, of course, order the gallery to sell *Voice of Fire* at auction ('de-accession' it, in museum jargon) and donate the proceeds to general revenue. That principle established, Maz and his colleagues could then work their way through the whole collection. 'Sell that.' 'Keep this.' They would end up with not only a gallery that politicians could wholeheartedly endorse but $100 million or so to pay down the deficit.

Of course that won't be done, but even if nothing is done, publicly reviewing the purchase has already violated the arm's-length principle. Mazankowski's decision implies that, whatever boards are appointed to run federal cultural institutions and whatever the laws say, there's still a court of last resort, a power that rests finally with politicians. This is the first time since the early 1960s that the cabinet has intruded on the Nation-

al Gallery in this way, and the larger principle that Mazankowski undermined reaches back to 1932 and the first public-broadcasting law.

Politicians may enjoy the idea of this newly asserted power, but the precedent they've set may cause them extreme discomfort in future. Once they declare that they can review one specific cultural expenditure, they acknowledge that they can also look at others. If they someday find themselves called upon to review every unpopular decision of every cultural agency in Ottawa, they may look back with longing on the good old days of the arm's-length principle.

Brydon Smith, Letter to the Editor, *Globe and Mail*, 17 April
By exaggerating the gap between the amount of money spent on contemporary Canadian art and on Barnett Newman's *Voice of Fire* by the National Gallery of Canada, Jane Martin has weakened her argument for increasing the purchase budget for the curator of contemporary Canadian art (letter – March 30).

This past year we actually spent a total of $480,000 on contemporary Canadian art in all media, not $75,000 as she reported. But the real point is that we saved all the money to purchase *Voice of Fire* from the three previous years of 1986, '87, and '88, and that during this same period the National Gallery and its affiliate the Canadian Museum of Contemporary Photography spent $1.15 million on contemporary Canadian art. Add that to the $480,000, and you get $1.63 million spent on contemporary Canadian art against $1.76 million on *Voice of Fire*.

I agree that our recently increased purchase account of $3 million is still too low given today's art prices, but distorting what we actually spent on contemporary Canadian art while saving up to buy the Newman is not a strong argument for increasing funds.

Regarding Ms. Martin's suggestion that if curators bring home bad meat too often they can be fired, I had the paint surface of *Voice of Fire* analyzed and am relieved to report that there are no traces of animal fat in the pigment.

As for Stephen Godfrey's article, 'Can This Voice Put Out the Fire?,' our intention in publishing a pamphlet on the painting is to put all but one of the fires out and not to extinguish the *Voice of Fire* itself.

Bronwyn Drainie, 'Voice of Fire's Elitist Message Sure to Make Canadians Burn,' *Globe and Mail*, 21 April
In the amazing torrent of words in the past seven weeks about the National Gallery's purchase of Barnett Newman's *Voice of Fire*,

one question has hardly been addressed: Why do we, as a society, hate this red-and-blue-striped painting so much?

Is it because it cost $1.8 million dollars? Highly doubtful, since the gallery has quietly spent similar amounts in the past and no one out in the vast Canadian hinterland has known or cared.

Is it because we think the money should have been spent on Canadian art? Given our lukewarm response to most of our own artistic output in this country – from films, to music, to paintings – that's pretty unlikely too.

Is it, as many commentators have said, that the staff of the National Gallery has done a rotten job of defending the purchase of the Newman, and that if only they had handled the public relations aspect of the thing properly Canadians would feel content and proud of such a shrewd buy?

The answer is none of the above. To put it crudely, Canadians don't like *Voice of Fire* because it doesn't like them. In fact, it wants nothing to do with them. It is an imposing symbol of one of the haughtiest, most elite art movements in world history, the New York school of abstract expressionism, which flourished from after the Second World War until about the mid-sixties (although its baleful influence continues to this day, especially among artists who don't keep up with the trends).

The abstract expressionists – besides Newman the big names are Jackson Pollock, Willem de Kooning, Mark Rothko, Franz Kline – devised a definition of art that was completely self-referential. 'All great art is about art,' pronounced one of the revered theorists of the day, Leo Steinberg, and Barnett Newman himself described his canvases as 'non-relational,' filled with nothing but color and 'drained of the impediments of memory, association, nostalgia, legend, myth, or what have you.' In other words, drained of anything that might relate them to other human beings who had not taken an academic course in abstract expressionism.

Mind you, if you put a bunch of these canvases together in a vast gallery space, they do exude great energy and exuberance. But separate them out, especially the colorfield works by Newman or Rothko, and they glare back at you austerely, just daring you to say something banal.

Now we can begin to see why the National Gallery folks are having such a tough time explaining *Voice of Fire* to a country that's already in a surly show-me mood. Brydon Smith, the curator who has lusted

after this gigantic canvas since he first saw it at the U.S. pavilion at Expo '67, put out a flyer three weeks ago in which he tried to explain the painting in the sort of flat-footed documentary terms he obviously thought Canadians would respond to.

The three stripes, he said, remain separate and yet coexist. 'As we struggle nationally and internationally with our individual and collective identities,' he pointed out, 'the painting is a timely reminder ... what it is to be independent and free of oppression while at the same time part of a larger world.' Hey, a kind of artistic gloss on Meech Lake, Europe in 1992 and perestroika, all in one painting! One can only imagine what Barnett Newman's response would be to such an opportunistic clutching after relevance, when relevance was the last thing he wanted.

Voice of Fire has hit the same hostile public nerve that Prince Charles touched with his lonely campaign against the ugliness and egotism of modern architecture. In his best-selling book, *A Vision of Britain*, Charles attacked the monolithic skyscrapers of the modernist school and called for a more democratic and humanistic man-made environment. The public response to his challenge has been overwhelming, as if people had just

been waiting for someone who had the guts to say what they'd been feeling for a long time.

In New York City last year, public hostility toward an arrogant work of art actually succeeded in getting it removed. The work was Richard Serra's *Tilted Arc*, a gargantuan wall of cor-ten steel, which deliberately slashed in half a large public square in front of a federal office building in downtown Manhattan. For eight years, the inhabitants of the building fought the installation through the courts, until it was quietly dismantled under heavy security in the dead of the night. Even before it came down, *Tilted Arc* looked like a dinosaur, a remnant of an earlier time when artists believed their only relationship with the public should be one of controversy and anxiety. Anything else was a sellout.

For a decade now, artists and architects have been showing encouraging signs of entering into a more friendly dialogue with the public. But old habits die hard. The acolytes of high modernism – the critics, the curators, the collectors – still hanker after the days, back in the fifties, when art was a formal private party and the general public simply wasn't invited.

It is that precise moment in cultural history that *Voice of Fire* captures, so it's not surprising that

it evokes feelings of inadequacy, smallness and resentment in the population at large. It was meant to. Should the National Gallery have purchased it? Of course, since it represents with singular eloquence a once powerful but spiritually dead-end artistic movement which is, one can only hope, gone forever.

Essays

The critical essays collected in this section analyse the *Voice of Fire* controversy from three distinctly different points of view. The first investigates the social processes by which the painting earned its designation as art, whereas the pastiches made after it did not. The second examines the role played by the media in shaping public opinion about the painting, and also the role of the media in the *Flesh Dress* controversy of 1991. And the third considers the repression of historical memory that was evident in the painting's 1990 reception.

THIERRY DE DUVE

Vox Ignis Vox Populi[1]

'It seems to me that the best way for an artist to be politically active and have a religion is for him to practise his métier in accordance with all its principles.'[2]

This quotation is from French actor Louis Jouvet. I have modified it by substituting 'artist' for his 'man of the theatre.' If I have done so, it is because in my heart and soul I don't believe that it will make Jouvet turn over in his grave; should the artist happen to be a stage actor, he will still perform as best he can. Yet the substitution is not innocent. On the back cover of *Au nom de l'art* I wrote: 'One should never cease to be amazed, or concerned, that our era finds it perfectly legitimate for someone to be an artist without being either a painter, or a writer, or a musician, or a sculptor, or a filmmaker ...' I could easily have added, 'or a man of the theatre.' Contrary to all of those, an 'artist' has no métier. And if he or she has no métier, he or she risks having neither politics nor religion, or, in other words, no ethics. These were the questions I had in mind when I concluded by asking: 'Is *art* in general an invention of modernity?'

As a paradigm of 'art in general,' Duchamp's ready-made has been for me the cornerstone of an extended meditation on the aesthetics of modernity. Essentially, this aesthetics lies in the fact that the cut-and-dried judgement 'this is art' has replaced judgements such as 'this, as something that is painted, sculpted, composed, written, performed ... etc., is beautiful (or sublime, or picturesque ...).' Selecting a ready-made requires no métier, nor does it partake of any profession that a particular know-how would qualify as artistic. Aesthetic judgement, which is more than ever left to the spectator's feeling, is all the more closely tied

up with the difficulties of appreciating the artist's ethics (so admirably summed up by Jouvet's maxim), now that the métier as such is no longer liable to an empirical definition governed by a sufficient aesthetic consensus. This, it seems to me, succinctly articulates the problem concerning the relationships between aesthetics and ethics today – in other words, 'after Duchamp.'

There are indeed three ways of 'defining' an artist. The first is ethical: an artist is someone who *practises his or her métier in accordance with all its principles.* The second is anthropological: an artist is someone whose métier is classified among the professions considered by society as artistic. The third is aesthetic: an artist is someone who has made something so beautiful, interesting, powerful or moving (cross out the qualities you think unimportant, or add your own) that it gives you the feeling that you are dealing with art. These three 'definitions' presuppose one another. To judge whether someone has practised the métier of *artist* in accordance with all its principles, one has to know whether this métier is an artistic profession. Likewise, before deciding whether something beautiful or moving can make a claim to the title of art, there must be agreement as to what constitutes the proper domains of the artistic métiers. In the absence of social mechanisms to regulate and restrict access to the artistic professions, or without a social consensus regarding the technical operations that define the métier, only the *aesthetic* feeling (this is a pleonasm) that the *ethical* principles demanded by the métier have been honoured and respected leads us to say that this métier falls within the domain of art. It is in this sense that modernity has invented 'art in general.'

'Art in general' is in no way a post-Duchamp novelty. Neither is it a new genre or a new artistic medium supposedly authorized by the advent of the ready-made. Still less is it a new métier without a métier component, one that (in the liberal scheme) would take its place alongside traditional practices or (in the radical scheme) supplant them. It is just as it says, 'art in general,' which means that the aesthetics of modernity revealed through Duchamp is valid for all works of art, including those produced via métiers that, like painting, can apparently still be specified in terms of skill or medium. I would even say that it is for painting especially that the advent of the ready-made has been revealing. If it seemed appropriate to me to establish a double link, via the tube of paint and the blank canvas,[3] between the ready-made and the

history of modern painting, it is precisely because the latter is composed of successive, aesthetically motivated renunciations of métier conventions, the ethical purpose of which was revealed by Duchamp's abandonment of painting itself. What is this ethical purpose? The following story may help to clarify matters. The story is too good to be true, and yet it is. I have invented nothing.

The hero of my story is named John Czupryniak, a painter by trade. He lives in Nepean, on the outskirts of Ottawa. His master work is a blue panel 5 metres high and a little more than 2 metres wide, and divided vertically by a wide red stripe (fig. 27). Aware of the symbolic importance of titles, Czupryniak hesitated for some time between *Voiceless, No Voice at All, Whose Voice, Voice of Anger, Voice of Stupidity, Voice of Amazement, Voice of Laughter, Voice of the Aghast, Voice of the Disillusioned,* and *Voice of the Confused,* before opting finally for *Voice of the Taxpayer.* Formally, the work could be described as Abstract Expressionist. Abstract it most certainly is, which doesn't prevent it from being the powerful expression of a deeply felt sentiment – hinted at in several of the rejected titles. This sentiment excludes neither disgust nor ridicule, those feelings that Kant judged incompatible with, respectively, the beautiful and the sublime, but which have received their credentials, as *anti-art,* from the history of the avant-gardes.

Like many avant-garde painters, Czupryniak paints against. A transgressive gesture along the lines of Dadaism, *Voice of the Taxpayer* assumes its full significance only in diametrical opposition to the tradition it attacks. A postmodern parody of modernism's celebrated flatness, *Voice of the Taxpayer* is a quote, a pastiche that appropriates the work of another, empties it of its meaning, and presents itself as a critique of 'the originality of the avant-garde and other modernist myths.' Better still, in its abstract guise *Voice of the Taxpayer* is a real allegory of the art world as institution, neither more nor less than Courbet's *L'Atelier du peintre.* Is it a bad painting? No, it is *bad painting,* if you get the difference. It is actually a subtle and refined conceptual piece whose feigned innocence makes the emperor's new clothes visible to all. The 'indispensable vulgarity' (Duchamp) of its title provokes the return of the repressed of the sole 'convention' that modernism forgot to deconstruct, the money of the people on whose back the élite builds its culture. In short, Czupryniak has got it all: he is more provocative than Rodchenko, more sarcastic than Manzoni, more strategic than

27 John and Joan Czupryniak standing beside *Voice of the Taxpayer*. *The Citizen* (Ottawa), 16 March 1990. Photograph courtesy of *The Citizen*

Buren, more political than Haacke, more nationalist than Broodthaers, more demagogic than Koons, more neo-geo than Taaffe, all this with Duchamp's caustic humour, and sincere to boot!

Canadian readers are already quite familiar with the bigger story with which that of my hero is associated. Here, for the others, is a synopsis of the event. In 1989, the National Gallery of Canada in Ottawa acquired a large Barnett Newman painting entitled *Voice of Fire*. It is 5.44 metres high by 2.45 metres wide and is composed of three vertical bands of equal width. The central band, in a bright cadmium red, is flanked by bands of a deep ultramarine. On loan to the gallery since it opened at its new location in May 1988, the painting, which belonged to the artist's widow, was already on display in a high-ceilinged, airy room that seemed to have been designed specifically for it, when its purchase was officially announced on 7 March 1990 and the fur started flying. Up until then, neither the press nor the public was particularly upset by the painting, which had been on display for art lovers but had been otherwise generally ignored. However, when its price ($1.76 million) was revealed, the controversy began.

On 7 and 8 March, the acquisition was duly reported in the newspapers, none of which failed to highlight the cost in its headlines. The first opinion poll, carried out in an Ottawa shopping mall, appeared on 8 March in the *Ottawa Sun*, a populist tabloid that made it its business to publish the most philistine opinions – with photographs of their proponents. *Le Droit* followed suit a few days later, although this time the poll was conducted at the National Gallery and harvested a more balanced range of opinions. The following week brought the caricatures; cries of indignation in every register monopolized the letters to the editor, and the headlines expressed increased hostility, with wordplays such as 'Wildlife,' 'Voices of Ire,' and 'Fire the Curators.' New heights were reached when Felix Holtmann, a pig farmer by trade as well as a Conservative Member of Parliament from Manitoba and chair of the House of Commons Standing Committee on Communications and Culture (oh yes!), publicly stated that anybody with a couple of cans of paint, a roller, and ten minutes could do as good as Newman. This was amply sufficient to spark John Czupryniak. Actually, as it should in art history, the flash of inspiration came from his muse. His wife, seeing *Voice of Fire* on television, exclaimed, 'Hey, anybody could paint this, even a painter.' I laugh now every time I think of it. And the more I think of it,

the more I like John Czupryniak. For Czupryniak is a painter but doesn't claim to be an artist. I simply neglected to tell you that he is a house painter.

Every story has a good guy and a bad guy. The bad guy in my story is Antoine Corege, a painter by trade. Born in France, he has spent the last thirty-five years in Canada and now lives in Toronto. He, too, has made his copy of *Voice of Fire* (fig. 28). Untitled, it nevertheless comes with a sign bearing this warning: 'This is a copy of the National Gallery's 1,800,000 dollar rip-off of the Canadian artiste [*sic*].' Corege has rebaptized the original 'garbage' and described it as 'a refugee flag in search of a country' – quite a nice definition, if you ask me. The more I think about it, the less I like Corege, and I have a nasty desire to fix his wagon. Too bad if I'm not being fair, basing my judgement of him on a single newspaper article while I have a fat file on Czupryniak. (The media, I'm tempted to believe, make no mistakes when they pick their favourites.) If I have decided not to pardon Corege, it is because he claims to be an artist. Possibly he is one, and I am not casting doubt on what he says; indeed, the *Toronto Star* of 28 March says he does paint-ing and sculpture. So he's an artist/painter and an artist/sculptor by trade, just as Louis Jouvet was an actor.

Both Czupryniak and Corege displayed their paintings outdoors, in front of their houses. Neither of them – need I emphasize it? – maintains that his painting is art: Czupryniak because he never claimed to make any, and Corege because he knows how to tell the difference between art and 'garbage.' Czupryniak doesn't know what art is and openly admits it. In none of his many interviews did he ever venture to say that *Voice of Fire* was not art. He simply believes that to pay nearly two million dollars of the taxpayers' money for three stripes of colour is revolting. His judgement is ethical, not aesthetic. As for Corege, he knows what art is and his rejection of *Voice of Fire* is an aesthetic one. 'That's not art, it's a 12–foot beast – garbage' was his statement to the *Toronto Star*.

By now you may feel that you know my reasons for liking Czupryniak and disliking Corege: the former remains on ethical turf, where everyone has the right to his or her opinion and where the de-fence of the taxpayer is a perfectly honourable cause, while the latter has stumbled onto the terrain of aesthetics, where I, the expert, lie in wait for him. If you believe that, you are wrong, because the same ethics

THIS IS A COPY OF THE NATIONAL GALLERY $ 1,800,000 RIP OFF OF T___ ___IAN ARTISTE

28 Antoine Corege in front of his copy after *Voice of Fire*. *Toronto Star*, 20 March 1990. Photograph by J. Wilkes

by which I grant Czupryniak the right to his opinion in cultural politics oblige me to be equally liberal-minded with regard to Corege's religion of art (to mention the poles of religion and politics with which Jouvet paraphrased the ethics of the artist). Fine, you may say, but Czupryniak

is a house painter and Corege an artist; the former's ignorance is excusable, but not the latter's. Besides, when Corege says, 'I don't know much about the National Gallery, but I know art,' does he not display a philistinism unforgivable in an artist? You want me to be condescending? And confused to boot? Then you make ignorance into a question of métier and are just as mistaken as ever. Reading in the *Toronto Star* that, for twenty years now, Corege has been festooning the exterior of his house with his works (greatly to the displeasure of his neighbours, who consider him an eccentric and complain to City Hall), I tend to grow sympathetic to the man. And that is when I become condescending. Not having seen his work, I will grant him the benefit of the doubt and, if he is the *facteur Cheval*,[4] so be it. But nothing will make me say that the *facteur Cheval* is equal to Barnett Newman.

The *facteur Cheval* of my story, by the way, would be John Czupryniak: a postmodern *facteur Cheval* who seems to have unwittingly arrived at a perfect understanding of Rodchenko, Manzoni, and Duchamp and knowingly parodied Barnett Newman, although he didn't understand a thing about *Voice of Fire*. The critical interpretation of his *Voice of the Taxpayer* which I gave above is perfectly plausible, and that's what worries me. A perverse and cynical art historian, I would have appropriated Czupryniak just as he appropriated *Voice of Fire*. I would have taken a painter and made him into an artist, an 'artist in general.' But I am not interested in defining an artist in this way. It goes against the anthropological facts (Czupryniak stakes no claim to the status of artist), it ridicules aesthetics (whereas Rodchenko, Manzoni, and Duchamp incorporated the sense of ridicule into aesthetics, which is a whole different matter), and it sins against ethics. I only played at being cynical to show you how absurd it is.

Let's go back, then: why does my liking for Czupryniak only grow while, for the poor unfortunate Corege, I can have only the most cruel pity? The answer is ethical in nature. I have a right to ask each one if he 'practises his métier in accordance with all its principles.' In the case of Czupryniak, the matter is clear: his wife having prompted him with 'You don't have to be an artist to paint that; all you have to be is a painter,' he simply practised his trade candidly: Corege, on the other hand, separated the artist and the painter in himself to execute his copy of *Voice of Fire*. In order to show the contempt in which the artist holds Barnett Newman, the painter had to despise himself and devalue his métier to

the point where it ceased to exist, since, as he said, 'any seven-year-old could do the same thing.' I can presume, without too great a fear of being mistaken, that he wouldn't want us to speak in this way of his own painting, that is, the painting he does as an artist.

I don't wish to beleaguer Corege. It is clear that his action proceeds from resentment and that he doesn't understand how he is hurting himself. I would rather dwell on the attitude of Czupryniak, who, in the various radio and television interviews he gave, always struck the right note. I met him and we talked shop. Why did he paint *Voice of the Taxpayer* on plywood? He told me that he had thought of painting it on canvas, but is not familiar with the technique. How did he choose his colours? He went to the paint store with a reproduction of *Voice of Fire* that appeared in a newspaper. Did he rely on such a poor reproduction? No, he quickly forgot about the colours in the picture and concentrated instead on picking paints that went well together. Was this not an aesthetic decision? Of course. (He had a complete grasp of the jargon, proudly adding, 'I've got an eye for colour.') How did he apply the colours? By first covering the panel with a coat of red and then putting the blue over it so that a reddish glow came through. When I told him that Barnett Newman did the same thing – which is incorrect, but I thought so at the time – his face lit up. 'I knew it!' he said. This conversation convinced me of something that I already felt instinctively: I was dealing with a tradesman (*homme de métier*) who considered Newman a colleague. Although it was unclear to him how Newman could gain a reputation as a great artist on the basis of a métier hardly more complex than his own, his sense of brotherhood was authentic and completely free of envy.

Czupryniak didn't seek to see *Voice of Fire* before painting *Voice of the Taxpayer*, and I suppose that this was because he didn't want to be intimidated. Yet he said on the radio, 'I liked it looking at the newspaper. I thought there was some depth in it.' After having painted his version, he went to see the original. I asked him what he thought about it and if he found that his own worked as well. 'I like it,' he said, in reference to the former; and about his own: 'It's pretty close.' He will forgive me if I don't agree. Aside from considerations of medium and texture, his red is right, but his blue is too purple. But this is not the crux of the matter. It was very clear to me at the end of our conversation that John Czupryniak, a house painter, had subscribed perfectly to the ethics of

the artist as defined by Jouvet; protesting in paint, he had 'practised his métier in accordance with all its principles.' Better still, he was well aware that, if the principles in question are technical and linked to the métier of painter, they are also, and above all, aesthetic.

His wife's exclamation – 'Anybody could paint this, even a painter' – was what authorized Czupryniak to redo *Voice of Fire*. This keeps coming back to me, and I am still delighted. My glee is unadulterated and free of irony because, although he may be a house painter and his painting only relatively successful on the planes of ethics and aesthetics, Czupryniak acted like an artist. I would even say that his action reveals the deep meaning of the painting against which he painted his own, yet which he did not parody. Although he undoubtedly wanted a parody, he was too much of a painter to carry it off. To succeed, he would have had to follow Corege: separate out the artist and the painter in himself and disparage the latter. But fortunately he had no preconceptions about what makes an artist and thus was able to connect with the oldest conception of art that exists: the love of a job well done. In this respect, he emulated Newman by simulating him just as Newman himself had emulated Mondrian by painting against him. What difference does it make, you may say, since he is unaware of it? Well, I don't believe he is unaware; indeed, I am convinced that he knows it – or senses it – quite well. What he doesn't know is a whole other matter. He doesn't know that the conditions of modern art – those revealed by Duchamp's ready-made – are such that even the artist/painter is an 'artist in general.' While house painting is a métier, the art of painting is not. Newman knew it, Mondrian knew it, as did Seurat. All of these painters were skilled craftsmen (*avaient du métier*); that is not the point. If the end result of their efforts has been, apparently, to renounce their craftsmanship to the point where the canvas got reduced to three bands of colour, this didn't stem from contempt for craftsmanship or from an entirely negative attitude, nor was it motivated – as is too often believed – by a desire to separate the concept, which has to do with art, from the execution, which is a matter of craft. Instead, it is that these artists have felt an ethical responsibility to use their métier in such a way as to show that 'anybody could paint this, even a painter.' With astounding ingenuousness, Mrs Czupryniak expressed what I believe to be the fundamental *ethical* meaning of the 'reductive' *aesthetic* governing *Voice of Fire*, as well as all great modern painting. This is the claim to

universality built into all aesthetic judgements as they are now uttered in the particular historical conditions that have obliterated the distinction between judging art and making art. Such is indeed the situation revealed by Duchamp's ready-made; it is a situation which stems from modernity's inability to legislate specific boundaries among the art professions.

The *Voice of Fire* controversy evidently would not have happened if the painting had not cost the Canadian taxpayer $1.76 million, and Czupryniak would never have painted *Voice of the Taxpayer* if he had not been outraged that such an extravagant sum was spent for something that he could do himself. A study of the connections between ethics and aesthetics would be incomplete if the economic side of the question were left untouched. One of the arguments offered by those who, like myself, supported the purchase of the Newman was that the price of the painting was, after all, reasonable – given the inane levels of inflation of the art market. I explained to Czupryniak that Annalee Newman could have obtained twice the amount for *Voice of Fire* had she sold it to the Japanese. He was not surprised, being already familiar with the story of Van Gogh's *Irises*, but neither was he convinced. I can't help but agree with him if I adopt his point of view: his translation into economic terms of the art ethics he has demonstrated in painting *Voice of the Taxpayer* is completely rigorous. On the other hand, he is entirely mistaken in his perception of the way aesthetic judgement translates into economic appreciation, but his misconception is so widespread that it can safely be said to be at the root of the whole controversy.

Not content solely to paint *Voice of the Taxpayer* and hang it in front of the house, Czupryniak put it up for sale. 'How much?' he was asked by all the journalists who interviewed him. 'If you're with the government,' he replied laughing, 'it's $1,800,000. If you are a private individual, you can have it for $400.' As this second price varies from $190 to $450 from one interview to another, several journalists asked him how he set it. His reply was admirable: he spent $190 on materials and worked seven hours at $45 per hour. If we add it up (he didn't even bother), we see that he could have asked $505. The $190 expenses are, in and by themselves, a measure of his love of the métier, as are the seven hours spent practising it 'in accordance with all its principles.' By way of contrast, poor Antoine Corege, who, according to the newspaper, sells his own works for up to $15,000, boasted to the press that he had

spent only ten dollars and an hour of his time making his copy of the '1,800,000 dollar rip-off of the Canadian artiste.' Here we have a naïve yet direct (not to mention rare) economic index of the ethics of each person; the first shows the respect he has for his métier, while the second demonstrates his contempt for the lack of métier of which he accuses Barnett Newman.

Czupryniak, as a painter/craftsman, calculated his price rigorously. Thus, *Voice of the Taxpayer* has a set exchange value; so much for the materials and the depreciation of equipment, so much for the worker's labour time, and so much for the boss's profit. The fact that the worker and the boss are one and the same person changes nothing in the breakdown of the price. It is a common practice for craftspeople to calculate labour time and profits separately. The main point is that Czupryniak doesn't see the market for painting as art as any different from the market for house painting. His ethics bespeak a congenial form of capitalism in which the worker works diligently, labour time is properly remunerated, and the boss reaps a reasonable profit. In his mind, the difference between $1,800,000 and $450 is a gauge of the exorbitant surplus value pocketed by Newman (or his widow) in the name of an artist's status which is incomprehensible to the uninitiated yet legitimated by a cultural élite whose code and scale of values are equally incomprehensible. For Czupryniak, who revolts, the artist is thus a particular kind of boss who is absolved by the élite for the most outrageous transgressions against the ethics of a congenial capitalism. However, and this struck me as I was going over the press clippings, Czupryniak was no different from any of the other protestors in that he did not reproach the artist/boss (or his widow) for cashing in on this exorbitant surplus value. Indeed, he is himself a craftsman/boss and, as such, cannot help admiring the commercial talent of a colleague who has managed to find a sucker ready to pay such a price for three stripes of colour. What he cannot stomach is that *he* is the sucker; after all, those three stripes were bought by a state institution, using taxpayer's money.

As in Althusser's 'spontaneous philosophy of the scientists,' there is in the spontaneous economics of craftspeople an element of truth that is at once recognized and misconstrued; Czupryniak's spontaneous economics is exemplary and particularly enlightening not only for the whole *Voice of Fire* controversy, but, also for the numerous scandals of

this kind that have marked the history of modern art. By viewing the artist (in general) as a boss, Czupryniak acknowledges that the artist has no métier. The tradesperson (*homme de métier*), the worker, is the painter from whose work the boss extracts surplus value. Thus, Newman the artist had to exploit Newman the painter. This is where the spontaneous economics of a Czupryniak is at one with the spontaneous aesthetics of the many who vaguely perceive what it is that modernity – in other words, the existence of the 'artist in general' – has changed to aesthetics, yet who misconstrue the *aesthetic economy* articulating the separation between artist and painter in the same individual. (By playing out this separation as a form of denial, Corege tragically embodies the misunderstanding.) Such people easily admit that artists exploit themselves: they exploit their talent, as made visible by their métier. They also admit that artists/bosses exploit the artist/painter in themselves, pocketing a surplus value which is the measure of their talent or métier. Well, as far as the métier goes, Czupryniak is practically equal to Newman; he proved as much by painting *Voice of the Taxpayer*. He knows, then, that *Voice of Fire* 'is worth' seven hours of work; such is its exchange value (which, as we know from Marx, is measured in labour time, just as surplus value is measured by the non-remunerated labour time which the boss extorts from the worker). Even greater than Czupryniak's indignation is his bewilderment: how could he, who worked only seven hours, have managed to hand over $1,799,550 worth of non-remunerated labour time to a cultural élite representing the Canadian people and collecting on its behalf?

I just made a mistake, which I bet went unnoticed. It is to Annalee Newman and thus, posthumously, to Barnett Newman himself that his supposed surplus value went, and not to the cultural élite appointed by the Canadian people who, quite to the contrary, were the ones who paid out the amount. Yet, if you put yourself in the shoes of John Czupryniak and all those who protested against *Voice of Fire*, you will readily agree that this feeling of being robbed which riles you really is that it is the élite which visits the National Gallery of Canada, appreciates Barnett Newman, and reads this essay that is the real beneficiary of your hard-earned money. And since you are part of this élite, you cannot deny that this feeling is justified. By tagging the price of *Voice of the Taxpayer* – should the state be the buyer – to that of *Voice of Fire*, Czupryniak sought (with a humour that concealed a profound truth) not to repair

the damage he suffered as a sucker/taxpayer, but to redress the wrong done him as a worker/painter. Suppose that the state were to buy his painting: as a taxpayer he would once again have contributed to financing a purchase whose aesthetic benefit would go to the cultural élite. Yet, as an artist recognized by the National Gallery, he would get back the $1,799,550 which, according to his spontaneous economics, Newman the artist extorted from Newman the painter.

Czupryniak is well aware that he won't be getting back this money. The amount is purely symbolic and 'quantifies' the difference between the status of artist and the métier of painter. It is, of course, not a surplus value that the artist/boss could wrest from the worker/painter in himself. Czupryniak doesn't have a clear idea of this since the only economy he knows is that of the craftsperson who produces commodities as a worker and sells them as a boss. But by fixing two incommensurable prices, depending on the buyer (you or me, on the one hand; the state, on the other), he recognizes that the economy governing art work is not an economy of commodities and that the time it takes an artist to complete a work is irrelevant because it is different in kind from the 'average socially necessary labour time' (Marx) constituting the substance of commodities. There was never, then, any point at which $1,799,550 worth of non-remunerated labour time entered into the exchange value of *Voice of Fire*, because *Voice of Fire* has no exchange value; this is precisely what is shown through its imaginary exchange with *Voice of the Taxpayer*.

It is still undeniable that *Voice of Fire* cost the Canadian taxpayer a considerable sum of money. If the art market were less speculative than it currently is, the price of the painting could have been decidedly lower. But it could just as well have been decidedly higher – infinite even. According to the standard ideology of the cultural élite, works of art are priceless, which is not true. Works of art have no *value*, but they do have a price; the payment of symbolic amounts doesn't mean that symbols cost nothing. On the contrary, they ought to be costly. Whether we are talking about the gold of the Incas, Gothic cathedrals, or Haida chests decorated with magical motifs, the extravagant expenditures which a society willingly concedes in the name of art are indeed of the order of potlatch. The only ethical justification for such outlays, which are made with everyone's money, is that everyone will benefit from them. Oh, I am not dreaming about an egalitarian society that would do

away with cultural élitism once and for all, even though this dream had a lot to do with the adventure of those painters, from Seurat to Newman, who reduced the métier in their work to the level where it could be compared with that of a house painter. I believe that as long as there are élites (and they will no doubt always exist), they should see that their role is to acquire costly symbols that speak to the work of all of us. Brydon Smith, the curator who purchased *Voice of Fire* for the National Gallery, was right when, with the following words, he ended the brief text of the leaflet he wrote about the painting at the height of the controversy: '*Voice of Fire*, like all great art, is one artist's gift to all of us.' And John Czupryniak was right in painting *Voice of the Taxpayer* because the voice of the taxpayer is that voice of all of us acknowledging receipt of Newman's gift, whether or not we are painters by trade. 'Anybody could paint this, even a painter.' I know of nothing closer to Newman's sense of the sublime than this 'even.'

BRUCE BARBER

Thalia Meets Melpomene

The Higher Meaning of the *Voice of Fire* and *Flesh Dress* Controversies[1]

During the past four years, we have been somewhat fortunate to have witnessed a number of extraordinary plays – I prefer to call them 'performances' – involving the plight of the institution art and its public. These performances had bizarre titles, elaborate scenarios, and a cast of disreputable players. In downtown Manhattan, Serra's 'The Destruction of Tilted Arc' played; Washington, D.C., premiered 'Eros Presumptive'; back in New York, the curtain opened upon 'The Plastic Crucifix in Urine.' The latter two performances were dubbed jointly in the popular press the 'Mapplethorpe, Serrano, Helms Affair.'[2] In Canada we had Vancouver's spectacular 'Sniffy the Rat,' a preliminary to Ottawa's controversial *Voice of Fire* and *Flesh Dress* performances.

It is not my intention here to link these controversial performances and then to unveil them as significant acts in a comic drama of epic proportions, although I must admit the temptation to do so is great. Neither is it my intention, notwithstanding the title and introduction to this essay, to parody the parodied, since the recognition of the tragi-comic circumstances of these performances has already shrunk into the dark crevices of contemporary history. However, I will argue that fertile conditions for the reproduction of these performances are still very much with us, and for this reason alone they are worthy of our re-examination for what they can tell us about the institutions of art, and, yes, the plight of their and, need I say, our publics. What I have in mind is an investigation of the higher meaning of these performances, one that takes as its point of entry the signatures of those actors at the margins of the production of meaning who participate, nevertheless, in the extended field of cultural reproduction, contaminating the institu-

tional discourses with their chatter, questioning institutional verities with their laughter. I am speaking here of the print media and their agents – writers, editors, cartoonists – those interpreters and critics, architects perhaps, of public opinion who, for better and for worse, have a hand on the fevered brow of our culture. In negotiating this territory at the margins, I will attempt to rescue the higher meaning of two of these controversial performances from the clutches of those who would wish them away as isolated and aberrant attempts at state intervention, misguided initiatives of arrogant misanthropes, rednecks, miscreants, and philistines.

Our task, then, is to examine the *Voice of Fire* and *Flesh Dress* controversies as these were represented (played out) in the media as examples of what the Russian semiotician of the 1920s, V.N. Volosinov, and, more recently, the French social theorist Pierre Bourdieu, have described variously as the struggle over the meaning of the sign. Thus, for Volosinov, 'sign becomes the arena of class struggle,'[3] and, for Bourdieu, 'different classes (and social fractions) are engaged in a specifically symbolic struggle to impose the definition of the social world most in conformity with their interests. The field of ideological positions reproduces in transfigured form the field of social positions';[4] and further, 'the field of symbolic production is [but] a microcosm of the struggle between the classes.'[5] But perhaps we should question the singular 'sign' of Volosinov and Bourdieu, for, in their separate ways, the *Voice of Fire* and *Flesh Dress* controversies represent struggle(s) over the meaning of an ensemble of intersecting signs differently oriented and accented, within the discursive fields of art, architecture, culture, history, business (capital), education, religion, gender, sexuality, and class, to name merely the major ones. I will argue that these struggles over the meaning of the sign(s) represent attempts from various constituencies to either accommodate and sustain, or resist, the hegemony of the dominant culture.

The nineteenth and early twentieth centuries had their share of private and public controversies about art. Unlike many subsequent examples, however, these were related predominantly to the exhibition, not the sale, of works.[6] This change can be attributed to a number of factors, including the decline, some would say the death, of the modernist or historical avant-garde(s); increasing participation by the state

in the cultural sphere, represented by increased public funding of museums, art institutions, and artists; and, at the conclusion of the Second World War, the heating-up of the international art market.

A survey of the recent history of significant public controversies precipitated by the purchase of major works of art by publicly funded institutions would include the mid-1970s purchase by Australia's National Gallery of Jackson Pollock's painting *Blue Poles*,[7] the Tate Gallery's purchase in 1972 of Carl Andre's famous low sculpture rectangle of fire bricks,[8] and the National Gallery of Canada's 1990 purchase of the Barnett Newman painting *Voice of Fire*. Each of these commanded an extraordinary amount of press time – one standard measure, at least since the invention of the printing press, of the importance of a public controversy.[9]

An examination of each case would reveal many similarities of a structural or institutional nature – to take our theatrical metaphor a little farther; the cast of characters, script, *mise en scène*, production schedule, funding, promotion, etc. – beginning with an institution's decision to purchase a work, accompanied by infra-institutional wrangling over its cost and its relevance and value to the collection. The purchase of a work is followed by its delivery and public unveiling, these subsequent steps prefaced by the press release – quiet, if some opposition is anticipated; loud and triumphant, if not. And, given the convention of press releases, their issuing occasions the release, or unleashing, of the press, with responses that may vary widely, depending most significantly upon the nature of the public debates attending the purchase, but also upon such difficult-to-analyse factors as the political alliances of those in positions of power within the press hierarchy, the editors, the owners, as well as the ideological positions held by the authors of the reports, editorials, essays, and cartoons. The public and press responses may be acclamatory if the gallery purchase is 'safe,' but declamatory – that is, noisy, the object of savage denunciation – if the purchase is deemed questionable. This is the *sine qua non* of the average art controversy. Criticism emanates from and circulates within various social groups and constituencies, from the highest levels of government, the boardrooms of the nation, the lunchrooms and restaurants, to the proverbial figure on the street. And while the individuals from these various constituencies (perhaps we should call them *classes*) may speak the same language, their use of it may be imbued with differ-

ently oriented *accents*, which reinforce or underscore different types of criticism, privileging, in transfigured (symbolic) form, separate, identifiable, and often competing ideologies.

We should examine a few of these accents as they were represented or played out in the media. Our method will be this: First, we will familiarize ourselves with a few of the facts of the purchase of Newman's *Voice of Fire* and the exhibition of Jana Sterbak's *Flesh Dress*, then proceed to an overview of the press reports, letters, graphic satires (cartoons), and performance parodies,[10] bearing in mind that we are examining the symbolic representation of the struggle over competing meanings, perhaps better described now as the *political economy* of the sign. In the *Voice of Fire* controversy, the focus will be upon the news reports, editorials, letters, and cartoons produced during a four-week period (8 March–8 April 1990), and with the *Flesh Dress* controversy, one year later, upon several graphic satires printed in various contexts over a one-week period (4–11 April 1991). The essay concludes with some historical reasons for the contestation over the meaning of the sign, a reductive schema of class-based attacks on the avant-garde, with some comments concerning the reasons why the most advanced modernist cultural practice has so engaged the public ire.

I To review briefly the circumstances surrounding the purchase of *Voice of Fire*: In August 1989, Barnett Newman's painting was acquired for the National Gallery by its assistant director for collections and research, Brydon Smith, for the price of $1.76 million, a figure which was subsequently rounded off in many of the media reports to $1.8 million. On 7 March 1990, approximately six months after the purchase, *Voice of Fire* was included in a press release announcing the acquisition of some 226 purchases and 185 gifts for the year. A few days after the announcement, a number of important events transpired. On 8 March the gallery's press release was commented upon in the *Globe and Mail* and then quickly responded to from a number of quarters. Felix Holtmann, chair of the House of Commons Standing Committee on Communications and Culture, raised the alarm with his very quotable 'looks like two cans of paint, and two rollers and about ten minutes would do the trick!,' which in the weeks that followed was reproduced in the press and on radio and television *ad nauseam*.[11]

Unofficially, beginning 8 March, the first parodists and satirists

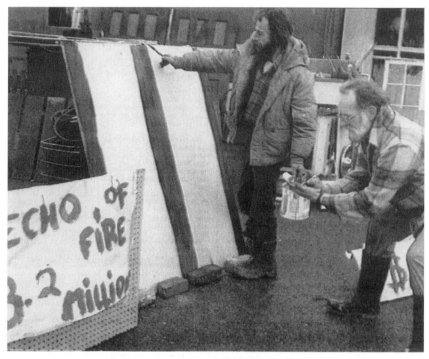

29 Louis Lesosky and Dave Trendle with *Echo of Fire*, *The Times–Colonist* (Victoria), 9 March 1990. Photograph by John Wells

began their acts. Bob Beland, an Ottawa-area silkscreen artist, reportedly stated that 'for a mere $20,000' he would sell, to anyone interested, a cotton short-sleeved T-shirt with his own rendition of *Voice of Fire* screen-printed on it. 'I think it's a good price, heck of a deal,' he said. Former house painter turned farmer John Czupryniak, from the Ottawa suburb of Nepean, painted his own *Voice of Fire* and propped it against a fence on his farm. 'It took a whole day to do. Everybody loves it,' said the artist. The painting cost him $190 in materials and 'is intended as a statement on behalf of the average taxpayer.'[12] The next day, a painting, *Echo of Fire*, by Louis Lesosky and Dave Trendle, was reproduced in the Victoria *Times–Colonist* with the caption revealing that it had a 'firesale price of $3.2 million' (fig. 29).

Over the next two weeks, reports and letters to the editor appeared in many of the French and English dailies across the country. In the conventional language of journalese, many of the reports evidenced a certain 'objective' gloss. However, a closer examination of thirty news reports reveals that opinion was clearly divided, with even some of the most positive commentaries clearly demonstrating ambivalence on

some aspects of the purchase, particularly the cost of the painting and the timing of the announcement. Unwilling or without the time to engage in some direct reportage, many of the authors of these articles reproduced sections of the first Canadian Press report, which relied heavily on information provided by the National Gallery, trotting out what became the standard line of defence for the purchase – that Newman's painting is of international significance; other galleries would borrow it for their exhibitions and the gallery could expect favours in return; the purchase would raise the profile of the contemporary collection; and, finally, that the painting would increase the number of gallery visitors.

A minority of the reports attempted to maintain the expected level of objectivity through a selective contrasting of quotes from individuals on various sides of the controversy, including government figures, staff from the National Gallery, representatives from the cultural community, dealers, critics, and members of the public. The academic community was conspicuously absent from most of these discussions. The objective gloss which many of the authors attempted to sustain was often undermined severely by the ironic headlines accompanying their reports, possibly the result of an intervention from those with editorial power from within the newsroom hierarchy. Many of these editors appropriated part or all of the title of Newman's painting to provide a proverbial hook for the reader, thus producing a crop of headline tropes which directly satirized the purchase and indirectly added more fuel to the controversy: 'Can This Voice Put Out the Fire?,' 'National Gallery Made a Tactical Error in Not Fanning the Fire,' 'Fire the Curators,' 'Painting's Elitist Message Sure to Make Canadians Burn,' 'Cabinet under Fire for Decision to Review 1.8 Million Art Deal,' 'Heat's on as "Voice" Outrage Deepens,' 'Masse Sidesteps Firestorm.'

The news reports and editorials tended to reduce criticism to a number of distinct categories: the timing of the announcement; the cost of the purchase, specifically its percentage of the gallery's total yearly purchase budget; the quality of the work; and the fact that it was by a dead American artist and not a living (or dead) Canadian one. In their reductive and somewhat repetitive form, these criticisms tended to mask the complexity and the often contradictory nature of many of the debates. For instance, the parodies of the painting and the critical discussions represented in many of the reports invoked a whole range

of stereotypical responses regarding the value of contemporary (specifically abstract) art, the issue of state funding for the arts, the role of the artist, and the function of museums within society. The criticisms also invoked a number of political positions, left and right, with respect to the role of publicly funded institutions and institutional autonomy, and even national identity, which ironically was used by all sides in the debate to reinforce their own ideological positions, whether these be nationalist, pro-Canadian, democratic, anti-statist, anti-American, or internationalist in origin.

As far back as May 1988, when the painting first entered the new National Gallery building, Brydon Smith had expected 'tough sailing' on the purchase. But, as the late *Globe and Mail* staff writer Stephen Godfrey acknowledged,[13] the gallery's 7 March press release announcing the purchase could not have come at a worse time, with the Canadian public reeling from the proposed goods and services tax; acrimonious parliamentary debates on increasing unemployment and the results of free trade with the United States; increasing business failures and personal bankruptcies; and deepening problems with the auto, lumber, textiles, and fishing industries.

Faced with considerable opposition, the National Gallery conducted 'damage control,' in the household phrase from *Star Trek*. The institution positioned its defences relative to the most important attacks, those from government and important figures in the media. Additional documents were sent out, and selective interviews were given to members of the press in an attempt to quell the rising tide of criticism. The gallery produced a brochure on the purchase that later backfired, indirectly providing a parody of its intended purpose and further evidence, for some, of the incompetence of gallery staff. The image on the flyer was flopped, a classic mistake reminiscent of the stereotypical abstract painting hung upside down.[14] The printing mistake was revealed by Kyle Brown, an observant young viewer from Edmonton, who noticed that the male viewer's jeans label was on the wrong pocket. National Gallery spokesperson Helen Murphy affirmed Brown's perception. 'The gallery has a policy of never showing a work flopped [in reverse],' she said, 'but in this instance it was a rush job. We wanted to get the information out as quickly as possible and we didn't look at the brochure proofs. At that point 50,000 had been printed, so we distributed them. The next printing will be correct.'

Written by Brydon Smith, the brochure attempted to respond to several criticisms of the purchase. The claim that the painting was 'un-Canadian' was dismissed with a reference to the reason for its creation – Newman 'created it as his contribution to Expo '67 in Montreal' – a claim that is disputed in one of the standard reference works on Newman. There, Thomas B. Hess wrote about *Voice of Fire*: 'This is the only time that Newman used the eighteen foot dimension for a vertical painting, and he had practically no hope of exhibiting it as there are few ceilings high enough to accommodate it. By a *happy chance*, however, he was invited by Alan Solomon to show it in Buckminster Fuller's United States pavilion at Expo '67, Montreal, and the picture was seen there and later in Boston' (my emphasis).[15]

In his defence of the painting, Smith underlined the connections between Newman and those Canadian artists whom he inspired – Guido Molinari, Robert Murray, and Claude Tousignant. The text extolled the virtues of this 'simple painting ... that can convey a range of meanings for those viewers who are willing to slow down and approach it with an open mind.' Commenting upon the structure of the painting – 'while there is twice the quantity of blue, the red band is just as important ... as the two blue ones. Each part remains separate and yet all coexist as a whole' – Smith concluded that this 'acts as a reminder of what it is to be independent and free of domination while at the same time part of a larger world.' Smith's invocation of the constitutional debates in Canada occasioned an ironic response from several writers. Bronwyn Drainie, for instance, wrote: 'Hey, a kind of artistic gloss on Meech Lake, Europe in 1992 and perestroika, all in one painting!'[16]

If we were to situate the Newman painting back to its time of production, we would have to consider carefully its role as a repository or vehicle for this kind of direct political association, as distinct from its religious or spiritual references, which became the subject of many commentaries and reviews. Even given Newman's lifelong attachment to politics (in 1933 he ran in the mayoralty election in New York) and the fact that some of his later works, including *Lace Curtain for Mayor Daley* (1968), produced in protest to the riots and arrests attending the 1968 Democratic Convention in Chicago, exist as a direct comentary on a political situation, the artist, at least after his first solo exhibition in 1950 at Betty Parson's Gallery in New York City, was careful not to suggest in published statements about his work that his paintings could be

read politically. In fact, to be successful in Newman's terms, the work of art had to acquire some transcendent condition *over* politics. 'Painting, like passion,' he wrote, 'is a living voice which, when I hear it, I must let speak, unfettered.'[17]

However, in so far as it is true that no artist's work exists within a vacuum but rather within special social and political contexts that have the capacity to change their meaning over time, it may be argued also that Newman's works entered different social and political realities and became subject to the ideological machinations of various discursive communities. Unlike some others of his generation, Newman was supremely aware of the importance of context in the production and de(con)struction of meaning in his work. It is interesting in this respect to compare his comments on the relationship between politics and art from the early years of his career with those from the last interview before his death in 1970. In his mayoralty candidacy paper, 'On the Need for Political Action by Men of Culture,' he opposed the interests of the artist to those of the worker, insisting that the artist's labour should be free and not expected to produce works of use to society: 'It is only the slave psychology of masses in chains, given expression in the Marxian parties, that insists that art must be useful. The worker recognizes the true creative artist as his enemy, because the artist is free and *insists* upon freedom. It is therefore a contradiction of his own nature for any artist to hope for anything more from the worker than from the politician.'[18]

In the 1970 interview Newman's views on the freedom of the artist were reiterated from the position of someone who is reviewing the stability of his beliefs over the course of several decades. However, this statement presents a very different emphasis on freedom and conveys quite different political meanings: 'Some twenty-two years ago, in a gathering, I was asked what my painting really means in terms of society, in terms of the world, in terms of the situation. And my answer then was that if my work were properly understood, it would be the end of state capitalism and totalitarianism. Because to the extent that my painting was not an arrangement of graphic elements, was an open painting, in the sense that it represented an open world – to that extent I thought, and I still believe, that my work in terms of its social impact does denote the possibility of an open society, of an open world, not of a closed institutional world.'[19]

Beyond the tinge of romantic idealism and latent utopianism which marks both statements, the latter one represents a curious conflation of political ideologies. It is tempting to relate Newman's position on artistic freedom to that exhibited by his contemporaries, the kind of thinking which Serge Guilbaut and others have recently identified as a version of liberalism, a quixotic transmutation of the Schlesingerian 'politics of the vital centre,'[20] or Eliotic Trotskyism (T.J. Clark) which supplanted the anarchism, Marxism, and Trotskyism of the 1930s and early 1940s. Newman's remarks may also be alluding to another foe of fascism, philosopher Karl Popper, whose famous dissertation on democracy and freedom, *The Open Society and Its Enemies*, engaged a wide if critical readership when it was published in 1945.

Notwithstanding the artist's own ambivalence towards the direct representation of politics in art, the National Gallery's purchase of *Voice of Fire* in 1989 became as much a symbolic vehicle for political use as it had been in its first Canadian exhibition at the 1967 world's fair in Montreal. The painting was not simply a site for a transcendent aesthetic experience; rather, it became, in the minds of some, an active signifier in search of some signifieds.[21] And, given the ripe circumstances of both its original showing in Montreal and its subsequent purchase by the National Gallery, these were easily attached. For instance, in defending the purchase, both Brydon Smith and Helen Murphy (head of communications at the gallery) indirectly paraphrased the open-society model implicit in Newman's statement by suggesting that Newman's painting illustrates a 'borderless, frontierless society ... where there are no frontiers for ideas, visual arts or design.'[22] Many defenders of the purchase supported this view, including, for example, John Cruickshank, who suggested in his positive review of the purchase that 'Canada can best promote its cultural vitality by a policy of openness to the world, including the United States.'[23]

We can identify several primary sites of meaning contestation – economic, political, moral, and aesthetic – to the purchase of *Voice of Fire*, each of which bears some relation to what may be termed conventional categories of rejection, about which I will have more to say at the conclusion of this essay. These issues are clearly articulated in the nineteen cartoons, published in various papers, which helped to fuel the controversy over the course of the two-month period (see 'Graphic Satires').

Ottawa cartoonist Dave Beresford's (fig. 7) was among the first of these. His image, which appeared in the 10 March Ottawa *Citizen*, showed a plaid-shirted figure gleefully painting a moustache on the central 'zip' of the Newman painting. This graphic satire cliché has a venerable history in art, dating from Marcel Duchamp's famous icono-clastic gesture on a reproduction of Leonardo's *Mona Lisa* through to Situationist Asger Jorn's 1962 parody of Duchamp, a found academic painting of a young girl with moustache and goatee titled *The Avant-Garde Doesn't Give Up*. As a sign of rejection or negation, the moustache relates also to Newman's own moustache, which had a tendency to curl in similar fashion to that represented in the cartoon. In Beresford's cartoon, both the artist and the artwork are symbolically negated. A second cartoon (fig. 8), by Zazulak in the *Toronto Star* (14 March), com-ments on the national-unity issue by showing two figures conversing in front of the Newman painting, one a cultured Québécois in a beret, the other an Anglo-Canadian philistine. The Quebecer's statement reads: 'I see it as an abstract expression of our country divided. The blue back-ground symbolic of the potential harmony between English and French isolated by a blazing redneck stripe … a contemporary mirror. What do you see?' The Philistine answers dismissively: '$1.8 million down the toilet.'

Bado's cartoon (fig. 9) from *Le Droit* (15 March) illustrates an artist figure, perhaps the cartoonist himself, walking past the base of the painting, with its price tag of $1.8 million, saying 'C'est décidé: je me lance dans l'art abstrait!' ('It's decided. I will launch myself into abstract art!'). Another cartoon, produced by Alan King (fig. 10) for the Ottawa *Citizen* (15 March), titled 'Canvas Controversy,' has a curator in six frames blandly delivering a formalistic description of the painting: 'Notice the delicate interplay of verticality and horizontality … the stoic abnegation of unnecessary surface values … the proclamation of a simple, bold, uncompromising philosophy.' When a distinguished-looking middle-aged woman affirms, 'Yes, it *is* a fabulous painting, isn't it …,' the male curator replies, 'Painting? Who said anything about a painting? … I'm talking about the cheque!' This cartoon subverts the philosophical and aesthetic values attached to the painting by its sup-porters to underwrite the primary value – money.

Gable's hilarious cartoon (fig. 11) for the *Globe and Mail* (17 March) shows an artist/husband figure painting a canvas with large dots, in his

studio full of dot paintings, while his wife, engaged in reading a newspaper containing the announcement of the purchase price of Newman's painting, exclaims: 'For thirty years I said "why don't you try stripes … just once … for variety?" … But *noooo* …' This cartoon brings together the purchase price of the painting with a potential domestic struggle over the value of creative work. The *Sudbury Star* cartoon (fig. 12) from 17 March contains a stereotypical bearded artist in a beret, telephoning the National Gallery from his loft space with his generous offer of his own 'two red stripes on blue background' for a mere $3 million, which he says is $600,000 less than it's worth. This satire is an ironic inversion similar to the parodic performances mentioned earlier. Cartoonist Sebastian's enigmatic image (fig. 13) from the *Ottawa Business News* (24 March–6 April 1990) shows guide dogs lined up outside the boardroom door of the National Gallery, beside which is a container with white canes. The somewhat opaque references here rely upon the viewer's identification with Sebastian's allusion to the gallery board members as the proverbial blind leading the blind.

John's cartoon (fig. 14) in the *Edmonton Bullet* (28 March) has two figures conversing in front of Newman's painting. One says to the other: 'How could you pay so much for this? It escapes me, I can't see the reason …,' to which the gallery curator mockingly replies, 'Oh, Ha, Ha, Herbie have you ever heard about thought distillation? … No … Then give me a break!' A Herman cartoon by Unger (fig. 17) with the caption 'What are you blind? You hung it upside down!' was produced in 1985, but was republished during the *Voice of Fire* controversy.

Cam's cartoon (fig. 19) for the Regina *Leader–Post* (14 April) convicts the reductive Newman painting by contrasting it with an acknowledged master work from the Renaissance, Michelangelo's *David*. As he looks dispairingly at *Voice of Fire*'s $1.8-million price tag, Michelangelo exclaims: 'Nuts!! I feel like such an amateur.'

Another Bado cartoon (fig. 20) from *Le Droit* (18 April) shows a puzzled Jean Chrétien, head of the Liberal party and soon to become prime minister of Canada, turning the critique of abstraction into a highly charged political sign, a clever reworking of the messages contained in the gallery's defensive brochure. The cartoon caption reads: 'Je ne comprends pas pourquoi tout le monde insiste à appeller ça une toile abstraite … J'y vois une percée libérale au milieu d'une mer de bleus!' ('I do not know why everyone insists on calling this an abstract

painting. I see a Liberal cut [red stripe] through the middle of a sea of blues [Conservatives].') Hutchings's ironic cartoon in the *Financial Post* (19 April) (fig. 21) recalls the horizontality of most of Newman's paintings this size. Of his striped effort, the artist cartoon says, 'I realize that it's similar to "Voice of Fire." The dramatic difference is that mine is horizontal. The National Gallery will love it!'

Roy Peterson's cartoon (fig. 15) from the *Vancouver Sun* (28 March 1990) shows a plaid-coated viewer peering sideways at the *Voice of Fire* while a museum guard and National Gallery curator replay the familiar scenario of the abstract work hung upside down. Pointing towards the viewer, the guard says, 'At least *this* one isn't complaining about the price. This one's asking why we hung it upside down ...' Mike Graston's cartoon (fig. 18) from the *Windsor Star* (12 April 1990) presents an ironic post-controversy scenario. The gallery officials in his cartoon walk towards the National Gallery Acquisitions Department containing striped abstracts of all sizes. The woman, possibly a stand-in for gallery director Shirley Thomson, declares: 'After the government decided to respect our professional judgement and maintain its arm's-length policy, we went out and really blew a wad! ...'

Finally, four highly symbolic vehicles for rejection: Pritchard's cartoon (fig. 22) in the Regina *Leader–Post* (21 April) transposes two paintings, *Voice of Fire* and *Silent Majority*. The latter Pop Art–like work presents a thumbs-down sign, which accords ironically with Pop Art's rejection of Abstract Expressionism. Blaine's cartoon (fig. 16) in the *Hamilton Spectator* (29 March 1990) shows three gleeful 'stooges' – house painters Larry, Curley, and Moe of the National Gallery selection committee – with Newman's painting, price tag, and paint roller. And Ben Lafontaine's cartoon (fig. 24) in *Ottawa Magazine*, published some months after the controversy had subsided, shows a huge foreshortened figure of a museum guard standing next to a father protectively holding his child as he examines the offending painting. Last, but not least, Susan Dewar's enigmatic cartoon (fig. 25), published by the *Ottawa Sun* (4 April 1991), symbolically connects *Voice of Fire* with the *Flesh Dress* controversy which was to follow a year later. This hard-hitting satire, the only one during the course of the controversy produced by a woman, shows a pork steak–headed Felix Holtmann sporting a ten-gallon hat, cowboy boots, and spurs, and carrying a suitcase full of money. He is leading a pig, either to, or from, the market, encouraging

the reader to identify the image with the children's nursery rhyme – 'to market, to market to buy a fat pig ... home again home again jiggity jig!' Dewar's speech caption for Holtmann is a single horizontal stripe, indicating that his resistance to the *Voice of Fire* and the *Flesh Dress* is but a natural product of his red-necked cowboy philistinism, as if, indeed, the word was flesh.

II The *Flesh Dress* controversy represents a similar set of struggles. Our attention here will focus upon the satirical representations of the work that appeared in the press over a period of several days. Jana Sterbak's *Vanitas: Flesh Dress for an Albino Anorectic* (the work's full title) was first shown in an exhibition at Galerie René Blouin in 1987. In this exhibition, as with the subsequent showing at the National Gallery, the work consisted of two elements: the 'Flesh Dress,' constructed from slabs of prime beef sewn together, mounted on a tailor's dummy, and, on an adjacent wall, a framed photograph of a model posing in the dress (figs. 30 and 31).

While scant attention was paid to the first showing of *Flesh Dress*, the exhibition at the National Gallery, approximately one year after the *Voice of Fire* controversy, quickly provoked outrage from members of local government, the public, and the media. And, like the earlier controversy, this one reveals clearly the contestation over the meaning of various discursive signs differently oriented and accented. The attacks began shortly after the exhibition opened. Many of the critics directed their attention to the use of expensive meat in the art work at a time when increasing numbers of people were lining up at food banks. Others attacked the institution for showing work which they argued was inappropriate to the maintenance of decorum in Canada's National Gallery. A few individuals cited the work as a potential health risk, while others attacked the feminist intent behind the work, arguing that Sterbak had merely reproduced the view of woman as consumable object.

Supporters of the work, including Montreal critic and historian Reesa Greenberg,[24] argued for the complex dialectics operating within the work; of how the work stimulates discussion to centre around society's expectation of women, their colonization, their self-exploitation and the resulting physiological symptoms, including anorexia nervosa occasioned by the alienation of the female subject. The work powerfully

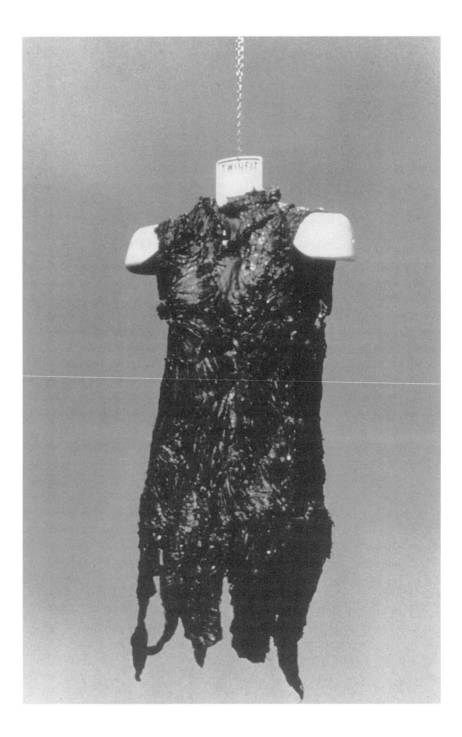

30 Jana Sterbak, *Vanitas: Flesh Dress for an Albino Anorectic.* Flank steak, variable dimensions. Collection of Galerie René Blouin, Montreal. Photograph by Louis Lussier

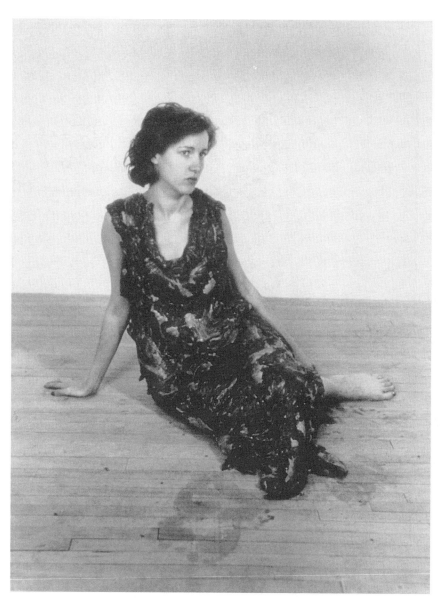

31 Model posing in Jana Sterbak's *Flesh Dress*. Photograph by Louis Lussier

engages the set of social relationships which, according to anthropologist Mary Douglas, are oscillating between the two poles of purity and danger – the politics of gender and sexuality.[25]

The cartoons that appeared in many papers across the country within a week of the exhibition revealed clearly the extent and foci of the criticism, if not the complexity of arguments either in support of or against the work. For instance, *Le Droit*'s 3 April cartoon by Bado, titled

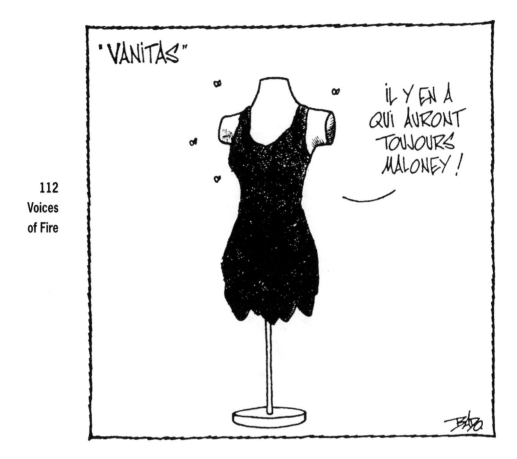

32 Bado [Guy Badeaux], *Le Droit* (Montreal), 3 April 1991

ironically 'Vanitas' (fig. 32) engages the health concern by representing
the dress with flies buzzing around it with an accompanying caption: 'Il
y en a qui auront toujours Maloney!' ('Some will always have Maloney!'),
a barbed reference to Ottawa alderman Mark Maloney, who stated that
he was 'absolutely disgusted and ashamed' of the beef and demanded
its removal. He ordered regional health inspectors to examine the work
in order to ensure that it did not violate Ontario's public health stand-
ards. 'People can actually touch the carcass,' he said; 'that's enough to
close it down.'[26]

The *Montreal Gazette*'s resident cartoonist Aislin (Terry Mosher)
drew a benapkined, poverty-stricken character standing before the
steaks of *Flesh Dress*, brandishing a bottle of A1 sauce, a fork, and a
plate (fig. 33), thus providing an ironic reference to statements by politi-
cians who expressed their rage at the exhibit, including Alderman Pierre

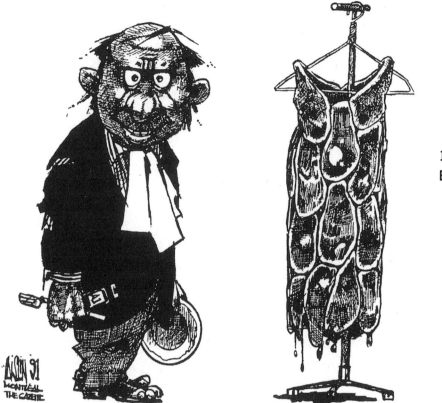

33 Aislin [Terry Mosher], *Montreal Gazette*, 3 April 1991

Bourque, who stated that the sculpture shows a 'malignant lack of passion' because 'it wastes food while others in the city are going hungry,' and Liberal MP Marlene Catterall, who said that 'it doesn't deal with the problem of a system that doesn't distribute food so that people have enough to eat.' These and other sentiments relating to the politics of food distribution were endorsed by Ottawa Food Bank manager Dick Hudson and officials from other food relief agencies, who attacked the $300 cost of the meat used in the production of the work.[27]

Other cartoons depoliticized Sterbak's ironical treatment of the use of meat in her work. Cartoonist Mariken Van Nimwegen's uncaptioned twin-set meat pants and meat dress (fig. 34) in the *Vancouver Sun* (20 April) both reinforces and deflates the relationship between women and food by providing a pair of genderless pants for a potentially contradictory reading of the original work.

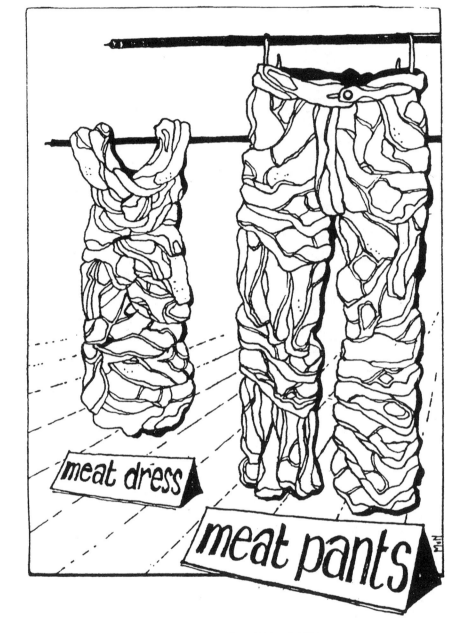

34 Mariken Van Nimwegen, *Vancouver Sun*, 28 April 1991

Sebastian's Ottawa *Citizen* cartoon (7 April; fig. 35): 'Meat Dress' –
'Where's the beef?,' which can be translated as 'Where's the substance?,'
merely reduces the issue into a blurted 'So what!,' while Jim Phillips's
Ottawa Sun cartoon (7 April) – 'Frankly I prefer my art barbecued' … –

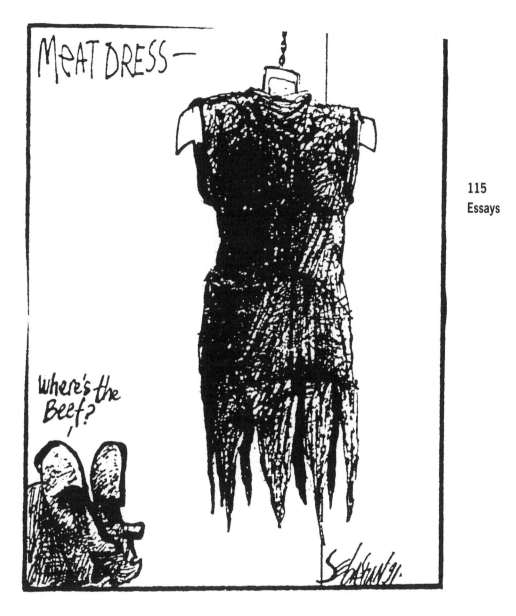

MeAT DRESS —

where's the
Beef?

35 Sebastian [Fred Sebastian], *The Citizen* (Ottawa), 7 April 1991

subtly domesticates the work, turning it away from the fractious politics
of sexuality and power, to suburban respectability (fig. 36). Similarly,
although the inversions are a little more ambiguous, the syndicated
'Back Bench' strip (fig. 37) distinguishes the ethical high art (existential)
reading in the left frame – 'This "meat dress" will make an important
statement about man's cultural depravity and bovine nihilistic tenden-

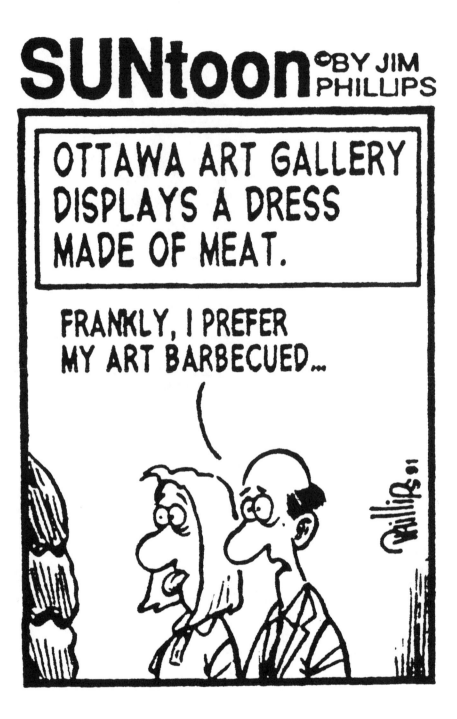

36 Jim Phillips, *Ottawa Sun*, 18 April 1991

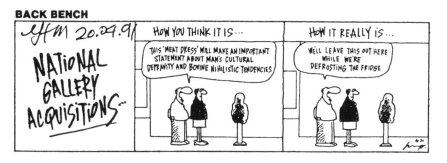

37 Harrop [Graham Harrop], 'Back Bench,' *Globe and Mail*, 20 April 1991

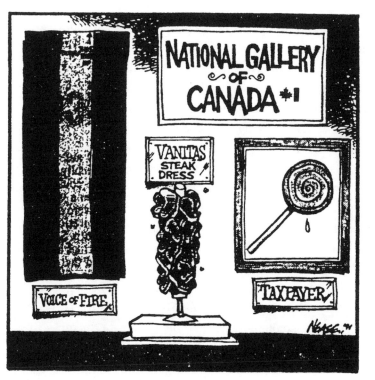

38 Nease, Southam Syndicate, Toronto, April 1991

cies' – from the practical, mundane, and domestic reading in the panel on the right – 'We'll leave this out here while we're defrosting the fridge.'

Finally, Nease's cartoon (fig. 38) links both the *Voice of Fire* and *Flesh Dress* controversies to invoke once again the debates around state funding for the arts by showing, beneath the obligatory sign of the state, the *Flesh Dress* between a miniaturized version of Newman's *Voice of Fire* and a portrait of the taxpayer as sucker.

III In summary, we should now briefly review the arguments used against avant-garde modernist work in general, and abstraction in particular, for these represent the underlying ideological positioning to which each class, in distinction, gives its name. Both the *Voice of Fire* and *Flesh Dress* controversies conform to the conventional attacks on the behaviour and work of the historical (modernist) avant-gardes, but they also represent attempts by various discursive communities to accommodate the critiques of the avant-garde. These attacks can be reduced to a number of overlapping categories which underscore the historical and political dimensions of these controversies.

1 / Politics Like its contemporary neo–avant-gardes, the historical avant-garde is often condemned for its politics. It is either bolshevik, communist, the work of dirty revolutionary anarchists, the result of some sort of subaltern conspiracy or foreign intervention. The art of the avant-garde is the product of members of the underclass or foreigners, and for this reason alone it is suspect. 'These people don't speak the same language as us' – which is to say, these people are out to challenge the system, to remove our privileges and destroy our way of life.

2 / Psychology While the Renaissance provided a rich context for the examination of individualism, and the *otherness* of artists,[28] it was not until the late nineteenth century and the development of psychology and the practice of psychoanalysis that the 'scientific' conflation of genius and madness occurred. It was spurred along by the hagiographic studies of artists like Van Gogh and Edvard Munch. Since the early twentieth century, the challenging art and behaviours of the modernists have often been associated with psychoneurosis. While the post–Second World War period saw a lessening in attention on the relationship between advanced art and insanity, throughout the 1970s to the present, the othering of artists has been based upon certain syndromes, such as schizophrenia, kleptomania, necrophilia, hysteria, scatophagia, rupophobia, and other obsessive manias. In this manner, avant-garde art, modernist and particularly abstract art, could be associated with a general sense of neurosis or, more popularly, madness.

3 / Physiological The physiological deficiencies of the modern artist have become favourite grounds for argument for those who feel be-

trayed by the increasing abstraction in modernist art ushered forth by
the invention of the photographic means of reproduction and its at-
tending crises in representation. Deviations from the conventions of
naturalist art are explained by inferences that abstract artists have some
physiological difficulty, usually a locomotor or retinal abnormality.

4 / Aesthetic/religious The work of modernist (abstract) art is ugly; it
contravenes the laws of beauty and perfection, which are part of nature,
and, ultimately, God.

5 / Moral/religious Avant-garde art offends against standard canons of
morality. It is immoral, offensive, dehumanizing, and decadent. This art
is an example of moral degeneracy and decay. The avant-garde artist is
an atheist doing the work of the devil.

6 / Law The work of the avant-garde artist is fraudulent, a hoax in-
tended to hoodwink the public into believing it is good, honest, legiti-
mate art. Modernist art is lawless.

7 / Economy These criticisms arise from a questioning of value,
whether from a material labour, capital, or metaphysical perspective.
Attacks within this category are usually prefaced with questions such as:
how can this work of the avant-garde artist – this useless abstract art –
be worth anything?; how can anyone sell this?; and why would anyone
pay money for this trash, this garbage which any decent law-abiding
citizen can see isn't worth the material it is made out of? Surely there is
labour with more social and economic value than this?

8 / Gender/sexuality This criticism is related to the psychological,
religious, moral, and legal categories. The work is phallic, unnatural, the
result of some kind of perversion. It contravenes common standards of
decorum and decency.

9 / Technical These criticisms are usually prefaced with remarks like 'a
child could do this better' or 'even a monkey could do it.' The avant-
garde work is the result of fortuitous forces that have nothing to do with
training, effort, perseverence, discipline, or God-given talent.

The press reports and cartoons reveal that the criticism of Newman's
Voice of Fire and Sterbak's *Flesh Dress* conforms to all of the categories
noted above. As an example of how these categories may overlap, Felix
Holtmann's 'two cans of paint and two rollers and about ten minutes
would do the trick' is a variant of the stereotypical negation often di-

rected at the abstract work of art (item 9, above), with the essential difference that Holtmann's technical critique is taken to the highest register of political governance.

This review of the media coverage of the *Voice of Fire* and *Flesh Dress* controversies articulates the manner in which symbolic representations of ideological positions are used critically against the avant-garde, particularly against those artists practising abstraction or otherwise presumed to be challenging the status quo. These examples demonstrate how the media can be deployed in ironic, parodic, or satirical fashion to provide critical and interrogative accents to those struggles over the meaning of signs occurring between various discursive communities.

The higher meaning of the *Voice of Fire* and *Flesh Dress* controversies can be summed up succinctly: class politics. I have tried to reveal how the political dimensions of humour – where tragedy meets comedy and *vice versa* – have a crucial part to play in the media's invocation of class conflict. Perhaps there is a simple formula underlying the higher meaning: Persuasion is to Power what Performance is to Politics.

JOHN O'BRIAN

Who's Afraid of Barnett Newman?

The question 'Who's afraid of Barnett Newman?' would not normally require a response. It would be understood as rhetorical. The same goes for the fustian query 'Who's afraid of Canadian history?' But the early 1990s were not normal, and more than a few people were gun-shy of Newman, his paintings, and the material evidence of history. During a lecture at the time, I remarked to an American audience that I wanted to speak about a recent instance of fear and loathing provoked by a Newman painting, in the collection of a prominent gallery, in a country noted for its reticence. The audience assumed I was referring to *Who's Afraid of Red, Yellow and Blue III?* (1968) and to the controversy surrounding *that* painting in Holland.[1] The recriminations and counter-recriminations over the conservation of *Who's Afraid of Red, Yellow and Blue III?*, following its vandalization some years earlier, dogged the Stedelijk Museum in Amsterdam throughout 1992 and were extensively reported in the American media.[2] I was not, however, referring to the Netherlandish controversy. I was talking about *Voice of Fire* and the reception it was accorded in Canada in 1990, an episode much less well publicized in the United States.

The absence of physical violence in the debate over *Voice of Fire* may have had something to do with American indifference to the Canadian uproar, though there was no shortage of symbolic violence for those who cared to search for it. In order to understand something about the painting's Canadian demonization, and the debate it ignited, I want to compare *Voice of Fire*'s reception in the early spring of 1990, when the National Gallery of Canada announced that it had acquired the work for $1.76 million, to its reception in the summer of 1967 at the Montreal world's fair – the event for which Newman expressly executed the work.[3]

The different treatments accorded the work could not be more extreme. I will argue that the circumstances of the painting's exhibition, first at Expo 67 and later at the National Gallery, had more to do with the shape of the ensuing discourse around *Voice of Fire* than any specific properties intrinsic to the work – not counting, that is, the generality of its abstraction. Because of abstract art's non-referentiality, its claim to visual purity and its refusal of what is contingent, the meanings that coalesce around it are famously unstable. The example of *Voice of Fire* is no exception. Abstraction may function as a universal sign of modernity, and has done so since the early years of the century, but when there are changes to the cultural frame that defines modernity, the sign also changes. In Montreal and Ottawa, the cultural frame established for *Voice of Fire* was paramount in determining its reception, and ordered the gazes levelled at the painting.

 | Before discussing how Newman came to be involved in the Montreal world's fair, it is necessary to say something about the fair itself.[4] Expo 67, like all world's fairs modelled on London's Crystal Palace Exhibition of 1851, was an occasion for promoting national superiority along with the latest in industrial products and luxury commodities. The fair, located on a site in the St Lawrence River extending over two islands and a peninsula, offered viewers an up-to-date spectacle of technological advancement from both the Western and the Soviet blocs (fig. 39). The sheer surfeit of visual display at Expo 67, like that on offer at today's mammoth shopping malls, confirmed Walter Benjamin's definition of world exhibitions as 'places of pilgrimage to the fetish commodity';[5] and the organizational control exerted in Montreal confirmed the fair as the most highly rationalized in history.[6] It was designed to accommodate record numbers of visitors, and to transport them from one exhibit to the next at unprecedented speeds. Visitors were propelled along a sophisticated transportation network that linked the various parts of the fair to the city, and were guided by colour-coded signs that advised where to get on, where to get off, what to do. (In a comic twist of irony, the official fair colours were Expo Red and Expo Blue, the two primary colours used by Newman in *Voice of Fire*.[7] When Newman executed the painting, I should add, he knew nothing about the fair's official colours.)

Sixty-two nations participated in the fair, each setting up shop in its

39 Aerial view of the Montreal world's fair, Expo 67. Photograph from
Architectural Review 142 (1967)

own pavilion. Thousands of international business corporations also
participated, twelve hundred from Canada alone.[8] The nations and the
corporations were all in Montreal to promote some version of national
pre-eminence or product pre-eminence. They were also on hand to
raise their international stature or to broaden market share, the two
ambitions often amounting to the same thing. It was not a matter of
coincidence that the organizers arranged for the American and Soviet
pavilions to be erected facing each other across a narrow body of water,
or that they should be joined by a bridge, popularly known as 'the hot
line,' that could be crossed only on foot. The organizers of the fair were
cautious, however, about presenting Expo 67 as a place for ideological
competition, just as they shied away from admitting to its status as a
pilgrimage destination for consumers. Instead, they advertised the fair
as a 'symbolic universe.' Attention was focused on the eponymous
human condition, giving rise to the fair's theme, 'Man and His World'
(or 'Terre des Hommes'), tritely adopted from a phrase attributed to the
French writer Antoine de Saint-Exupéry.

Jean-Louis Roux, one of the fair's advisers, was quoted as saying the theme should properly be interpreted to mean 'Man, as opposed to corporations' and 'Man, as opposed to nations.'[9] The contradictions in Roux's statement do not need to be spelled out, though it does seem worth pointing to the fact that Expo 67 was conceived as a centennial celebration of Canadian nationhood. *Amor patriae*: even that nationalist sentiment was full of contradictions, however, for Canadian federalists understood it one way and Quebec sovereigntists another. For the federalists Expo 67 was the coming of age of a united Canada; for the sovereigntists it was proof of Quebec's capacity for independent rule.[10]

II I observed that Newman painted *Voice of Fire* expressly for inclusion in the fair. Early in 1966, the art critic and historian Alan Solomon was commissioned by the United States Information Agency (USIA) to mount an exhibition of contemporary art in the fair's American pavilion, and he selected Newman as one of the artists he wanted to show. Looking for work he categorized as 'broad and simple' in style, Solomon approached twenty-two artists, ranging from Robert Motherwell to Robert Rauschenberg, to Robert Indiana, about participating in an exhibition called *American Painting Now*, and invited them to contribute paintings that were (a) large in scale, and (b) vertical in format.[11] Given Solomon's selection criteria, his choice of Newman is unsurprising.

At the time that Solomon solicited Newman's participation, the USIA had already decided on the form the United States pavilion would take. It would be a geodesic dome, a hexahedron of steel tubing about 200 feet high and 250 feet in diameter, clad in lightweight, transparent acrylic pads, and designed by Buckminster Fuller (fig. 40). By 1964, when Fuller first talked to the USIA about the project, his reputation as an architectural maverick of radical ideas and limited practicability had been established for some time.[12] He designed the first version of his free-standing Dymaxion House in the late 1920s as a mass-reproducible alternative to conventional housing. By the mid-1950s, however, the social ideals of Fuller's Dymaxion world had degenerated into an ethic of consumer efficiency and capricious individualism that is evident in the ditty he composed to be sung to the tune of 'Home on the Range' by students at Yale University:

40 The United States pavilion at Expo 67, designed by Buckminster Fuller.
Photograph from *Architectural Review* 142 (1967)

Roam home to a dome
Where Georgian and Gothic once stood
Now chemical bonds alone guard our blondes
And even the plumbing looks good.[13]

The USIA recognized that Fuller's maverick status as a cranky gen-
ius, cut in the American mould, made him a perfect candidate to design
the United States pavilion. His radicality and his individualism could be
harnessed to support claims of moral superiority for the American way
of life compared with that of the Soviet Union. He could help legitimate
a shift in the U.S. program, away from the presentation of sophisticated
weaponry and household goods exhibited at previous fairs towards an
agglomerated spectacle of art, entertainment, and space technology.
There was a cogent political reason for the shift, for the change in sym-
bols deployed by the USIA at Expo 67. The USIA was determined not
only to score an ideological victory over the Soviet Union, but also to
direct attention away from what was most troubling at the time to the
general populace of the United States – the Vietnam war and social
upheaval in American cities.
 In short, the American strategy at the fair was to submerge Vietnam

beneath a shimmering display of Apollo space paraphernalia and colourful abstract paintings. 'Given world conditions at present,' Solomon wrote, the plan was to 'soft sell America rather than display muscle.'[14] To achieve this end, the USIA allotted 90 per cent of its budget for the pavilion structure and 10 per cent for interior displays. The dome itself would represent the image the United States wished to project at the fair, while the inside exhibits would complement that image.

The strategy succeeded. Almost immediately 'Bucky's Bubble,' as it was called, was taken up as the surrogate symbol for the fair as a whole. It became a prototype structure for subsequent world fairs and theme parks. The decision to place so much emphasis on the building was strongly endorsed by Fuller. 'I told the United States Information Agency in 1964,' he wrote, 'that by 1967 the regard of the rest of the world for the United States would be at its lowest ebb in many decades ... Since each country's world's fair exhibit would be well-published all around the Earth, I felt it was important the United States do something that would tend to regain the spontaneous admiration and confidence of the whole world.'[15] Given the direction the Vietnam war had taken, Fuller was correct in his prediction about the international reputation of the United States when the fair opened. He was also correct in thinking that his geodesic dome would bring the United States 'spontaneous admiration.'

'Bucky's Bubble' chimed perfectly with Marshall McLuhan's epithets of the 1960s about the global village and the medium being the message. It is doubtful, however, that Barnett Newman would have been persuaded by the McLuhanist hype, any more than he would have been persuaded by the engineering feat of the dome. He deeply distrusted, as he once wrote, 'the domination of science over the mind of modern man,' which is to say that he distrusted all forms of scientific instrumentalism.[16] As an anarchist, Newman also distrusted institutionalized power and nationalist breast-beating. His acceptance of Solomon's invitation to exhibit at the fair is therefore puzzling. The artist was notorious for jealously guarding his work against contrary interpretations and unsympathetic installations.[17] Better than most artists, he understood that the environment in which a work of art is seen, particularly an abstract work, plays a large part in determining the discursive meanings that become attached to it.

Newman's motives for choosing to participate were several and

mixed. He undoubtedly thought that official acknowledgment of his work was long past due, especially given the many years during which he had received little recognition at all, regardless of the ideological uses to which his art might be put. Still, it is not clear that Newman realized at the time, or later, the precise implication of his involvement. He visited Montreal while Expo 67 was in progress and, reacting as a touristic *flâneur*, approved of both the fair and the pavilion.[18] He may also have participated because he thought that *Voice of Fire* would stand out strongly in Fuller's spherical space compared with the contributions of the generation of artists behind him, say, Jasper Johns, who specially executed a collaged homage to Fuller, *Map (based on Buckminster Fuller's Dymaxion Projection of the World)*. Like Johns, it is probable that Newman identified with Fuller's quixotic ideas and personality (Newman and Fuller were acquaintances, if not friends).[19] Lastly, Newman knew Solomon, with whom he had worked on a project at the Jewish Museum in New York, and trusted his judgement.[20] None of these reasons, in my view, makes Newman's agreement to participate in *American Painting Now* any less contradictory. At the same time that he was painting *Voice of Fire* in early 1967, for example, he also was work-ing on the sculpture *Broken Obelisk* (1967), that dark meditation upon a failed Western order of civilization, the same failed order that he joined in celebrating at Montreal.

Before the Expo 67 commission, Newman had previously executed four big canvases that measured 8 feet by 18 feet, including *Who's Afraid of Red, Yellow and Blue III?*, all in a horizontal format. *Voice of Fire*, Newman's fifth and last painting of that size, and painted in the same cadmium red and ultramarine blue as *Who's Afraid ...*, was oriented vertically in order to comply with Solomon's instructions.[21] Inside the dome, *Voice of Fire* and most of the other works in Solomon's exhibition were floated against sailcloth panels suspended on stainless steel cables hung from the roof.[22] Keeping them company were an Apollo space capsule, close-up photographs of the moon, three huge red-and-white-striped Apollo parachutes that encircled the paintings, and blow-ups of movie stars (fig. 41). The longest explanatory label anywhere in sight was fewer than fifty words. Because visitors were conducted through the building along a system of steadily moving escalators, from the entrance to the exit, no time was set aside for reading or reflecting upon what it all might be meant to signify. Nor did the organizers wish visi-tors to read; the intention was to provide visitors with an environmental

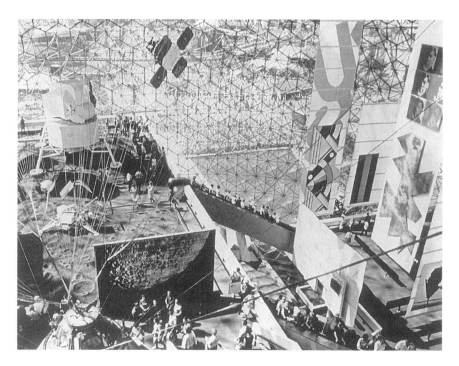

41 Interior of the United States pavilion at Expo 67, with *Voice of Fire* visible to the middle right. Photograph from *American Painting Now*, 1967

gestalt. The watchword of the pavilion's master plan, after all, was not art but 'entertainment.' At the other end of 'the hot line,' meanwhile, the Soviet message was unchanged from that promoted by it at previous fairs. The Soviet pavilion was filled with heavy industrial equipment, and its information booths were packed with earnest educational literature.

There is no doubt which country won the battle of symbols in Montreal. Nor, to my mind, is there any doubt that *Voice of Fire* was trivialized in the process. Whatever Newman wanted to achieve with *Voice of Fire* – in passing, I observe that he had lofty expectations about the power of visual art to communicate moral values, and that he chose an admonitory Old Testament title for the painting[23] – I am certain he did not wish it to function as incidental decoration in a technophiliac dream. But that is precisely how it did function. The dome and its contents struck most fair-goers as the ideal embodiment of a happy, untroubled technological future.[24] 'After the impressive oppressiveness of the U.S.S.R.'s phalanxes of machinery,' wrote Canadian journalist Pierre Berton, 'I found [the United States pavilion] an unexpected delight. I

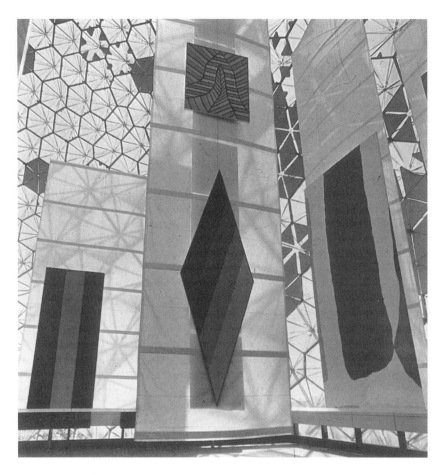

42 Interior of the United States pavilion at Expo 67, with paintings by Barnett Newman, Nicholas Krushenick, Kenneth Noland, and Helen Frankenthaler. Photograph from *American Painting Now*, 1967

mean, one expects places like Jamaica and Trinidad to be gay and frivo-lous: but the United States?'[25] The art critic of the *Montreal Star*, Michael Ballantyne, also found the United States pavilion to be light-hearted, and he liked the paintings on exhibition. 'They hang inside Buckminster Fuller's geodesic dome,' he wrote, 'like heraldic banners of the space age, crying Excelsior!'[26]

Ballantyne got it right, I think. The works in the pavilion did hang like so many banners beneath the dome, no less important than the blow-ups of movie stars and the inflated Apollo parachutes that sur-rounded them – and no more important, either (see fig. 42). In that psychedelic-cybernetic space, *Voice of Fire* was just one more highly coloured commodity clamouring for the attention of viewers who had

43 Installation of *Voice of Fire* at the National Gallery of Canada, with a Tony
Smith sculpture (left) and two other works by Barnett Newman. Photograph
courtesy of the National Gallery of Canada, Ottawa

been launched on an escalator trip from which they could not disem-
bark. Serious thoughts about painting were beside the point in such a
fantasy environment, and so were anxious thoughts about Vietnam.

III When *Voice of Fire* was installed some two
decades later in the newly constructed National Gallery of Canada in
Ottawa, the painting received more conventional museological treat-
ment than it had in Montreal. No escalator ran nearby, and no visitor
was likely to mistake the painting for a banner. Brydon Smith, then
assistant director of the National Gallery, provided *Voice of Fire* with a
wall to itself in one of the largest interior spaces in the building, and
kept its surroundings ruthlessly spare. Only four other works were
admitted into the same area: a Tony Smith sculpture, paintings by
Milton Resnick and Jackson Pollock, and a six-unit plywood piece by
Donald Judd (fig. 43 shows a slightly later installation). Identification
labels were discreetly placed on the door jamb of the entrance to the
room, in order not to detract from the room's spareness. It was a mod-
ernist installation for resolutely modernist objects. In the gallery's
presentation of art after the Second World War, *Voice of Fire* was given
pride of place.

44 'Felix Holtmann has challenged National Gallery on expensive painting,'
Montreal Gazette, 19 April 1990. Photograph by Mike Pinder

At the time of this installation in May 1988, the painting was still on
loan to the National Gallery from the artist's widow, Annalee Newman.
Although there were some scattered comments in the press about the
installation, *Voice of Fire* generated relatively little coverage. Certainly
there was nothing to predict the uproar that would follow the gallery's
announcement nearly two years later, in March 1990, that it had pur-
chased the painting.[27] Even though the gallery included the announce-
ment in an umbrella press release covering all of its purchases for the
previous year, rather than trumpeting the acquisition in a separate
communiqué, the media were onto the story immediately. 'Gallery Pays
$1.8 Million for Fire' headlined the *Globe and Mail* the next day, adding
that the price represented nearly two-thirds of the National Gallery's
annual acquisition budget.[28] Nor were some Conservative politicians,
representing the party in power, slow to voice disapproval. MP Felix
Holtmann (fig. 44), then chair of the House of Commons Standing
Committee on Communications and Culture, told an open-line radio
program in Winnipeg that he had received numerous calls complaining
about public money being spent on a 'costly U.S. painting.' 'I'm not
exactly impressed,' Holtmann added in a sound-bite calculated to make

the evening news: 'It looks like two cans of paint and two rollers and about ten minutes would do the trick.'[29]

After that, *Voice of Fire* remained headline news in Canada for the better part of two months. Most politicians not openly hostile to the purchase, like politicians in the United States not openly hostile to the work of Robert Mapplethorpe or to the National Endowment for the Arts, refrained from commenting on the matter. When they did speak out, it was generally on the negatve side of the debate. Their response helped fuel the wide public backlash against the painting, against the National Gallery for purchasing the painting, and against the government itself for funding the painting's acquisition. Deputy prime minister, Don Mazankowski announced through a spokesperson that a Cabinet committee would examine 'whether the purchase can be stopped ... [because ministers] don't like the way the money was spent.'[30] The wave of criticism directed at the painting and the gallery demonstrated the gulf that had opened up between the cultural norms represented by the gallery and those of the society it served.

I do not want to overemphasize the family resemblance between art controversies in the United States in the early 1990s and the debate over *Voice of Fire* in Canada. There are more differences than there are similarities. Although both involved attacks upon élites with authority in the cultural arena, the Canadian episode also entailed a symbolic lashing-out at things American. It is important to recall that, at the time of the announcement of the purchase in 1990, there was intense political unease in Canada over the recently signed Canada–United States free-trade agreement and what it meant for the Canadian economy, the social safety net, and Canadian culture. There was also unease about Quebec's renewed aspirations for sovereignty and the increasing likelihood of a national rupture, which would result in still more American influence throughout the country.

In such an atmosphere, the announcement that the National Gallery was purchasing an expensive and difficult abstract work by an American artist gave the media and various segments of the Canadian public a target to aim at. In a way, the painting was an unsuspecting participant in a contest over the meaning of political signs in Canada – and, equally, over who had the power to control them. In its defence of the painting and the purchase, it seems to me that the National Gallery misread the signs, just as Newman himself misread the signs of how his

work would be received at Expo 67. The gallery failed to recognize that it had precipitated a debate not only over the merits of a particular painting and its price, but also over the ability of Canadian culture to withstand the dominance of American culture. National identity was at issue. The artists' lobby group CARFAC argued that the gallery should have bought more work by Canadian artists instead of squandering its funds 'to purchase a work by an American artist.'[31] Although the sanctified aura that had surrounded federal government support for the arts since the Second World War as a guarantee of national identity had begun to tarnish, the CARFAC argument still found many adherents.

This is not to deny that other factors were at work in the controversy. The animosity directed at the painting reflected a long-standing popular mistrust of abstract art, in particular its failure to give value for money in terms of skilled labour. A cartoon by Gable on the editorial page of the *Globe and Mail* (see fig. 11), in which an artist is being harangued by his wife for making a career out of painting dots instead of stripes, depends for its humour on this stereotypical perception. (At a more subliminal level, the cartoon also plays upon a second durable stereotype, that of the long-suffering male constantly nagged by his wife.)[32] Both Thierry de Duve and Brydon Smith, in very different ways for their respective essays in this volume, take up the theme of Newman's mastery over his medium. Smith scrutinizes the materials and techniques employed by Newman to make *Voice of Fire*, submitting the canvas to a stroke-by-stroke analysis. He demonstrates that Newman took a craftman's professional care in selecting his paints and applying them, something confirmed by critics admitted to Newman's studio during the artist's lifetime.[33]

Nor is it to deny that similar controversies, also tinged with anti-American sentiment, had previously occurred elsewhere. They had. In 1973, the controversy over the Australian National Gallery's purchase of Jackson Pollock's *Blue Poles* (1953) for $2 million was exacerbated by anti-American feeling, and to a lesser extent so was the Tate Gallery's exhibition of Carl Andre's 'bricks' (*Untitled*, 1965) in 1976.[34] In the terminology of post-colonialist discourse, these two galleries and the National Gallery of Canada stood accused of complicity with the language of the dominant centre, which is to say the language of New York. In Canada, the result of the National Gallery's perceived acquiescence

brought it face to face with an unlikely 'coalition of left-wing anti-Americans and right-wing anti-artists' – two constituencies that normally could be expected to occupy opposite ends of the political spectrum.[35]

The gallery's misunderstanding of the ideological stakes involved in its purchase of *Voice of Fire* was underscored by its public statements about the painting. Its first pronouncement, prepared by Brydon Smith, read as follows: '*Voice of Fire*'s soaring height, strengthened by the deep cadmium-red centre between dark blue sides, is for many visitors an exhilarating affirmation of their being wholly in the world and in a special place where art and architecture complement each other.'[36] Smith might have been better advised to insist on Newman's craftsmanly skills as a painter. By using such an apologia, the gallery suggested that the value of the painting was transcendent, and therefore removed from historical circumstance. In other words, the history of the painting's production and of its exhibition at Expo 67 were incidental to any direct experience of the work, as were Newman's extensive relations with Canadian artists. Little wonder the anti-American contingent responded by asking: affirmation of being wholly in *whose* world? an American world? while the anti-abstraction brigade queried: exhilaration at being in *what* special place? a place where the wall is covered in stripes?

Had the National Gallery read the signs correctly, it might have acknowledged the difficulties that abstract art, especially costly abstract art, habitually poses for viewers. It might also have recognized the need to explain in detail the painting's material relationship to Canada, its indivisible connection with Montreal, thus allowing the conclusion that the acquisition represented a homecoming of sorts for *Voice of Fire*. In turn, this might have encouraged the gallery to emphasize more fully than it did Newman's visit to Saskatchewan in the summer of 1959 (fig. 45) and his impact on the Canadian artists he encountered there when he led the Emma Lake Artists' Workshop, among whom were Ronald Bloore, Roy Kiyooka, and Robert Murray, perhaps even to point out that the experience was an important one for Newman, too. He had never travelled such a long distance from New York City, and imagined himself to be visiting the true 'North.'[37] By the same token, the gallery might have acknowledged the admiration for Newman felt by the *néo-plasticiens* in Montreal, notably Guido Molinari and Claude Tousignant.

45 Barnett Newman on the steps of his cabin, Emma Lake, Saskatchewan, 1959.
Photograph by Annalee Newman

Tousignant has stated that Newman 'was a sort of hero for me because … in the New York School he was the most radical and he kept his ideas.'[38]

This is not to say the gallery would not still have felt heat over the purchase, but I doubt that critics would have been quite so inclined to write, even in jest, that 'gigantic U.S. abstract canvases are raining down on us like cultural ICBMs launched from New York silos.'[39] This comment represents a return of the repressed. What could not be mentioned by the United States at Expo 67, what had to be masked with red-and-white-striped Apollo parachutes and red-and-blue-striped paintings, had come back to haunt Canadians rather than Americans. By refusing to recognize that art is historically contingent, that *Voice of Fire* had a history that involved Canada directly, the National Gallery fanned the flames of Canadian cultural nationalism at a time of political uncertainty – and set itself ablaze. Unwittingly, it followed the example of Buckminster Fuller's geodesic dome in Montreal, which caught fire some years after Expo 67 closed and burned to the ground.

Symposium

In October 1990, six months after the controversy over *Voice of Fire* had subsided, the National Gallery of Canada organized a symposium in Ottawa on the work of Barnett Newman and the disputed painting. It was called 'Other Voices' to indicate that points of view not heard at the time of the controversy would be given a forum. This section presents the proceedings of the symposium, moderated by John O'Brian. They consist of four papers delivered by experts on Newman and a transcription made from audiotapes of an open exchange between the speakers and their audience. In the transcription of the general discussion, an attempt has been made to preserve a sense of the occasion.

SERGE GUILBAUT

Voicing the Fire of the Fierce Father

It is for sure somewhat funny that the same resentment and attacks launched when Barnett Newman had his first show in New York in 1950 were again directed against his work when the purchase of the painting *Voice of Fire* was announced by the National Gallery of Canada in 1990. There is, however, a slight difference. In New York, in 1950, there was a high level of violence directed against the work, surprising as it might seem, by Newman's own peers. Peyton Boswell, editor of *Art Digest*, could not understand why anybody could take such simple works seriously. According to him, Newman's art was merely 'shallow abstract painting with only decorative value.' Barnett Newman, pamphleteer that he was, could not go without responding. He maliciously asked Boswell if, since Boswell liked his work so much, it was not him who had defaced one of the paintings during opening night: 'During the exhibition, one of my pictures was mutilated by someone who smeared some of the area with paint – did you do it?'[1] Boswell's response, typical of the climate in those days, came right back in his next *Art Digest* column: 'I do not make a practice of improving an artist's pictures.'[2]

The strong critique (or total disdain) reserved for Barnett Newman's 1950s work – those large, empty surfaces – can be readily understood. The art public was just then beginning to get the point of Jackson Pollock's busy and overwhelmingly complicated surfaces. It was now suddenly asked to integrate into its value system Barnett Newman's large simple fields of colour punctuated by one or several bars. Even if seemingly empty of complicated formal design, Barnett Newman's pictures were by no means empty of meaning at the time of production. One has simply to recall Newman's desire to produce an art of the sub-lime sized down to human scale; an art concerned with the myth of

origin but told in the present time; an art, not of relation or metaphors but simply of presence, of the presence of man. Meanings were hard to extract, but these images were not blank slates. They are even less so today. The meaning of three bars of colour punctuating a coloured field was directly related at the time to the discourse about abstract painting developed during the late 1940s. Since then, these works have also taken on, like a series of archaeological deposits, the succession of discourses they have generated as well as the multiple uses in which the pictures have been enrolled. Meaning, as we now agree, is multiform, not unique. It is sometimes contradictory, and certainly not concentrated solely in the artist's intention. In 1990, *Voice of Fire* carried in its aura the entire debate around abstract art, postwar international relations, American power, Canada's relationship to modernism, and the issue of centres and margins.

In the voluptuous geodesic dome of the United States pavilion at Montreal's Expo 67, Newman's verticality impregnated the curved space with a political signification that could be felt by many Canadian fair-goers and has recently been analysed by John O'Brian and David Howard.[3] Father Newman's voice in that international environment could not be but thunderous, and his impact could not be, despite his constant reference to freedom, other than authoritative, if not authoritarian. What started in his mind and work as a desire for liberation from society's shackles in the late 1940s became in the 1960s a sign for the power of the United States at a time when 'American freedom' was constantly used as a generic term, thrown in the face of communism along with ultra-modern American kitchens.[4] In Canada and in Europe, the liberating 'zip' in Newman's paintings was, for many, synonymous with the infamous 'big-stick' of past neocolonial times. However, Newman conceived his paintings, not as empty or decorative formal devices, but – through their social and symbolic effect – as active tools of individual liberation at a time of controlling political systems. That is why he could declare in an interview as late as 1962 that 'if he [Harold Rosenberg] and others could read it [his work] properly it would mean the end of all state capitalism and totalitarianism.'[5]

This extraordinary burden put on abstract painting was not merely a quip. In fact, moral and, to some extent, political effects of painting were considered crucial by many artists of that generation. Pollock, Still, and Rothko thought their painted surfaces to be loaded with the sub-

versive negativity secreted by the exalted individualism they embodied. This cult of the individual sprang up in New York in the later years of the war, as fear of anonymity spread in an artistic community threatened by a growing fear of massification. One understands, then, what Barnett Newman saw as the major menace to what had been the base of modern culture: the unfreedom of the individual artist. Newman's anarchism was a strong weapon in the construction of a line of defence against rampantly growing populism at home and communism abroad. But this anarchism was coupled with another preoccupation. Since the war, modernism had been in profound trouble, and was even showing signs of weakness in Paris, where it was born, as Harold Rosenberg explained in his famous 1940 article 'On the Fall of Paris.'[6] In France, even Picasso – the symbol of modernist freedom – seemed to buckle down under communist pressure by participating in a 'peace rally' and in anti-American propaganda, and that at a time when the Communist party had been able to impose a strong showing for new realism into the cultural discourse. These are some of the reasons why Newman and other American abstract artists felt it crucial to rebuild from the ground up the old concept of modernism in their writings and their art during the 1940s.

Barnett Newman's particular solution was discovered in the construction of paintings which would break with the modern tradition of translating the world in plastic terms, a transfer he thought was often too dependent on metaphors and associations. Newman discovered in 1948, while painting *Onement 1*, that it was possible to announce visually the simple individual presence as an instant occurrence without the burden of too much mediation.

This 'presence' was the hopeful sign of a new Western individual constructed by Newman out of two important traditions that he felt were liberating for the new postwar 'Man': the anarchist tradition and Northwest Coast Indian culture. Liberation, he thought, would come from uniting scattered and disparate cultural elements. In times of weakness, modernism had always looked towards other cultures, often colonized ones, to revitalize itself. This time, as the United States seemed to have the only vitality left in the West to continue the anti-authoritarian struggle, the foundation of this revival in Newman's mind had to be American. Pre-Columbian and Amerindian cultures became the inspiring base. Newman's works and texts of these crucial years tend

towards this solution: the creation of a space where the new Western individual could be constructed out of a juxtaposition of anarchist beliefs and Northwest Coast identity in order to transpose to modern times transcendental 'primitive' preoccupations. A strange concoction, only made possible because, as Michael Leja has explained, Barnett Newman constructed his 'primitive man' along the lines of the 'modern man' literature which was so prolific in the 1940s.[7] This literature proposed paradoxically that, on the one hand, the 'primitive' felt awe, terror, and agitation in front of nature and, on the other hand, felt spirituality and community with it. This construction, disregarding and often in complete opposition to the work of specialists like Franz Boas, fulfilled an important role in a period of destabilization. To quote Leja: 'the Primitive was needed as a form, a container, for conceiving the irrational, the barbaric, the evil of which modern man was showing himself capable.'[8] Newman was then able to superimpose unproblematically his contemporary program and desires on top of the available primitive body, legitimating his own opposition to the social system in which he lived.

The art of the Northwest Coast Indian, and the totem pole in particular, became the vehicle for his own art production. The presentation of this culture in his writings was to a large extent a phantasm, in that he located the importance of 'profound art' in men, against the superficiality of decorative art produced by women. Since these statements were made as if differences were natural, an air of inevitability permeated them: 'The abstract shape he [the Kwakiutl] used, his entire plastic language, was directed by a ritualistic will toward metaphysical understanding. The everyday realities he left to the toymakers; the pleasant play of nonobjective pattern, to the women basket weavers.'[9] There is a certain amount of irony in this statement, as one quickly realizes that Newman, in his attempt to root his new art away from European models, in fact utilizes gendered concepts that go back as far as Sixteenth-century Spanish literary critics. He repeats, in particular, the division they made between the epic (male, gravity) and the lyric (female, delightfulness, ornament and decoration). Old European concepts were thus overlaid onto the 'other' in order to use the other's symbolic contemporary freshness, and this constructed authenticity was then – in a full-circle arrangement – directed against Europe itself. The American artist, impregnated with symbolic content, could grapple with these

new and dangerous times in a way that pleasant abstract decorators – like Parisian painters – could not. Or so Newman believed. This is why he was so devastated by the 1950 criticism by Boswell, who, in seeing Newman's work as only decorative, could not have more fully misread Newman's intentions.

Newman's concept of male presence was part and parcel of a type of ideology very much in the making during the postwar era, when the United States was in the process of revirilizing itself in order to be ready for the 'soon to come' anti-communist war. This was a time when women, as Elaine Tyler May has pointed out, after their accidental emancipation during the war, were recorralled into their renovated suburban kitchens by a society bounded by the ideologies of the Cold War and containment at home as much as by foreign policy abroad.

Symbols of sexual containment proliferated during these years. Even the fashions reflected this image. Gone was the look of boyish freedom that characterized the flapper of the 1920s and the shoulder-padded styles evoking strength of the 1930s and early 1940s. In the late 1940s and 1950s, quasi-Victorian long wide skirts, crinolines and frills were back, along with exaggerated bustlines and curves that created the aura of untouch-able eroticism ... The body itself was protected in a fortress of undergarment, warding off sexual contact but promising erotic excitement in the marital bed.[10]

Newman's *Abraham* (1949), with its powerful verticality and deep blackness slowly vibrating on a quiet ground, encapsulated a gender division that is symbolized by its contrast to the new American kitchen, which kept women in their pastel-coloured cooking environments, away from the harsh philosophical colours of the avant-garde artist – a division Newman fantasized and saw in Northwest Coast Indian cultures.

What the Kwakiutl artist gave to Newman was the important image of the 'myth-maker,' the individual who, confronted by chaos and fear, was nevertheless able to present an idea-concept directly, profoundly, and strikingly. The Indian carver seemed to be the perfect carrier of modern virility, as he was able to transform, through the carving of tree trunks (nature, the forest) into beautiful cultural artefacts (totem poles and masks). That is why I think one can say that the 'zip' in the early vertical pictures played a role similar to totem poles in Newman's mind. Not, of course, that they were representations of totems, but rather

ideas of the mediation which occurs in the totem between the land and the metaphysical sphere of the sky. The 'power' assigned to poles by Native cultures was redirected by Newman from family and social lineage to the private and the individual. I said 'earlier' pictures because I think that, in the initial series of vertical pictures painted in 1947–9, there is the production of an authority that the later horizontal works – with their implied lateral reading – lack.[11] In the earlier works, Newman emphasized authority by keeping the viewer close to the surface in order to feel the awe of the 'zip.' Domination is what Newman was against, but he was not against power *per se*. Through the verticality of the bar, he hoped to empower 'Man' to stand up. These paintings were successful in producing a picture able to speak directly to the spectator without the help of a third person, and successful also in giving, as Barnett Newman said, a 'place to the beholder' (fig. 46). But what I am not sure about is what kind of place this was. In the end it might not be a place as liberating as the one occupied by the painter, because here the viewer is confronted with a declarative ground, without the doubt that could be found, for example, in the tortured texture of a Clyfford Still or in the problematic but nevertheless materialistic questioning of figuration in Pollock's abstractions.

If, indeed, Pollock deals, like Newman, with the fear of chaos (as François Lyotard has aptly said, Newman's art is the production of presence against absence), Pollock, while rejecting chaos, does not want to impose symmetry or anything else on the viewer. He chooses instead to present the mechanism of his modernist struggle with con-cepts of figuration. Newman, in contrast, imposes calm and rhythms from above in a powerful streak of sublime light which literally strikes the viewer. The artist does not interpret because, like God, he creates.[12]

This is the reason why, even late in his career, Newman still wanted to highlight the textured quality of his paintings. He always wanted people to realize that his surfaces were not stained (as Greenberg mis-takenly said once),[13] but that the paint quality was 'heavy, solid, direct, the opposite of a stain.' This, of course, differentiated his work from Rothko's, but, more to the point, it announced a virility which pro-foundly despised a technique of such soft handling as staining. Texture had been an old interest of Newman's, as he had already explained in the 'Plasmic Image' text of 1945: 'More characteristic of the primitive concept of beauty are the wood carvings, the totem pole sculpture of

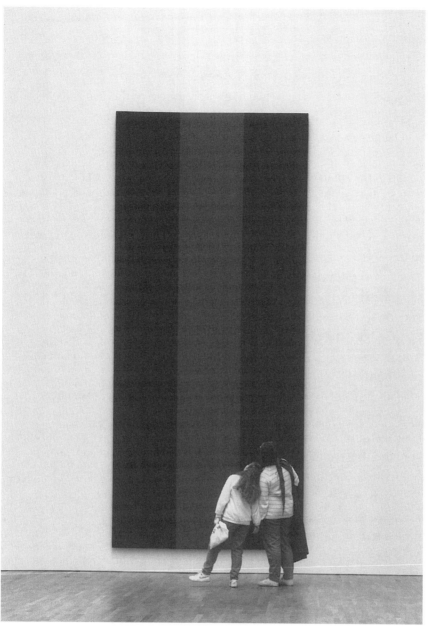

46 *Voice of Fire* being looked at by two spectators. Photograph courtesy of the National Gallery of Canada

the Northwest Coast Indian, where the mark of the adze is evident. It can be said safely that the high finish, the polished surface of Negro sculpture reduces its heroic character.'[14] It was becoming clear in Newman's mind – and this was thinly coded in the text – that Parisian

art associated with African colonial influences (smooth masks) would be incapable of attaining the 'heroic character' so desperately needed in this new world order. Newman, thanks to his American Native link, could clearly relate to this heroic dimension of Northwest Coast culture. The traditional division between the roughness of the 'primitive' against academic suave surfaces still had beautiful days ahead.

Despite the fact that the well-known work of Franz Boas and James George Frazer was actually contradicting many of his ideas, Newman's construction played an important role in the definition of an advanced avant-garde art production in the United States.[15] The mixture of virility and abstract conceptualization of 'primitive' metaphysics played an important part in the redefinition of American modernism. This seems to have been essential and workable in the redefinition of modern American cultural identity because, on the one hand, this division separated popular culture/kitsch from high-art modernist production and, on the other hand, it proposed a strong, virile model capable of fighting back the international communist hydra at a time when America was said to be endangered by people who were 'too soft on communism.'

This position becomes even more problematic, or rather becomes more complicated and more tied to historical and geographical circumstances, when one realizes that other possibilities were available for constructing contemporary culture. Another voice was coming from France that was literally worlds apart from Newman's practice. If Newman's voice was thunderous, Bram Van Velde's was a whisper, sensitive to the dangers of cultural and gender exploitations, determined to avoid any triumphalism, aware that a mindset such as Newman's had often led to barbarism. What Van Velde had learned in the late 1930s during his relationship with the radical ethnographer Marthe Arnaud, who became his wife, was that many of Matisse's and Picasso's images were inappropriate in their exploitation of Native cultures through exoticization. Marthe Arnaud, working as a missionary in Africa in the 1930s, came to recognize there the cultural and social abandonment of the people she was supposed to help. Back in France she wrote a book called *Manières de Blanc* in which she poignantly described her experience and the cultural exploitation she encountered in Africa.

Bram Van Velde's paintings and gouaches are informed by all this

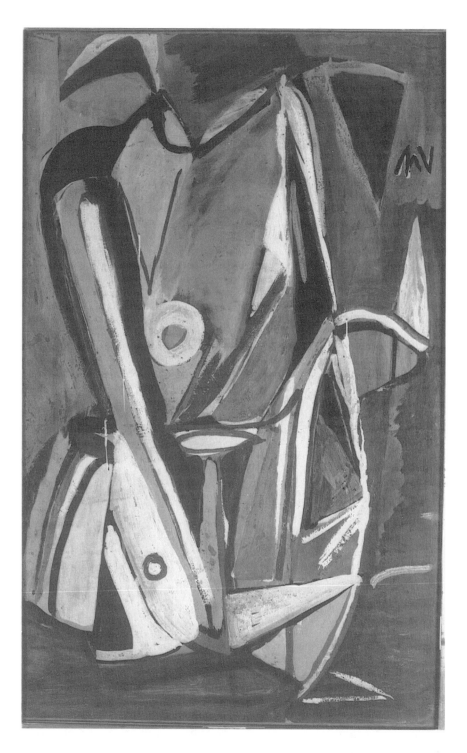

47 Bram Van Velde, *Untitled (Montrouge)*, 1946–8. Gouache, 116 × 73 cm.
Private collection. Photograph courtesy of the Centre Pompidou, Paris

(fig. 47). They make a direct critique of Matisse's exoticism, and of Picasso's manipulation of African artefacts, by reminding us that Native artefacts could indeed be powerful, as these images recall some of our fears – Van Velde had learned this from surrealism – but they could no longer be used as stereotyped representations of Native vitality, sensuality, or power. In the chaotic sea of signs constituting his painted surfaces, Kwakiutl masks, reworked through Picassoesque shapes, arise in our memory. They are, however, unable to firmly establish their presence. Their cultural memory is treated as a passing ghost. What is interesting is that Van Velde denies their presence as traditional 'Native artefacts' but lets them peek through the modernist structure in a nostalgic but nevertheless negative gesture towards Picasso – a nostalgia which, in its ephemeral appearance and impact, signifies the impossible return of past certitudes and usages. Bram Van Velde, in these pictures, was in fact rebelling against the two pillars of Parisian tradition and success, Matisse and Picasso, and in particular against their use – direct and indirect – of exotic clichés. In Van Velde's works produced between 1948 and 1952, masks, mythical bird beaks, and totempole figures, because of their loose, unfinished construction, seem to glide through the surfaces of paintings, robbing the viewer of the pleasure of recognizing and projecting fantasies onto them. By appearing and often dissolving simultaneously into signs attached to Van Velde's individuality (his initials look very much like a Matisse signature upside down), the flickering apparitions act as a cipher of revolt against exploitation, against misery perpetrated against the other, and consequently also against Bram Van Velde himself, as he considered himself – and he was – totally marginalized (a kind of modern savage, as he used to put it). His outsider position in Paris after the war was similar to that of Newman, but the comparison stops there. Bram Van Velde's interest in Northwest Coast Indian art was not based on an attempt to revitalize French culture, or to produce a heroic individualism. His modernist production was one of despair confronted with the impossibility of recapturing the past, or even of moving ahead. The end of the war and the beginning of the Cold War and the politicization of culture pushed him more and more into an alienated space from which he could – through his pictures – only whisper that he was still breathing, alive but without arrogant desire.

Several intellectuals in Paris, confronted with the Manichean Cold

War debate, decided that a position of withdrawal was better than participating in the political and aesthetic debate because the terrain was booby-trapped. That is why Van Velde continuously stated that he refused to be either master or slave, preferring to be 'a martyr rather than an executioner,' suffering in the solitude of everyday life. This attitude had in fact been theorized in the late 1930s by Georges Bataille as a viable personal political and ethical position.

We witness in Paris during the very late 1930s and through the 1940s, after so many political disillusionments, the development of an activist Cold War thought; it entailed a type of individual revolt, but a cautious one, detached from active political involvement. After the war, Bataille represented well the shift which occurred among Parisian intellectuals between the kind of desperate engagement that was characteristic of the 1930s and the new desperate withdrawal of the postwar period. Bataille, confronted with a chaotic cultural landscape, felt that 'the temptation of inertia had some fascinating qualities.' Thinking was now not an alternative to action but a brake, a lucid type of paralysis, an enlightened silence. He resigned himself to informed inaction. Bram Van Velde's position follows this same kind of existential impossibility. His public failure, his anonymity, his invisibility, and his distress, fuelled endlessly his desire for painting images born out of his catastrophic life. Newman, while also claiming to take an isolated stand, was more aggressive and confident.

In the end what is fascinating is the fact that both artists, Newman and Van Velde, despite their very different outlooks on modernity and virility, had somehow a similar fate. Barnett Newman initially could not make his radical aesthetic understood, either by his friends or by the public. The public was at first not receptive to this type of naked will, as if, having struggled for so long to understand and accept the anxiety and negativity of the drip, it was not ready to jump into the overtly positive 'zip.'

And so it was with Bram Van Velde's initial efforts. Van Velde went unrecognized in Paris as he visually deconstructed the qualities of the School of Paris at a time when the establishment desperately needed a positive and nostalgic image of itself to conform to a period of physical and moral reconstruction. Van Velde triumphed only after 1959, when he became for the public the opposite of what he intended to be: a gestural abstract painter. Commercial success came to Newman also at

the time when his virile assertive art was seen as symbolizing another 'age,' as the critic/painter Hubert Crehan said in one of his reviews: 'Newman believes in a masculine environment, and he gets this idea across in his paintings which seem to me the apogee of a he-man cult ... It is a proud and inflexible archaic, male sensibility that Newman expresses, lifted from the Old Testament. But we live in another world, really, one certainly that is in need of the phallic charge, although the new man, I imagine, will be aware that we should have more music with the dancing. It takes two to tango.'[16] Was it the femininity of pop culture which Crehan was referring to? In any case, Van Velde in Paris, reminiscing about Northwest Coast cultures, did construct them differently than Newman did. They were seen, as a text from his friend Georges Duthuit makes clear in 1946, as representing, not a heroic people carving beautiful objects, but rather a tragic group of people trying to survive amidst terrible political and social difficulties. They were a good example to reminisce about in order to understand the fate of Western culture in the midst of this dangerous and destructive moment. As André Breton wrote in *Arcane 17*, while the war was raging and he was in North America: 'Artists should definitively be suspicious of destructive male culture and replace it as soon as possible by female culture in order to avoid a global disaster. Time has come to promote women's ideas rather than the totally bankrupt ones of men. It is the artist who should, in particular, only if as in protest, promote female systems of ideas.'[17] Some, like Samuel Beckett and Bram Van Velde, seemed to agree with this statement; the postwar era in France was not sympathetic to virile utopian plans of the sort concocted during the 1930s. Painting no longer seemed capable of participating in the large utopian social experiments. Some painters thought that it was more crucial to be humble, see smaller, accept one's impotence in order to save a spark of individuality, that individuality threatened by so much contemporary ideological righteousness. Beckett finally was able to express this fear in a short but brilliant parable which went like this:

The Client: God made the world in 6 days, and you, you are not even capable of making me a pair of trousers in 6 months?

The Tailor: But, sir, look at the world, and ... look at your trousers.[18]

What Beckett and Van Velde declared was that God's great schemes and positive projects were pathetically unfinished, overrated, and even dangerous. If Barnett Newman, as creator of presence, seems to play God, Van Velde and Beckett preferred to criticize the absurdity of this project and to place emphasis on the potential exploitiveness of such a position.

The fact that Newman was not recognized-discussed-sold or heroized until the late 1950s may mean that the 'zip' was seen to be too essentialist at a time when liberal society, anxious about its force and direction during the Cold War, could only recognize itself in the existential drip. In the late 1950s and 1960s, when America was more powerful than ever, immensely rich and self-satisfied, anxiety was no longer the mood of the day. Then Clement Greenberg discovered colours, veils, hedonism and ... Barnett Newman. Assurances and not anxieties were needed to represent American strength (Pop Art was there to show the joy of living in consumerist America). It was then appropriate for the United States to send *Voice of Fire* as the Voice of America to the world's fair in Montreal. That is why, in fact, this image is important, not only for its place in art history, not only for what Newman tried to do, not only because Minimalist artists tried to recuperate the form without the soul of Newman's art, not only because the painting looks gorgeous, not only because, last year, it gave some farmers in the prairies the desire to become painters for a day, not only because I like or dislike it, but also because *Voice of Fire*'s aesthetic reductiveness incorporates a myriad of meanings, because it has played a part in producing our history and our past, and because in the end it helps us (I am thinking of the way the painting was displayed in Montreal) to remember what our southern neighbours have been telling us: that their voice can always be heard here, and that when it is a voice of fire we cannot do anything but melt.

NICOLE DUBREUIL-BLONDIN

Tightrope Metaphysics

Barnett Newman's position in the art of this century seems important to us because it carries to an extreme degree of tension one of the dominant and paradoxical traits of modernism: the conviction that art can communicate ineffable meanings and acquire critical relevance by returning to the limiting conditions of its own existence. That is what is meant here by 'tightrope metaphysics.' Stretched between the imperative of making sense and the radical hermeticism of its formal means, the work becomes committed to an aesthetic of vacillation, making it extremely vulnerable to the specific context of its appearance and its reception.

A Symptomatic Quarrel Between April and September 1961, the letters to the editor section of *Art News* was the scene of a quarrel by correspondence between Professor Erwin Panofsky, the eminent art historian at Princeton's Institute for Advanced Studies, and artist Barnett Newman, a well-known figure in New York's avant-garde art world.[1] The fact that this duel has gone down in history owes a great deal to the fame of the belligerents. But its prime importance is its symptomatic value: it reveals the crisis of meaning brought to a head by modern art in general, and the work of Barnett Newman in particular.

The specific subject they quarrelled over takes us far from art, into the caprices of Latin grammar. Panofsky noted that the title of a painting by Barnett Newman reproduced in the journal was incorrect. This was the celebrated *Vir Heroicus Sublimis* of 1950–1 (fig. 48), illustrating the no-less-famous article by Robert Rosenblum on the American abstract sublime,[2] the last word of which had been transformed by a

48 Barnett Newman, *Vir Heroicus Sublimis*, 1950–1. Oil on canvas, 242.2 × 513.6 cm. The Museum of Modern Art, New York. Gift of Mr and Mrs Ben Heller. Photograph © 1994 The Museum of Modern Art

typographical error into *Sublimus*. Panofsky suspected that the incorrect title was indicative of a more serious problem, one which he felt entitled to point out. 'I find it increasingly hard to keep up with contemporary art,' he wrote, 'particularly with the titles affixed to some of the objects.'[3] The word 'objects' seems to be very revealing when used by one of the fathers of art history. In developing his studies of iconography and iconology, Panofsky was interested in the way a work of art elaborates its meanings. Not only did he devise the most prestigious and widely used method in the field, he also provided some of its most brilliant applications. So, when Panofsky states that contemporary art produces 'objects,' he undoubtedly judges them to be suffering a lack of meaning that the pretension of the titles is intended to mask. Perhaps, the author of the letter suggests ironically, Mr Newman is above grammar, like God, according to a definition given by the monk Aelfric in the Middle Ages?[4]

The artist Barnett Newman enjoyed a good fight. In fact, in the early 1960s, he was better known and appreciated for his polemics than for his painting.[5] That is why, in addition to arguing in favour of the legitimacy of *Sublimus*, he attacked Panofsky's aesthetic blindness: 'As for the matter of Aelfric, the tenth-century monk had a greater sensitivity for the meaning of the act of creation than does Panofsky. One would think that by now Prof. Panofsky would know the basic fact about a work of art, that for a work of art to be a work of art, it must rise above grammar

and syntax – pro gloria Dei.'[6] It is nevertheless with respect to the grammar and syntax of a work that its meanings should be defined, and that is just where Newman's paintings seemed to present problems for the humanist historian. The artist, in effect, has made a deliberate commitment to an aesthetic of all or nothing, the consequence of which is to make meaning the problem, rather than providing specific meanings for deciphering.

The Search for the Subject
For the first generation of the New York School, to which Newman belonged, painting could not be imagined outside its ability to portray a great subject. On 7 June 1943, artists Mark Rothko and Adolph Gottlieb, supported and advised by Newman, sent the *New York Times* a letter that was equivalent to a program, responding to the suspicions of hermeticism floating over the group. It contained this significant statement: 'There is no such thing as good painting about nothing. We assert that the subject is crucial and only that subject matter is valid which is tragic and timeless.'[7] The question resurfaced in the fall of 1948, when David Hare, Robert Motherwell, Clyfford Still, William Baziotes, Newman, and Rothko set up a small cooperative academy in a warehouse on 8th Street. The school's name was 'Subjects of the Artists' and its prospectus defined it as 'a spontaneous investigation into the subjects of the modern artist – what his subjects are, how they are arrived at, methods of inspiration and transformation, moral attitudes, possibilities for further explorations, what is being done now and what might be done, and so on.'[8] The desire to link the value of art to the quest for a great subject extends a well-established tradition in Western painting, one which was not disavowed by pioneers of abstraction like Kandinsky, Malevich, and Mondrian in the need to justify the abandonment of representation in painting by the pursuit of an ambitious spiritual undertaking. What has changed since the advent of modernism is the dependency that associates painting the great subject with the conventions of the noble genres of history painting and religious painting. The rejection of figurative painting made the old categories obsolete, the opacification of the form (signifier) resulting in a kind of openness to the freer circulation of meanings (signified).

Thus we see develop within the New York avant-garde a tremendous network of references that expresses the convictions of a whole era. The

fabulous and the mythical, the primitive and the symbolic appear on the horizon of the new painting. The thematic range has a strong touch of Surrealism, which served as catalyst for this whole generation, allowing it to remove a double stranglehold: that of figurative art with a regionalist flavour and that of a purist geometric abstraction. The group of themes aspires to a form of universal, transhistorical meaning to which the forces of the individual and the collective unconscious would allow access. Art leads simultaneously to metaphysical concerns, which a sampling from postwar philosophy marked with the seal of anxiety. In 1943, Rothko said on the radio: 'Our presentation of these myths ... must be in our own terms, which are at once more primitive and more modern than the myths themselves – more primitive because we seek the primeval and atavistic roots of the idea rather than their graceful classical version: more modern than the myths themselves because we must redescribe their implications through our own experience.'[9] Newman associated himself with the same line of thought. A text from 1945 entitled 'The New Sense of Fate' contains this reflection, which reformulates the existential question in contemporary terms: 'The war, as the Surrealists predicted, has robbed us of our hidden terror, as terror can only exist if the forces of tragedy are unknown. We know now the terror to expect. Hiroshima showed it to us.'[10]

To reach his subject, in which the sense of the tragic is combined with an aspiration for the sublime,[11] Newman must distil his substantial cultural background, ranging from science (the artist was interested in life-related fields like botany and ornithology) and philosophy (he greatly admired John Dewey before turning to Sartre and Spinoza), anthropology (American Indian culture fascinated him), and religion (he was strongly influenced by Jewish mysticism and the Cabbala, combined with an occasional Christian reference). As a result, Newman's subject often proves to be synchretic in nature and, although founded on a basis that is both broader and more personal, it recalls the role that theosophy (a sort of ready-made synchretism) played for the first abstract painters.

The subject to which Newman aspired found its written formulation just before he created the paintings in which he reached artistic maturity and discovered his image. The important texts, which define the major features of his aesthetic, date back to the 1940s,[12] when the artists of the New York School still grazed in the vegeto-viscero-sexual pastures

of Surrealism and were not completely free from the representation of myth. Newman's subject appears to us to be a kind of moral program, by which his later output would be defined. For the artist, who belongs to the generation of the Action Painters, the true content of a work can only be affirmed in the confrontation with the blank canvas.[13] It is a revelation linked to the act of painting, which constitutes another way of distinguishing the practice of these artists from that of the pioneers of abstraction. It is true that Barnett Newman did not choose an approach based on gesture, like Pollock or de Kooning, whose paintings look like the arena of a muscular battle. Instead, he is the champion of an idea given form or, to use his own words, 'plasmic' art: art linking *plastic* (or form-giving) to the concept, which he calls mental *plasma*.[14]

Grammar and Syntax: An Intractable Form

From the perspective of Panofsky's kind of art history, the subject envisaged by Newman can be considered based on the iconological level of the image, the level of meaning that reflects the deep symbolic values of a culture and society.[15] Newman's painting would thus be the expression of the postwar *Weltanschauung*, an anguished questioning provoked by the mystery of human fate. According to Panofsky, this register was usually not known to the artist himself. We may therefore assume that, if Newman shows himself to be explicit about the iconological scope of his work, it is because he has just short-circuited the first two levels of Panofsky's system, the pre-iconographic and the iconographic reference, where the primary or natural subject is formulated first and the secondary or conventional subject of the work afterward.

At the source of the whole interpretative process, Panofsky places the motif ('certain configurations of line and color'), which must be recognized as the representation of natural objects (human beings, animals, plants, etc.) if the real iconographic level is to be reached.[16] Newman, for his part, will keep to 'certain configurations of line and color' which not only do not constitute a natural motif but require minimal mechanisms of existence and articulation. Abstract painting had long kept its distance from traditional representation, avoiding the worldly referent and immediately recognizable objects. That does not necessarily mean that it had severed any connection with the structure of figurative images. While the 'configurations of line and color' in

Kandinsky's paintings do not always have an assignable identity, they nevertheless constitute distinct units, able to become alive in the fictive space of the painting. The eschatological dimension of the first abstractions done in Murnau is based on this capacity of the pictorial elements to enter into conflict or to form cores of energy in a kind of turbulent landscape deployed beyond the picture plane.

Newman, on the other hand, tried to neutralize the motif or, at the very least, to keep it at its lowest level of existence and visibility. It becomes virtually impossible to make it the anchor point of meaning in the way that Panofsky intends it to be. Newman's paintings subsume the dichotomy on which they are based in an effect of totality: they consist of fields with divisions, 'zips' in the artist's vocabulary, meaning that the breaks are essentially there to serve the field. The 'zips' specify the surface and animate it, suffusing it with greater intensity: a surface which the bands make present. It is all based on a redefinition of drawing in which Newman is in the process of reversing conventional roles. In classical drawing, the line defines a silhouette, causes a volume to be felt or a perspective to be opened. The principal function of the drawing in Newman's work is to turn the picture plane into surface colour, according to the inflections induced by the 'zips.' What the artist seeks is to create a unitary image, a chromatic all-over, in response to the linear all-over of Pollock, who sought to free painting from the figure–background opposition and dramatic composition.

This would happen with *Onement*, the small painting done in 1948 in which the artist felt he had found his way. The Newman image comes from raising to the vertical the horizon line of the allusive landscapes he traced by semi-automatic writing and which featured biomorphous elements playing at the origins of life in a scarcely hinted setting, a sort of inner panorama (inscape) rather than a piece of nature (landscape). *Onement* simultaneously does away with both the stage and the actors. It reverses the order of the world, taking refuge in the absolute of art. This leaving of a universe of symbolic figuration and moving to an unbounded pictorialness occupied Newman's whole generation. Some, like Pollock, drowned it in the splattering. Closer to Newman's solution, Still and Rothko also looked for a unified chromatic field which avoids the dissociation of the figure and the background. Areas of colour entwined or merged with one another are used to establish the painting as a surface able to generate purely optical situations.

These artists felt they could achieve the total liberation of a medium that would nevertheless not sacrifice anything of its ability to communicate. The old ideology of *mimesis*, which legitimated painting as a transparency to the world, had given way to a new chimera, pursued by the romantics and numerous modernists ever since, who want to make of art a forum for dialogue from soul to soul, from sensibility to sensibility. The risks taken with grammar and syntax are intended to allow the circulation of the most ineffable meanings, as if the investment on the surface imposed a greater value in depth.

Voice of Fire: Meaning as Problem

This, then, is the paradox of Newman's work, which the painting *Voice of Fire*, shown for the first time at Expo 67 in Montreal[17] and later acquired by the National Gallery of Canada in Ottawa, well exemplifies. Before discussing the special features of these two contexts of presentation, we should first acknowledge that *Voice of Fire* clearly reproduces this tension that is specific to all of Newman's work, the tension between the suggestive force of the subject and the formal reticence of the painted motif. A first insight into Newman's subject is given by the connotations of the title, whose biblical allusion (it suggests the voice of Jehovah from the burning bush) is made poetically in order to rid itself of anecdote.[18]

That, a few years earlier, Panofsky had stumbled over the formulation of a title rather than the composition of a painting is not surprising. The consequence of Newman's aesthetic choices is to exert exceptional pressure on that 'parergonal' element, somewhat uncertain in status, the title of a painting.[19] The artist frequently uses suggestive titles, which he sometimes even completes with subtitles (*Shining Forth*, 1961, bears the dedication 'to George,' a reference to the artist's brother, who had died shortly before) or accompanying texts (*The Stations of the Cross: Lema Sabachtani*, done between 1958 and 1966, were exhibited with a commentary by Newman on the modern meaning of the Passion). It was by creating a summary typology of the painter's titles that critic Harold Rosenberg was able to analyse the components of an imagination devoted to exploring the heroic (*Ulysses*, 1952), the cosmic (*Pagan Void*, 1946), the mythic (*Dyonisius*, 1949), and the primitive (*Day One*, 1951–2). Newman's subject, aspiring to raise itself to the level of the great existential questions, breaks away from the specifics of particular situations by means of the artist's recurrent use of certain words

in many titles throughout his work. *The Voice*, (1950), *White Fire I* (1954), and *Black Fire I* (1961) already announce the themes of *Voice of Fire*.[20]

Once the referential aura of the title has been established, what is left for the viewer to allow him to experience the subject of the painting? A certain configuration of line and colour, in Panofsky's words, arranged in an unusual format, even for those long familiar with modernist extravaganzas. Newman's exegetes have recognized in the dimensions of *Voice of Fire* (nearly 18 feet high) a symbolic number from Hebraic tradition the painter was fond of.[21] Actually, the Ottawa painting has almost exactly the same dimensions as *Vir Heroicus Sublimis*, but reversed, thus replacing the experience of breadth or passage with one of height or elevation. Newman here maintains the old custom of linking a large format with an important subject, even if what the work presents is radically different from the narrative conventions of academic painting and composition, in the classical sense of the word.[22] The imposing deployment of surface that *Voice of Fire* constitutes is not really subject to the usual principles of control, that hierarchy-creating scansion or rhythmic harmony used by easel painting until Mondrian. A sense of the arbitrary and a call to transcendence result from the unusual manipulation of scale that causes the spectator to lose his bearings.

The form of address that *Voice of Fire* introduces can be described, besides the question of dimensions, by the extreme frontalization of the image. The saturation of the fields of colour and their symmetrical distribution (a central red zone flanked by a blue of great density) create the effect of presence perhaps equivalent to a kind of dialogue: I and Thou, placed opposite each other, as in the relationship of the believer with the saints of images. The tripartite division of the surface, a principle of summary organization that Newman was particularly fond of during the period in which he painted *Voice of Fire* (it is also found in *Profile of Light* and *Now II* from 1967), evokes the triptych composition of old church paintings. Newman, who deliberately chose the ascetic path, gives us a kind of icon without iconography, an aid to pure meditation.

This is no doubt why, in their effort to elicit a reluctant meaning, Newman's interpreters have often hunted for the figure hidden 'under' the painting, preventing the unitary functioning of the surface, reifying the band of colour as motif (in *Voice of Fire*, this would be the immense

red flow metaphorized by the title) and releasing the spiritual message. The 'zip' then becomes a kind of archetype, a figure of the sacred, the transcendental presence in the burning bush, but also a figure of immanence, that of the upright man (*vir erectus sublimis*), facing his fate alone, whether as a biblical prophet or a witness to Hiroshima, the disenchanted and emaciated *kouros* who is not very comfortable here on Earth.[23] Newman himself sometimes induces this type of reading by giving way to a kind of need for symbolization. On several occasions, in his sculptures particularly, he treats the band as figure, setting it up on a mound (*Here I*, 1950) or arranging a base for it that serves as a site (*Here II*, 1965).

Turning the figure into a metaphor results in making a metaphor of the background. It takes only a little imagination to see arising from the original emptiness and chaos – unless they are post-atomic – the flash of the 'zip' that will organize them. After God and the Abraham of the Book of Yetsirah, Newman seems to have the power to understand the system of things by measurement and combination.[24] More generally, the artist's works can appear to us to be exercises in high morality, beacons illuminating the dark postwar world. There is conviction and obstinacy in the risk of repeating these senseless gestures instead of painting beautiful pictures or more easily understood pictures. Surely an artist with the courage to make such renunciations or such new beginnings has a message for his contemporaries.

Why, then, do some think that Newman has produced only 'objects,' from an art historian like Erwin Panofsky, who does not recognize the signs of significant practice in the abstraction, to artist Donald Judd, who believes himself authorized by Newman's approach to announce that painting is exhausted and to throw himself into the production of 'specific objects'?[25] Still others, including critic Dore Ashton, are not convinced that the subject developed by the artist's writings (we would add the diffuse resonance of this subject in the titles of the paintings) is felt in the experience of the work.[26]

Whether he was the last of the spiritualist abstract painters or the first minimalist artist, Barnett Newman was at a kind of historical turning-point, an artist whose interest and strength come from the tension that forced it. Those who look at Newman feel that they, like the creator facing the enigma of his canvas, are being asked to redo an exercise in which their understanding of the painting is closely linked to

a form of self-reflection and thought about their deepest expectations from art. The result is a kind of aesthetics of uncertainty and vacillation, which may be partly responsible for the scandalous effect that the work of the American painter still creates.[27] It is the whole question of meaning, it is meaning as a question that is asked in the radical abstraction of Newman's paintings. Obviously, this is no small subject!

The Place of Meaning According to Barnett

Newman, an artist paints to have something to look at.[28] However, his paintings were not designed as simple alternative images for contemplation. They were also intended to open up a space where one could encounter the unsayable and the unrepresentable – hence, the importance of the large format, enabling them to constitute a kind of place for experience outside the spaces of ordinary experience (i.e., utopian in its fullest sense). Newman discussed his intentions in an interview with David Sylvester in 1965. Each of his works was trying to make clear to a person 'that he knows he's there, so he's aware of himself. In that sense he relates to me when I made the painting because in that sense I was there To me, the sense of place not only has a mystery but has that sense of metaphysical fact ...'[29] Newman's concept of place is thus a substitute for real historic sites (Golgotha, the Miaimisburg mound)[30] or imaginary ones (the burning bush, the throne of Yahweh),[31] loaded with symbolic connotations and suitable for the emergence of the sublime. The use of a deictic vocabulary reflecting topography is striking, especially the use of the word 'Here' in the titles of his paintings and sculptures (*Here I*, 1950; *Right Here*, 1954; *Not There – Here*, 1962; *Here II*, 1965; *Here III*, 1966).

Critics writing on Newman, from Thomas B. Hess to Carter Ratcliff, have recognized a more specifically contextual dimension in this sense of place, one that may also evoke for the artist the New York situation and the American experience in general.[32] Ratcliff sees Newman's originality in the radical way in which he expresses this identity, using a kind of non-compositional method where control of scale is lost:[33] 'Newman's canvases encourage us to see far beyond art, to the place where 'absolute emotions' sustain a politics of the self in absolutist American style.'[34] Here again, there is a purely aesthetic relationship that acts as a model in relation to the real place. The presence of *Voice of Fire* at the United States pavilion at Expo 67 seems particularly worth investigating here, since for once it reverses the terms of the problem: it

implies creating a real situation in a place where the symbolic and political are inextricably linked. Even if Newman's painting was not done for the event,[35] it is clear why it seemed completely appropriate for the gigantic glass bubble formed by Buckminister Fuller's geodesic dome. This sort of non-architecture, in which spatial references become almost impossible to establish, evokes essential elements of Newman's art. In the impenetrable emptiness above the walkways, the designers of the pavilion had stretched very long cloths (the material used was sailcloth), which moved through the space like immense banners. It is to these canvases that other canvases, bearing art, were attached. There were works by veterans of Abstract Expressionism, like Motherwell and Frankenthaler, but even more by younger proponents of hard-edge, post-painterly abstraction and Pop Art (fig. 49).[36]

In this fair-like atmosphere, what happens to Newman's specificity and his aesthetics of vacillation? For Alan Solomon, in charge of the exhibition, the context of the pavilion imposed a number of constraints on the painting: 'It was quite clear that visitors would not be able to spend long periods looking at the pictures from afar, and that the visual intensity and contrast of the environment would unavoidably give the art a lot of competition ...'[37] That is why it was necessary to make use of large objects: 'The art works would clearly have to be very large to hold their own in this enormous environment ...'[38] A photograph of the United States pavilion showing *Voice of Fire* in the company of paintings by Frankenthaler, Noland, and Kruschenik clearly shows all the works reduced to the status of objects, coloured banners animating an otherwise unfathomable space. In the retrospective text he devoted to the artistic concept of the pavilion, Alan Solomon reduced the styles represented to three major tendencies: geometric painting, Pop Art, and shaped canvases.[39] Curiously enough, he had no category for the art of Newman, who would be completely disfigured by assignment to any of these designations.

If metaphysics, whether too volatile or too timid, seemed to have deserted the geodesic dome, politics found numerous new symbols there. While the neighbouring Russians were exploiting the prowess of their space hardware for propaganda purposes, it seemed preferable to the Americans, assured of their technological eminence, to 'soft sell' the American dream by brandishing the seductive effigies of their modernist art. 'The official decision in effect from the beginning was made in the real conviction – I believe with enormous wisdom and special

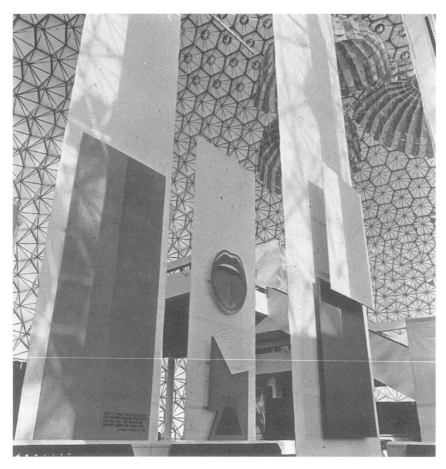

49 Interior of the United States pavilion at Expo 67, with paintings by Jim Dine,
Tom Wesselman, Frank Stella, and Ellsworth Kelly. Photograph from *American
Painting Now*, 1967

courage – that given world conditions at present, 1967 was a year to soft
sell America rather than to display muscle.'[40] It took the contested
decision by the National Gallery of Canada to reclaim *Voice of Fire* and
give it a permanent home for the aesthetics of vacillation to regain its
rights. In fact, the great subject corresponding to Newman's aspirations
is addressed by its new context: standing at the end of a hall whose
inclined roof suggests the basilicas of old, the painting is presented to
the spectator in an atmosphere of silence and reflection favourable to
epiphanies of all kinds. The museum in turn, sees itself confirmed as
the site (theoretical and ideological) for modernist painting, which
makes it possible for the work to have meaning, even if in a deliberately
critical or paradoxical way.

ROBERT MURRAY

The Sculpture of
Barnett Newman

Barnett Newman is best known for his large-format paintings. However, he also made prints, designed a synagogue, and built six pieces of sculpture (seven, if you count the two versions of *Zim Zum*). *Here I*, his first sculpture, dates from 1950 (fig. 50). It consists of two vertical elements approximately eight feet tall. They are anchored in mounds of plaster which overflow a wood-and-wire milk crate. Small casters were attached to the base of the crate for ease of moving the sculpture. The larger of the two verticals – made from reinforced plaster – is about eight inches wide by about two inches deep and has irregular, highly textured edges. In silhouette it is similar to the jagged bands in some of Newman's paintings, where paint flowed beneath the masking tape resist or was feathered by means of a brush. The second element is made from an unaltered piece of 1-inch by 2-inch lumber that is painted white. The smooth surfaces of the narrow vertical and its slender dimensions act as a foil for the larger slab-like element, and these two forms enter into a kind of silent dialogue, one with the other. The space between fairly bristles with tension and seems almost palpable.

Here I was cast in bronze in 1962 by the Modern Art Foundry, located in Astoria, Queens, New York. (I had cast a series of bronze pieces at this foundry and encouraged Newman to use their facility.) *Here I* was cast in an edition of two – each pulled from a rubber mould. My initial reaction to this work, when I saw it in Newman's Front Street studio, was to its wonderfully basic sculptural statement: two sticks jammed into the earth as if to mark a location. I helped Barney move the fragile work to the foundry and accompanied him on periodic trips to track its progress through rubber mould to bronze (fig. 51). In the process I suggested that he eliminate the milk-crate base. But, once the first

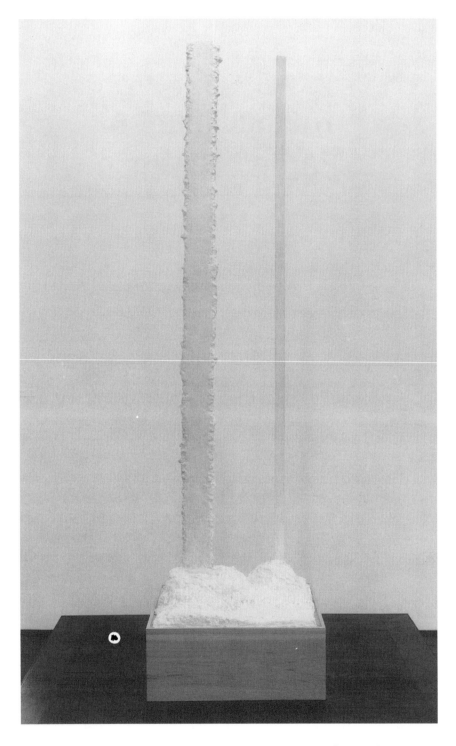

50 Barnett Newman, *Here I*, 1950. Plaster, 243.8 × 71.8 cm. The Menil
Collection, Houston. Photograph by Paul Hester, 1992

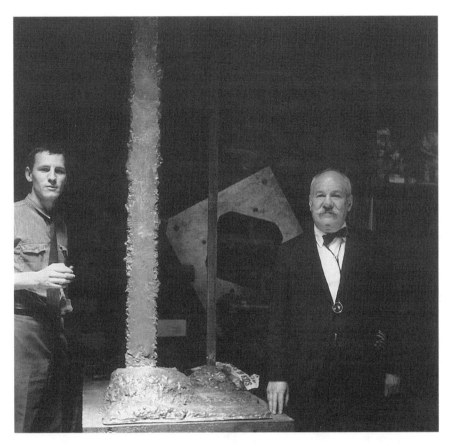

51 Barnett Newman and Robert Murray, with Newman's sculpture *Here I*, 1962.
Photograph by Jonathan Holstein

casting was complete, I conceded that the piece tended to disappear
into the floor and seemed to need isolation from the groundplane. We
experimented with slabs of marble and wood as a means of identifying
the sculpture's turf, or footprint, until – finally – Barney decided to
reinstate the box in the form of a fabricated bronze cube. It was an
interesting problem to wrestle with. Structurally, the box was not
needed for the bronze version, but without it the piece seemed dimin-
ished. Never one to accept the conventions of a particular medium,
Newman also struggled, as I recall, with the concept of margins and the
proportions of borders (or selvage) surrounding the images in a series
of lithographs he published in the mid-1960s. How one presented a
free-standing piece of sculpture – with or without a base – was no less
interesting to him. He took nothing for granted.

Some of the solutions for setting off *Here I* carried over into Barney's

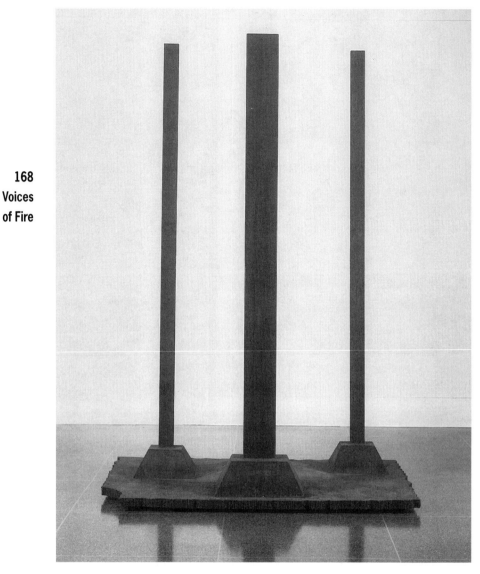

52 Barnett Newman, *Here II*, 1965. Hot rolled and cor-ten steel, 261.6 × 200.6 × 129.5 cm. National Gallery of Canada, Ottawa

second work, *Here II* (1965; fig. 52). Although it was made from a section of thick steel plate, the slab-like base for this piece derived to some extent from large pieces of stone, retaining the irregular edges characteristic, for example, of lithographic stones. In this case, the edges were 'burned' with an oxyacetylene torch. This treatment was also given to the base sections of *Here III* (1966) and *Broken Obelisk* (1967).

Here I, as I have noted, was cast in bronze from a plaster and wood original at a foundry. All the rest of Newman's sculpture was fabricated, that is built up from steel plate or structural sections in such materials as cor-ten and stainless steel, which Newman left unfinished. Surface detail from burning (cutting), forming, welding, and grinding the metal was left visible on some works. *Broken Obelisk* and versions of *Zim Zum* were sandblasted to allow the brownish-red oxides to form evenly. Apart from the black patina on *Here I*, Newman chose not to use applied colour on his sculpture.

Here II and *Here III* were fabricated at Treitel-Gratz in Manhattan, a firm that specialized in architects' prototypes for metal furniture. Alex Liberman had told Barney and me about this shop, and it is where I built some of my first fabricated works after moving to New York. Four years later, Barney came to New Haven, Connecticut, to see a work of mine built in the Lippincott plant. In the following year, he and Don Lippincott set to work on the first *Broken Obelisk. Lace Curtain for Mayor Daley* (1968) and the two versions of *Zim Zum* (1968 and, posthumously, 1985) were also built at Lippincott's. I say 'built' because Barney objected to the term 'fabricated,' given its negative connotations. Lippincott's plant was unique at that time because it was the first facility established for making large works of sculpture.

The titles for Newman's sculpture deserve mention. For example, *Here I*, *Here II*, and *Here III* are a bit confusing in that *Here I* contains two vertical elements, *Here II* three verticals, and *Here III* one vertical. The numbers represent sequence. The title is meant to indicate – quite literally – that the sculpture is here, not there, drawing attention to its physical fact and the space it occupies. A painting from 1962 was titled *Not There – Here.*

The plaster mounds in *Here I* evolved into truncated pyramidal forms that functioned as footings in the fabricated pieces. The footings achieved even greater emphasis in *Broken Obelisk*, where the pyramid-like section becomes almost equal in mass to the column it supports. *Broken Obelisk*, which was built in an edition of three (an unusual occurrence for fabricated rather than cast sculpture because no mould exists) is the most solid-looking, architectural, and monumental (in the traditional sense) of all Newman's sculpture. Symbolism seems to win over metaphor, as is suggested by its title. This work has such an impressive physical presence, however, that it transcends its less abstract

characteristics – the appropriation of Egyptian obelisk and pyramid – as few other pieces of twentieth-century sculpture have been able to do.

If the referential symbolism of *Broken Obelisk* didn't make Newman hesitate, he was even more overt in *Lace Curtain for Mayor Daley*, which he ordered built at the time of the 1968 Democratic Convention, when Chicago's Mayor Daley made anti-Semitic remarks to Senator Abraham Ribicoff, who was protesting the treatment of anti-war demonstrators. The steel frame and barbed-wire sculpture is clearly a political statement – but a political statement in the tradition of Picasso's *Guernica*. It might stand just as effectively outside of Dachau as outside Chicago City Hall.

The referential aspects and literal symbolism of these two works disappeared entirely from *Zim Zum*, which reinstated Newman's more typical reliance on abstract imagery. Gone too are the staged pediments of earlier works. *Zim Zum* consists of two free-standing walls constructed from panels of steel plate set on edge in a zigzag fashion. It draws the viewer into the space between the two walls and encourages active exploration of the work, in much the same way that Newman invited those who came to view his large paintings to do so at close range.

Zim Zum, which comes from the Hebraic word 'Tsimtsum' and refers to the tension or squeezing of space – out of which the world was created – derived from the large, accordion-shaped windows of a synagogue that Newman designed. A model of the synagogue, which was never constructed, was shown in an exhibition, *Recent American Synagogues*, at the Jewish Museum, New York, in 1963. Two sculptures were built. In the first sculpture, the walls are 8 feet high. Following Newman's death (and in compliance with his wishes) Annalee Newman had a version with 12-foot walls made.

It may be of interest to note in closing that, also at the request of Annalee Newman, two years ago I restored the original plaster and wood components of *Here I*. Because they had been cut into sections during the casting process, the pieces were thought to be lost or discarded. As it turned out, the sections were located in a New York warehouse, where they had been in storage since 1962. With the help of the Modern Art Foundry, the sculpture was restored and mounted on a new wooden box. It is now in the permanent collection of the Menil Museum in Houston, Texas.

Newman's sculpture evolved from being three-dimensional representations of his painted images into significant works that, in turn, influenced his painting. In both media – painting and sculpture – Newman greatly influenced the course of contemporary art. Of his generation, he may have been the most influential figure for younger artists.

BRYDON SMITH

Some Thoughts about the Making and Meaning of *Voice of Fire*[1]

The freedom of space, the emotion of human scale, the sanctity of place, are what is moving – not size (I wish to overcome size), not colors (I wish to create color), not area (I wish to declare space), not absolutes (I wish to feel and to know at all risk). Barnett Newman, 1965[2]

I will limit my remarks on Barnett Newman's *Voice of Fire* to three aspects of its making. First, I will describe the physical characteristics of this very large painting, including the materials and techniques the artist used to make it. Second, I will look at the specific circumstances which brought *Voice of Fire* into being. Third, I will explore how I think Newman was inspired by current events and the opportunity of having this painting seen by millions of people from around the world at Expo 67 in Montreal to create a work of art that would personify his guiding vision of our common humanity – that each individual should be free of coercion in civic society.

Voice of Fire is 17 feet 10 inches high by 8 feet wide, with each of its three vertical bands 32 inches wide. It was painted using a water-based acrylic medium, beginning with a highly reflective titanium-white ground applied uniformly over a cotton-duck canvas that had been tightly stretched over a wooden frame and stapled around its sides.

A close look at both the surface of the painting and magnified cross-sections of the red and blue paint layers[3] reveals something about their colour and composition. The intensely coloured red band was painted with two thick coats of the same light cadmium red and has a characteristic orange hue. The flanking deep-blue bands were each painted with two thinner coats of differently coloured blues. The undercoat is per-

ceptibly darker, as it is composed of both Prussian- and ultramarine-blue pigments, in addition to zinc white, whereas the final blue coat is lighter, containing only ultramarine mixed with zinc white. It is the addition of Prussian blue in the undercoat that darkens this layer and gives the blue bands their purplish hue. Because Newman paid close attention to the quality of his materials, he had his paint specially mixed at Bocour Paints in New York, in order to get both the right physical consistency for smooth application and the strong, intense colours that he was using at that time in a series of paintings titled 'Who's Afraid of Red, Yellow and Blue?'

Voice of Fire was painted in at least four separate stages after the white ground had been allowed to dry. First, Newman applied a coat of red along the centre band. Next, he applied a thin coat of the dark blue over the flanking areas. After that, he applied the final coat of red, and lastly the final coat of blue. At each stage he allowed the paint to dry thoroughly before applying the next coat. The result is a uniformly painted surface that reflects red and blue light very intensely. According to Marion Barclay, Senior Paintings Conservator at the National Gallery, the brush Newman used was approximately 4 inches wide and, as was his practice, he used masking tape to obtain a straight edge between the coloured bands. The tape would also have held brown paper in place over those areas not being painted, to keep drips and splatters off them and to allow for his complete concentration on the colour being applied.

From the pick-up address on the shipping company's waybill, we know that *Voice of Fire* was painted in Newman's studio at 100 Front Street in New York. We also know that it was picked up on 11 April, just seventeen days before Expo 67 opened in Montreal. Because this studio had a ceiling height of about 12 feet, *Voice of Fire* was most likely painted on the wall in a horizontal orientation, with what is now the right side topmost for the final coats, even though Newman had conceived it to be shown vertically. Observations by Ms Barclay as to the way the final brushstrokes were applied and the action of gravity on the liquid paint support the suggestion that it was painted in a horizontal position. The strokes, which run along the entire length of all three bands, consistently cover about an arm's length and rise or dip slightly in their middle. That the right side was topmost is supported by the fact that, when one looks closely at a detail of the edge between the right-hand blue band and the central red band (fig. 53), one finds that the

blue paint has bled slightly under the masking tape and over the red
band, helped in its flow by the downward pull of gravity. This bleeding
of the blue paint over the red is much less extensive between the left-
hand blue band and the central red one – something one would expect
if, as suggested here, that band was below the red one while it was being
painted.

The circumstances that prompted Newman to paint *Voice of Fire* can
be reconstructed from a number of sources. In early 1966, Alan Solo-
mon, an art historian and critic, was appointed by the United States
Information Agency to organize an art exhibition for the United States
pavilion at Expo 67. This pavilion, designed by Buckminster Fuller, was
to be a geodesic dome, about 200 feet high, whose vast, open interior
would be filled with natural light during the day. Newman's files on
Voice of Fire contain no correspondence inviting him to participate in
the exhibition, and Annalee Newman, the artist's widow, recalls that all
the arrangements were made by phone. Based on Solomon's comments
about the organization of the exhibition, published after Expo 67
closed, one can construe the salient factors that he would have dis-
cussed with Newman.[4]

1 / The artworks would have to be very large, in order to hold their own
in the soaring, airy structure.
2 / Visitors would not be able to spend long periods looking at pictures
because of their steady rate of movement through the pavilion.
3 / The visual intensity of the environment would give the art a lot of
competition, despite the muting backgrounds provided by the sailcloth
panels against which the paintings would be hung.
4 / Sculpture could not be included because of the limited floor space.[5]

Based on these criteria, Solomon decided to organize an exhibition
titled *American Painting Now* that would be a small survey of the major
trends in contemporary American art. He thought an exhibition of large
vertical pictures would look best in the spacious dome and asked a
number of artists if they would create works specially for it. He received
favourable responses from thirteen artists, including Newman. From
the other nine artists who made up the show, he selected works that
were already finished. None of the works was commissioned, but those
artists who created new works were reimbursed for the cost of materi-
als. Newman received $423.60. In a letter of 11 June 1967 to Alan Solo-

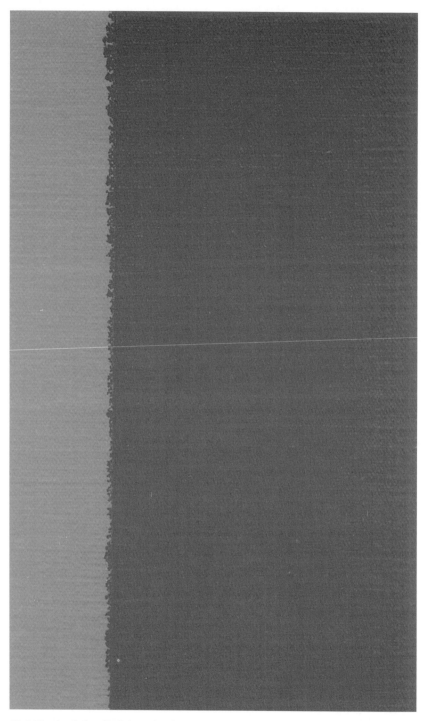

53 Life-sized detail of the edge between the right-hand blue element and the central red one of *Voice of Fire*. Photograph courtesy of the National Gallery of Canada, Ottawa

mon accompanying his invoice, Newman summarily wrote, 'I understand that this does not give anyone an equity in my work.'

The vast display space in the American pavilion gave Newman the opportunity to hang his large 8-foot by 18-foot canvas vertically. This was a size he favoured for his large canvases, but it was the first time he moved away from the horizontal orientation. In keeping with the viewing conditions, he selected intense, strong colours and a distinct image that could be easily seen in its entirety by the thousands of people who would be passing through the pavilion every hour. When I first saw *Voice of Fire* at Expo 67, I remember being struck by its bold simplicity relative to the other non-representational paintings on display, but most of all by its luminous red centre hanging in space between deep-blue sides, which looked as if they had parted to reveal an inferno of red behind. This experience struck a visual chord that was reinforced the following year when I saw *Voice of Fire* at Documenta 4 in Kassel, Germany, albeit in a much more confined space. Together, these experiences left me with a lasting impression of this remarkable painting.

Nineteen years later, in the spring of 1987, I called Annalee Newman to find out if *Voice of Fire* was still in her possession and if she would consider lending it for a special installation for the opening of our new building in a year's time. She agreed, and on a Saturday morning a few weeks before the opening on 21 May 1988, I found myself once again facing *Voice of Fire*, while installing it on the end wall of a very spacious room with a high-pitched ceiling, along with works by Jackson Pollock, Tony Smith, Milton Resnick, and Donald Judd.

Like all of Newman's paintings from 1948 on, the year he first applied a narrow, thickly textured, light-red line down the middle of a smoothly painted, dark-red ground, *Voice of Fire* is not an abstraction of some thing. Rather, it is a deeply considered painting that contains Newman's thoughts and feelings about our humanity. Newman called these lines of energy in his paintings 'zips.' Their colour, form, and placement on the canvas varied, depending on the meanings that were generated and expressed during the act of their creation and that were reinforced by the titles Newman gave them after he had finished.

Because I believe Newman's life provided the specific context for his art, I began to look for possible connections to *Voice of Fire* in his writings of the late 1960s. I quickly came across the foreword he wrote for

54 'Brydon Smith, assistant director of the National Gallery, with part of Newman's *Yellow Edge*. Experts are paid for their judgment about art,' *Toronto Star*, 15 April 1990. Photograph by Erin Combs

the reissue in 1968 of *Memoirs of a Revolutionist* by Peter Kropotkin, the Russian prince, scientist, anarchist, and revolutionary. This book was first published in the United States in 1899. Knowing that Newman's own persuasions had been anarchistic, I was not surprised that he would contribute a foreword to such a publication, but I was surprised to find his repeated use of 'voice' at the outset: 'In the twenties and thirties, the din against libertarian ideas that came from shouting dogmatists, Marxist, Leninist, Stalinist, and Trotskyite alike, was so shrill it built an intellectual prison that locked one in tight. The only free voice one heard was one's own. The existence of these *Memoirs*, this remarkable work that was Kropotkin himself, telling of himself, broke one's loneliness inside this solitary confinement. There were no other voices.'[6]

However, a little farther on, Newman holds out hope by saying: 'The re-issue now of this classic Anarchist literary masterpiece at this moment of revolutionary ferment, when the New Left has already begun to build a new prison with its Marcusian, Maoist and Guevara [*sic*] walls, is

an event of importance for the thinking young and their elders – if they will listen.'[7]

Guessing that there might be a link between *Voice of Fire* and this foreword, I asked Annalee Newman about the circumstances of Newman's writing it. She informed me that Newman had been approached in the mid-1960s by Ben Raeburn, the publisher/editor of Horizon Press, to publish an anthology of his writings. Newman countered that he still had a few more things to say, but if Raeburn would consider republishing Kropotkin's memoirs instead, he would write a foreword. Newman felt strongly that the youth of America would benefit from the example of Kropotkin's life as a revolutionist.

My talk with Annalee led spontaneously to a discussion of Newman's concern at that time about the undeclared war in Vietnam. We also touched on his acute awareness that the students who were openly opposing this military intervention by their government to prop up a corrupt dictatorship in the name of freedom were not only threatened with arrest for civil disobedience but were also vulnerable to being co-opted by doctrinaire student leaders. In his foreword, Newman described the situation:

The take-over of the college is just as much in the American tradition as it is Anarchist. It was inside the buildings that the Anarchist drama took place. There the students found themselves resisting not only the Administration on the Right but the several cadres on the Left who were trying to politicize them. As one of them said to me, 'What happened is that we ended up having the "Anarchist experience".' Face to face with the philosophic problem of liberty and freedom and the pragmatic problem of revolt against any apparatus and the necessity for objectives, they became involved in the tragic dilemmas of revolutionary action and learned that revolution is more than a Nihilist Happening.[8]

Generated out of Barnett Newman's personal concerns with these events in the United States in the late 1960s as written about by him, *Voice of Fire* is a passionate creation of the specific made general through the act of the artist. I now see *Voice of Fire*, with its sheer perpendicular colours, human proportions, and bilateral symmetry of three equal parts reaching all the way out to the stars, as a beacon that affirms and inspires each person's being and freedom in the world.

General Discussion

JOHN O'BRIAN: We have heard four provocative papers that raise issues the panellists probably want to discuss among themselves. But I'm not going to allow them that privilege until we've had a chance to hear from the audience. Are there any questions?

AUDIENCE: I'd like to ask Robert Murray to talk to us about Barnett Newman, the teacher. What was he like as a teacher? What were his objectives, methods, and so on.

ROBERT MURRAY: As John O'Brian mentioned when introducing me, I met Barnett Newman at the Emma Lake Artists' Workshop in Saskatchewan in 1959. Barney's reaction to all of us was almost as interesting as our reaction to him. The story has been told many times over by now, but for those of you who may not know, he suggested that we didn't need him, we needed a psychiatrist. That had to do with the sense of paranoia and lack of confidence that he saw in many of us, which came from the isolation of living in the middle of Canada, where interest in our work from the Eastern establishment was almost non-existent.

One of the reasons for the Emma Lake Workshops in the first place was to provide an opportunity for artists living in Saskatchewan, Manitoba, and Alberta to get together and to invite someone to come from the 'outside' to talk to us. What was interesting about Newman was that he did not come to teach us how to paint. He talked to us individually about our work, but spoke to the group in general about taking ourselves seriously and putting our work first in our priorities. It helped many of us come to grips with our situation. For others it led to such things as the formation of the Regina Five.

As far as his actual teaching is concerned – and I've heard him speak

to college classes in a number of places – Barney usually led off with a provocative idea that began as a kind of Socratic monologue and then opened up into very lively discussion. I remember, for example, going with him and Annalee [Newman's wife] to the Pratt Institute in New York, where Barney was to talk to the students. We were involved in a minor traffic accident on the way and arrived late. Barney looked quite ashen and he put his head down on a table at the front of the stage. Everyone was concerned and quiet. Finally someone at the back of the audience said, 'Mr Newman, can I ask you a question?' Barney looked up and said, 'Go ahead' and the question was 'Why do you paint?' I won't try to reconstruct the whole answer, which was quite remarkable under the circumstances, but he began by saying, 'I once wrote a piano concerto because I wanted something to listen to and I paint for pretty much the same reason ...'

What was significant about Barney's visit to Emma Lake – at least for some of us – is that he didn't try to tell anyone how to make a painting and he certainly didn't try to tell anyone how to make paintings like his.

AUDIENCE: Two questions. One to Professor O'Brian and one to anyone on the panel. Professor O'Brian, you seem to imply that the controversy that arose last year, when *Voice of Fire* was purchased, was part of some kind of conspiracy, and the fault of the political right. I'd like to see you expand on that. And, the other question to the panel: to what extent do your talks today address the issues of concern that were raised last spring when *Voice of Fire* was bought?

JOHN O'BRIAN: Could you stay there for just a second, because I have a question for you. I wouldn't say there was any kind of conspiracy at all. Why would you say that the shift to the right in politics is *not* implicated in the kinds of attitudes towards art that we've seen in the last year?

AUDIENCE: I don't know anything about the shifts from one end to the other; all I know is that I was outraged, and I'm nowhere on the right, I'm very much on the left. And so are a lot of my friends. So I was astonished to hear you say that. Whether or not there are other movements to the left, to the right, to the centre, I have no idea. I just think that there are concerns that are legitimate in themselves and to ascribe it to some kind of great conspiracy is improper. [Scattered applause]

JOHN O'BRIAN: Fair enough. What we have is not a conspiracy, then, but a shift of attitudes in Western society about the constraints that should be placed on art. There has been a change in the social climate, if you like, and part of the change is a new – or, rather, old – kind of intolerance. It seems to me that if we don't own up to that, then we have no way of understanding the events of our own time. Does anyone want to add to that? [Scattered applause]

SERGE GUILBAUT: Yes, I would. Interestingly, I think this debate is not new. Having done some reading about postwar culture, I can see some close affinities between today's debate and the 1947–8 debate against modern art in the United States. Then, as well as today, modern art ('extremist abstraction' as it was then called) was attacked by the right as a game for effeminate aesthetes from the Museum of Modern Art in New York, and by the left as a bourgeois plot to under-mine the spirit of the working class. So the person in the audience is right in saying that not only the political right is against a picture like *Voice of Fire*. The orthodox left also is against it in a way a Trotskyite would not be. The left, like anybody else, often fears what it does not know.

The amount of money spent for *Voice of Fire* was really what trig-gered the popular anger. So much money for three juxtaposed areas of colour seemed a bit extravagant. But if, for example, this museum would have spent their entire budget to buy a Van Gogh, or a tea set previously owned by Queen Victoria, I bet everybody would have been delighted. What is particularly interesting in this case is that, paradoxi-cally, an abstract painting like Newman's is, despite its emptiness, a work which carries an incredible amount of our contemporary history in a way a Van Gogh does not. I'm afraid to say that Barnett Newman's bar is part of our complex past, whether we want it or not. [Applause]

JOHN O'BRIAN: Would anyone care to address the second question, about the degree to which today's talks have addressed – or avoided – the concerns raised when *Voice of Fire* was purchased?

SERGE GUILBAUT: I think I addressed this question in my talk already, but to repeat, it seems that a public-relations blunder was made by the National Gallery. This is a traditional one, frequently made by formalist art history. It's great, it's beautiful, it's three bars. It's impor-tant. The problem is that the rationalization for greatness stops there. You have to be a believer to believe them.

I think that if you try to understand the reason why such a picture came about, in the middle of a series of discussions about aesthetic possibilities, then you understand that a simple abstract shape can carry a complex network of meanings developed in relationship to the discourse about what made a painting 'American' in the 1950s. The gallery should have discussed Newman's three areas of colour in their historical relationship and significance rather than merely in terms of aesthetic orgasm.

It doesn't mean – I hope you got my point – that I have any quarrel with Barnett Newman. I am not talking here about his personality, which I understand was very caring, but about the way he constructed through his paintings his very authoritative individuality, which in fact is not my 'bag of tea,' so to speak. But let me stress that the type of work Newman was involved in, in relation to a particular historical moment, was very important. This should have been emphasized by the gallery.

JOHN O'BRIAN: Brydon Smith has a response to Serge Guilbaut's statement.

BRYDON SMITH: The outrage didn't happen in terms of the painting; the outrage happened because we bought it. That's the only way I can describe it. I mean, why wasn't there an incredible protest when we opened the gallery with *Voice of Fire* in the large gallery on the second floor? Why did it take two years to erupt? The only difference was the fact that we had bought it for $1.76 million. So it's the economics of it, not really the painting.

NICOLE DUBREUIL-BLONDIN: I would like to continue along the lines of Serge Guilbaut, and say that the gallery has the responsibility to present us with the visual documents that are significant to our understanding of the modern situation. I believe that Barnett Newman occupies a very specific position in the modernist tradition. He is somehow at the end of the line, which means that, of all the abstract painters, he was among the last to believe that a minimal form was going to be tied to a great spiritual and metaphysical subject. The generation that followed kept the minimal form, but not the metaphysics. This position alone, along with the problems and tensions it creates, is sufficently important to be brought to our attention. What is more phallic than this abstract painting? For better or worse, these phallocentric characteristics exist in the modernist tradition, which has not been critical on all fronts, as we all know. As far as phallocentrism is

concerned, modernism has done little to change the rules prevailing in 'the academic' tradition.

Where one discovers a problem, and you are going to find us cowardly for not addressing the financial question, is that the market and not aesthetics often determines the importance of a work of art. There is a hiatus between the two. In the marketplace, because of the demand and competition for works of art, a Van Gogh can now sell for millions. We did not predict this. Indeed, we are embarrassed to talk about it; it is like two systems of law operating differently. We cannot say that, if a work of art is deemed significant, it is worth three to four million dollars. There is no equation between the two.

AUDIENCE: A question for Robert Murray. Just why was Barnett Newman so influential, particularly for a group of Canadian artists?

ROBERT MURRAY: It's a good question and a very difficult one for me to answer briefly. It has been interesting to hear how others on the panel react to Newman's work. Abstract painting is not necessarily good in and of itself, but issues and ideas that grew out of the work of some New York painters in the late forties and early fifties who were attempting to make work that was free from obvious outside references – the figure, still-life, etc. – resulted in some very exciting painting and attracted the attention of artists virtually all over the world, including Canada. Newman was an important member of this group of artists. He made large, impressive, passionately abstract paintings. Initially, however – with the exception of Art McKay – none of us had seen Newman's work, and it was his wit, charm, and remarkable ability to talk about complex issues in seemingly simple terms that impressed us at Emma Lake.

The bands in *Voice of Fire*, for example, do not have any figurative references. Newman himself argued this point. In most of his work they are a touchstone – a device – that allows you to engage the large field of colour. They give scale to the painting. One of the things that makes *Voice of Fire* somewhat unusual in terms of Newman's work is that it is more symmetrical than most of his paintings, where the bands are generally narrower and occur in an incidental, informal manner. In other words, there is no program of predetermined geometry and proportion going on, and I believe that even *Voice of Fire* doesn't measure as exactly equal bands.

The idea that a painting could be a different kind of experience to the 'window on the world' (as with Impressionism), that it could be a phenomenon that you react to on a visceral level, the idea of walking up to it to experience the expanse of colour rather than looking at it as an object, evoked a new kind of painting space and painting experience. For some of us it also translated into ideas for experiencing sculpture, where you walk in and around the work to learn about it rather than view it at a distance from a fixed position.

These are ideas which may sound terribly formal, but for younger artists in particular, Newman's work offered an important alternative to the Cubists. Better than anyone else's of his generation, his work offered a new kind of space in which the viewer and painting could come to grips with each other, each asking the other 'What do you mean?' That's the most direct answer I can give you.

AUDIENCE: I would like to make a point also with respect to what John O'Brian said about the shift to the political right and to ask a question to the members of the panel. You did invoke the name of Mapplethorpe, which you associated with the resistance to *Voice of Fire*. You did enclose this within a frame of the political centre shifting to the right.

Now, in the light of the comments around the phallocentricity of Newman's work, and then your invoking of the name of Mapplethorpe, and then talking about the political centre shifting to the right, I think what you're really addressing is that the political centre isn't quite where it used to be, and that there are, in fact, other voices that are articulate and that, in fact, are a bit more empowered to make critiques of mainstream art.

And, having said that, my question is – it's a question I've often asked myself and in the light of the brouhaha over Mapplethorpe and the brouhaha over so-called other voices, I still don't know how to answer it – and the question is, how can a lay person critique state institutions and their decisions about art in the face of the so-called experts? What kind of criticism of art purchases or sanctioning of art in institutions and museums is available to the layperson? [Applause]

JOHN O'BRIAN: Brydon, would you like to address that first, as the one professional museum person on the panel?

BRYDON SMITH: I can try to. When the Montreal Museum of Fine Arts – perhaps after our experience here with purchasing *Voice of*

Fire and not having a ballot before we purchased it – wanted to purchase a Salvador Dali out of one of their shows, I think they had a public ballot. Yes or no, should they purchase it or not? I felt that that wasn't really going far enough because the museum was making the choice and saying to the public, do you accept it? A further extension of that would be to invite the public to tell us what we should be purchasing. And I guess that points towards the impossibility of bringing order to what amounts to very, very many diverse and different points of view.

In terms of the curators and what we do here at the National Gallery of Canada, and we certainly are working within a tradition, we make selections within that tradition. And then the public has the chance at some point to see and critique.

Another way of approaching it, which I introduced into a panel in 1980, is to propose that we don't buy works any more. We rent them. Nobody liked that idea in 1980. And they still don't. All that is to say, I don't have a quick and easy answer to your question.

SERGE GUILBAUT: I think it is a very good question, this eruption of other voices in the very ethereal world of high art. The difficulty is that museums are trying to do the old traditional job of museums, to buy art works in order to build a historical collection. It used to be easy in the old days (I mean twenty years ago), it used to be easy to buy historical modern art because it was fairly cheap and also because it was pretty clear who the players were. Today, with skyrocketing prices and multiplication of artistic input, the role of the museum has changed from guarantor of canonicity to supermarket of tastes. Historically, then, *Voice of Fire* was an important image for this country, for the role it played, not only at the Montreal fair, but also as a symbol of the relationship developed between New York and Saskatchewan since the 1950s. This empty abstract image is to my mind historically full. We have to make it speak, that's all. Yes, maybe it will be expensive to own part of Canadian history, yes, at times it will be painful to hear and see the Canadian historical past, but at least the picture can trigger several readings thanks to these new voices which start to empower themselves today. Even if the gallery didn't know it, it was a good choice to buy and preserve a piece of Canadian history.

ROBERT MURRAY: I'd like to build for a second on something Serge said. I remember in the late 1960s, when Henry Geldzahler was the curator of contemporary art at the Metropolitan Museum in

New York. He defended the fact that they didn't buy much contemporary work and had no significant collection of it at that time. He felt that there were enough other museums to deal with contemporary work and that the Metropolitan should be a repository for tried and tested works. (This situation has since changed, partly through Henry's efforts.) Unfortunately, museums have not been able to maintain that long-term perspective. Nowadays exhibitions of current work sometimes circumvent the commercial galleries altogether. This may or may not be a good thing; however, it does change the role of museums and makes their practices more controversial. And I think something is lost when the natural evolution of exposure to the art community doesn't take place. What I mean is, there is a big difference between people who go to the galleries, who see the one-person shows, pay attention to changes and developments, and the more general public who only visit museums and have difficulty putting the work into some sort of context. In the museum, people expect to get 'it.' That's the trouble. They expect to get 'it' without putting any effort into the process. And if they don't get 'it' easily, the museum can find itself seriously on the defensive.

Now, to some extent, this may sound contradictory. Newman paid his dues; he came up through the ranks and only slowly received acceptance in museum collections. There has been ample time for the public to catch up with the ideas of his generation. It shouldn't be all that daring for a museum to purchase a Newman painting or sculpture today, and in most countries it is not. The problem, in part, is that abstract art has still not been accepted by much of the Canadian public; it has not been well presented and not well written about. On the other hand, much of the criticism of the National Gallery's acquisition of *Voice of Fire* came from people who hadn't seen the painting, who are still trapped in the Victorian era of literary art appreciation (story-telling) and whose only curiosity about the painting came from the price tag. Should their opinions carry any weight?

NICOLE DUBREUIL-BLONDIN: The sociologist Pierre Bourdieu said that one of the features of the avant-garde is the marginalized social position of artists, as opposed to the classical age, where artists were at the service of the state. Modern art has withdrawn itself, and as a consequence has become very specialized: art for artists, art for museums, and art for limited numbers of informed viewers. This creates tensions for those who are not familar with deciphering its codes, and

this is a sort of misery of our modern-day cultural and social situation.

JOHN O'BRIAN: There is a line-up of questions from the audience.

AUDIENCE: I want to say that my question has changed significantly since I started on my way down here from my seat to the microphone. [Laughter] With each new exchange, something else gets covered that I wanted to address. So I'll try to reformulate what I was going to say. I've got nothing against formalist analysis and criticism *per se*, as long as it doesn't monopolize things. And for that reason, I'm very appreciative of your presence, Professor Guilbaut. I think you add a very important other perspective to things.

I want to address myself partly to what Mr Smith said earlier and I think this has also been addressed since I formulated my question. Obviously, the response to the painting at this point, the hostility and so on, does not have to do with its status as an Abstract Expressionist painting, or whatever; it has to do with the fact that it's an object that has cost $1.76 million. I'm not sure that, at this point in history, that can any longer be separated from the status of that object as a painting. I call it the hyper-commodification of art. This is a phenomenon that has taken place – and people have been very aware of it – since the beginning of the seventies. And you have the whole Minimalist movement in the United States in the seventies that was, at least in part, in response to that tendency to commodification.

Now, I find it very ironical that among virtually all of the work that have been produced over the past thirty or forty years, the one group of artists whose work has not significantly appreciated in value are those Minimalists. They fought against the gallery system. They fought against the commodification of art and, lo and behold, nobody pays tens or hundreds of thousands of dollars for their work at this point.

It seems to me that what happened subsequently with the influx of European art into New York and North America in the eighties was in a large part a response on the part of the art-buying public to that vacuum that was created there. It seems to me that this whole question of the value of *Voice of Fire* has a lot to do with the fact that in Canada – and I think this is important to remember – it's public money that's being spent on it. We're not dealing with a private foundation here, we're dealing with taxpayers' money. Now, theoretically and ideally, those taxpayers should be having input into the purchase of works. My

personal opinion is that the painting is worth $1.76 million simply by virtue of the fact of the debate that it did generate. Because suddenly, the National Gallery is on the map, that painting is on the map, people are writing about Barnett Newman in the *Ottawa Sun*. I mean, this is a phenomenal event! [Laughter] I think that is very important. And I think the painting is justified just for that reason alone. The other thing, I wanted to point to, and I think this is just a gloss on it ...

ROBERT MURRAY: Can I stop you there for a moment, just so I don't forget this point. Whatever happened to government by representation? [Laughter] I'm absolutely astounded at some of the folly that we're putting up with on a more serious political basis in this country at the moment. Then all of a sudden our curators are being taken to task for doing the jobs that they were hired and paid to do. We don't seem to put the same pressure on the politicians. [Applause]

AUDIENCE: I agree. Are we disagreeing?

ROBERT MURRAY: Not if you like my answer.

AUDIENCE: Fine. I think that all sorts of pressure should be put on politicians, but I also think that art functions as a fundamentally marginal activity, certainly in Canadian culture and in North American culture. I mean, it seems that the parameters that govern the admission of art into the mainstream keep changing. They change all the time. What people saw as outrageous in 1948, they certainly don't see as outrageous anymore, unless a two-million-dollar price tag is attached to it. That changes the terms of the debate completely. You know what's been going on in the United States recently regarding Mapplethorpe's show, and to a lesser extent, performance art — I mean, there's a term that's used among performance artists in the United States that refers to the art ghetto – as long as people are performing for one another, nobody pays much attention to the question of obscenity, or stepping on the flag, or whatever have you. As soon as it ventures out of that ghetto and comes into the public domain, comes into the larger sphere of public activity, then it gets attacked, and obviously what is going on with Jesse Helms and the National Endowment for the Arts and so on in the United States right now has a lot to do with that phenomenon.

I think it's very healthy that these issues come into the public domain. If it means a few curators get attacked, so what? I mean artists get attacked all the time. I think that's very, very useful.

I wanted to address one other thing: I didn't know this painting was shown at Expo 67, and I think it's really neat that it was shown at Expo. The reason why is that when you showed that slide of Buckminster Fuller's dome there with the lunar module inside, and all the sort of Pop and so on paintings inside and Barnett Newman's *Voice of Fire* there as well, sort of shooting up into the sky, I mean it was an incredibly confident phallic image. I mean, this is American civilization at its peak, this is pre–Tet Offensive, this is really something. And I think it is remarkable that this painting has now been bought by Canada. Because it means that a symbol, a primary symbol, that functioned at that time and in that place has now been appropriated by Canada. It's like Japan buying all kinds of international and European and North American culture right now. It's appropriating cultural heritage. Well, all I can say is that at least it's nice that Canada gets a little chunk of it. [Applause]

AUDIENCE: I have a couple of questions. First of all, in regard to the idea of the phallic image, if you go back to Newman's earlier work, you'll know that he was struggling in a search for a new form of Genesis. He worked with circles and a lot of other kinds of images. Whether you want to say his later work was figurative or not, that's debatable. That's not really a question, it's just a comment on what has been said about the phallic image.

The question I have for all panellists is, if you came across a baffled viewer in the gallery, who was trying to make sense of these three bands, what words of encouragement or insight could you offer them?

BRYDON SMITH: Well, I'll lead off because I guess I've been in that position frequently. It's a matter of getting people to slow down enough to really look at the painting. And to, in fact, trust their own feeling about it. That's how I approach it. I mean there's no one way, and I think this is very clear in terms of what's been said. There are obviously many coordinates that cross in terms of the painting, and there are just as many thoughts and feelings about it as there are people who see it. But, it's really to get people to slow down and look.

SERGE GUILBAUT: I'm sorry. I've been invited here, and it's very nice to be invited, but I cannot let Brydon off the Barnett Newman hook so easily. I'm afraid I will be the voice of dissent again. I really think that Western museums have totally failed in their role as contemporary institutions. They have not progressed with the times. They are still stuck in some nineteenth-century time capsule where there was a

belief in one proper way to experience art: religiosity. Art and artists were removed from everyday life, connected to higher spheres of cognition. Modern museums (despite some rare exceptions) have not changed their mode of thinking. Museums are still presenting aesthetic objects completely divorced from any kind of reality. Meanings carried by works of art are evacuated as soon as they enter the great white castrating cubic space of the gallery. To say that the public has only to look hard and closely to understand the painting is to negate the role of modern museums. Paintings don't talk. They don't tell us anything. They give us clues which have to be connected with history in order to make some kind of sense, to be interpreted. To say that just by looking at a picture anybody can deal with it – without any kind of idea about the reason behind its production, without knowledge of the conditions of production and a description of the aesthetic and political culture out of which the image came – is wrong. I think that as long as our museums are basically formalist institutions, dedicated to pure form, they will be unable to avoid misunderstandings. But more sadly, they will perpetuate the cultural alienation which transforms our past into repressive monuments. We should do something about it. Now, and why not here? [Applause]

JOHN O'BRIAN: Last words from anybody?

ROBERT MURRAY: Well, if it's any consolation to any of you, Newman constantly reminded me, among others, that you should never prejudge who your audience is. I remember one occasion when Barney dragged a cab driver into the Guggenheim Museum to see a work of his. I don't think it's necessary to have Newman here to appreciate his work, but it sure would have helped at moments during the controversy because he enjoyed this kind of exchange. When he was in his studio, creating a work, he wanted as much privacy as he could get. But, once the work was released into the public domain, Newman felt that it should be there and available to everybody, and that people should not be made to feel alienated from the experience.

JOHN O'BRIAN: This sort of public exchange ought to happen more often. Perhaps the National Gallery should conduct a forum every time it acquires a major new work – controversial or not – for its collection.

Notes

Introduction: Bruising the Public Eye

1 'MP Wants Art Gallery to Explain $1.8M Choice,' Ottawa *Citizen*, 10 March 1990; Graham Parley, 'Cabinet to Review $1.8M Art Purchase,' Ottawa *Citizen*, 10 March 1990.
2 'Voice of Fire Has Some People Breathing Fire,' Ottawa *Citizen*, 15 March 1990.
3 For the paradoxical relations between avant-gardes and the bourgeoisie, see Clement Greenberg, 'Avant-Garde and Kitsch' (1939), in *The Collected Essays and Criticism: Perceptions and Judgments, 1939–1944*, edited by John O'Brian, 5–22 (Chicago: University of Chicago Press 1986), and Roland Barthes, 'Myth Today' 109–59 (1957), in *Mythologies*, translated by Annette Lavers, (New York: Noonday Press 1976).
4 See *Barnett Newman: Selected Writings and Interviews*, edited by John P. O'Neill (New York: Knopf 1990), for a compendium of Newman's public fights.
5 Quoted in John Bentley Mays, 'National Gallery Should Tune Out Static Over Painting,' *Globe and Mail*, 14 March 1990.
6 Since 1991, I have been directly linked to the National Gallery as an advisor on acquisitions to the board of trustees.
7 For Max Weber's ideas about bureaucracy under capitalism see his *Economy and Society: An Outline of Interpretative Sociology* (1920), 3 vol (New York: Bedminster Press 1968).
8 The phrase 'bruising the public eye' is from Meyer Schapiro, 'Introduction of Modern Art in America: The Armory Show,' *Modern Art: 19th and 20th Centuries: Selected Papers*, 135–78 (New York: George Braziller 1978).
9 Hector Charlesworth, 'And Still They Come! Aftermath of a Recent Article on the National Gallery,' *Saturday Night*, 30 December 1922.
10 Quoted by Roger Berthoud, 'Down by the Henry Moore,' *Globe and Mail*, 17 October 1987.
11 William Withrow, in a telephone conversation with John O'Brian, Toronto, 14 January 1993.
12 The volunteer committee voted to allot its funds to the purchase of a painting by Sam Francis; *Day One* was acquired by the Whitney Museum of American Art, New York.
13 Annalee Newman, in conversation with John O'Brian, New York, 5 December 1986.

14 See Cyndra MacDowall, *Issues in Censorship* (Toronto: A Space 1985).

15 For an incisive review of the case, see Marian Botsford Fraser, 'The Art of Eli Langer and the Meaning of Freedom,' *PEN Canada Newsletter*, December 1994, 10–11. For the judge's ruling, see Donn Downey, 'Seized Art Work No Risk to Children, Ontario Judge Rules,' *Globe and Mail*, 21 April 1995.

16 Linda Milrod, quoted by Liam Lacey and Isabel Vincent, 'Saskatoon Gallery under Fire for "Offensive" Exhibition,' *Globe and Mail*, 23 March 1990.

17 See Ian Burn, 'Buying Cultural Dependency,' *The Fox*, April 1975, 141–4, on Pollock's *Blue Poles*. The controversy over Andre's 'bricks' (*Untitled*, 1965) did not erupt until four years after the Tate Gallery acquired the work in 1972.

18 Editorial, *New York Times*, 16 March 1913.

19 Letter from Senator Jesse Helms to the Reverend Jerry Falwell, 1991, reprinted in *Culture Wars: Documents from the Recent Controversies in the Arts*, edited by Richard Bolton (New York: New Press 1992), 306.

20 Antoine Corege, quoted in the *Toronto Star*, 28 March 1990.

21 Greg Graham, director of Canadian Artists' Representation/Front des artistes canadiens (CARFAC), quoted by Christopher Hume in 'National Gallery Criticized for Buying U.S. Work,' *Toronto Star*, 8 March 1990.

22 Dot Tuer, 'The Art of Nation Building: Constructing a "Cultural Identity" for Post-War Canada,' *Parallélograme* 17/4 (1992), 24–36.

23 In March 1995, the Canada Council announced that it was shutting down the Canada Council Art Bank as a direct result of budget cuts it had sustained. Other national cultural institutions likewise cut programs to conform with shrinking financial support for their activities.

24 Following Royal Assent, only final proclamation is required for a bill to become law.

25 Felix Holtmann, Letter to the Editor, *Globe and Mail*, 10 April 1990.

26 House of Commons, 'Minutes of Proceedings and Evidence of the Standing Committee on Communications and Culture,' Issue No. 8, 10 April 1990, 9.

27 Brydon Smith, quoted in the *Globe and Mail*, 8 March 1990.

28 See Brydon Smith's remarks in a round-table discussion held on 29 April 1990, seven weeks after the acquisition was announced, subsequently published in *C Magazine*, Fall 1990, 16–23. 'I am optimistic,' he said, 'that if we can get people to slow down enough and, again, trust themselves, they can grow and learn from [the] individual experience [of the painting]' (p. 21).

29 D.H. Lawrence, 'Introduction to His Paintings' (1929), in *Selected Essays* (Harmondsworth: Penguin 1950), 326.

Vox Ignis Vox Populi

1 This essay first appeared in *Parachute* 60 (October– December 1990), in both French and English. Donald McGrath translated the piece from French to English. I would like to thank the students in my 1989–90 course 'Art et Critique' who worked with me on the topic and whose questions I found very stimulating. I wish also to thank my colleague Olivier Asselin, who in the course of a long conversation convinced me to take up again the ethical question opened up by my work on the aesthetics of modernity in *Au nom de l'art* (Paris: Minuit 1989), *Résonances du readymade* (Nimes: Jacqueline Chambon, 1989), and *Cousus de fil d'or* (Villeurbanne: Art Édition 1990). Most of the material in these books is now available in English, in *Kant after Duchamp* (Cambridge, MA: MIT Press 1996).

2 Translator's note: in the French, *métier* bridges a variety of meanings. It is sometimes equivalent to the English word *trade*, while in other instances it refers to the element of skill or craft in an art activity. As the author's argument plays upon the polyvalence of meaning, I have kept *métier* in many cases where a more idiomatic usage in English would have deprived us of the connections the author is making. (Although *métier* is also, of course, a perfectly good word in English, it tends to be used in restrictive contexts and does not combine to form idiomatic expressions as readily as in French.)

3 See *Kant after Duchamp*, chs 3 and 4. An earlier version of ch. 3 ('The Readymade and the Tube of Paint') appeared in *Artforum* in May 1986; an earlier version of ch. 4 ('The Monochrome and the Blank Canvas') was published in *Reconstructing Modernism*, edited by Serge Guilbaut (Cambridge, MA.: MIT Press 1990).

4 Translator's note: Ferdinand Cheval was an amateur architect and a rural postman (*facteur*) who, from 1879 to 1912, built in Drôme (France) a residence whose mixture of dreamy baroqueness and exoticism has evoked comparisons that range from Henri Rousseau to Brutalism (Petit Robert: *Dictionnaire universel des noms propres*, 1986).

Thalia Meets Melpomene

1 Sections of this essay were prepared for a conference organized by the Faculty of Art History of the University of British Columbia to take place in Vancouver in 1990. Unfortunately the conference did not take place, for lack of funding. A version of this essay was read subsequently at the annual meeting of the University Art Association of Canada in a session titled 'Disciplinarity: Questioning the Borderlines of Art History,' chaired by Mark Cheetham, University of Western Ontario.

 I would like to thank Chris Creighton-Kelly, formerly of the Canada Council, and Diana Nemiroff, Curator of Canadian Contemporary Art at the National Gallery of Canada, for providing me with many of the press clippings for this essay.

2 For a thorough survey of documents and essays covering the Mapplethorpe and Serrano controversies see *Culture Wars: Documents from the Recent Controversies in the Arts*, edited by Richard Bolton (New York: The New Press 1992).

3 V.N. Volosinov, *Marxism and The Philosophy of Language*, translated by Ladislave Matejka and I.R. Titunik (Cambridge, MA: Harvard University Press 1973), 23. The Russian original was published in 1929.

4 P. Bourdieu, 'Symbolic Power,' in *Identity and Structure: Issues in the Sociology of Education*, edited by Dennis Gleason (Dimifield 1977), 112.

5 Ibid., 115.

6 Both exhibition and sale (with state funding) are the basis for the two examples in this study.

7 In 1974, the Australian Postal Corporation published a *Blue Poles* stamp to commemorate the purchase. And in another attempt to give state endorsement to the purchase, the Australian prime minister of the time, Gough Whitlam, and his wife distributed the image on their Christmas card.

8 This Andre work (1965) was purchased in 1972, but the furore over the Tate Gallery acquisition did not occur until four years later, when the purchase was made public.

9 In all three cases there was generous radio and television coverage as well.

10 The terms 'irony,' 'satire,' and 'parody' have quite distinct meanings in this essay. 'Graphic satire' is used specifically in reference to newspaper cartoons that have a critical and subversive intent. 'Performed parodies' refers to instances in which individuals have (re)produced their own versions of *Voice of Fire* as ironic inversions and acts of resistance. Differences lie in the degree of ironic emphasis given to each representation, either by the author/producer or by the recipient/reader. For an examination of the specific debates on the differences among parody, irony, and satire see Linda Hutcheon, *Theory of Parody* (London: Methuen 1985), especially ch. 3, pp. 50–68.

11 This was not the first time that Newman had his work accused of being painted with a house painter's roller. In an unsympathetic review of the exhibition *American Paintings, 1945–1947* at the Minneapolis Institute of Arts in 1957, Frank Getlein of the *New Republic* wrote that, at the show's opening, someone told organizer Stanton Catlin that 'the Institute could have saved a good chunk by getting the plan and having the thing run off by the janitors with rollers': *The New Republic*, 26 August 1957, 21. Newman's acerbic reply appeared in *The New Republic*, 28 October 1957, 23.

 Most recently the repair work undertaken on Newman's slashed painting *Who's Afraid of Red, Yellow and Blue III?* caused some Dutch art historians unhappy with the results to claim that the New York based conservator had used a roller.

12 Halifax *Mail–Star*, 16 March 1990.

13 *Globe and Mail*, 7 April 1990.

14 An upside-down abstract similar to *Voice of Fire* appeared in an Unger cartoon (fig. 17) published in the 7 April 1990 edition of the *Globe and Mail*.

15 Thomas N. Hess, *Barnett Newman* (New York: Museum of Modern Art 1971), 141.

16 *Globe and Mail*, 21 April 1990.

17 *Barnett Newman: Selected Writings and Interviews*, edited by John P. O'Neill (New York: Knopf 1990), 179.

18 Ibid., 8.

19 Ibid., 307–8.

20 See Serge Guilbaut, *How New York Stole the Idea of Modern Art: Abstract Expressionism, Freedom and the Cold War* (Chicago: University of Chicago Press 1983), especially 68–9 and 113.

21 The reference here is to Luigi Pirandello's famous play *Six Characters in Search of an Author* (1918).

22 *Ottawa Sun*, 18 March 1990.

23 *Globe and Mail*, 16 March 1990.

24 Reesa Greenberg, 'Jana Sterbak,' *C Magazine* 16 (Winter 1987–8), 50–3.

25 Mary Douglas, *Purity and Danger: An Analysis of Concepts of Pollution and Taboo* (New York: Praeger 1966).

26 *Globe and Mail*, 2 April 1991.

27 Ibid.

28 See Rudolf Wittkower and Margot Wittkower, *Born under Saturn: The Character and Conduct of Artists. A Documented History from Antiquity to the French Revolution* (New York: Norton/Random House 1963), and Geraldine Pelles, *Art, Artists and Society: Origins of a Modern Dilemma: Painting in France and England, 1750–1850* (Englewood Cliffs, NJ: Prentice-Hall 1963).

Who's Afraid of Barnett Newman?

1 A version of this essay was presented at a symposium on Barnett Newman at Harvard University, on 16 May 1992. Subsequent versions were presented at the Universities Art Association of Canada annual conference at the University of Victoria, 14 November 1992, and at Concordia University, 16 February 1993. Some ideas from the paper appeared in a brief article, 'Power: Government and the Arts,' *Vancouver Sun*, 6 April 1994, op. ed. page. I am grateful to Brydon Smith and Robert Murray for supplying me with information and photographs, and to William Wood for editorial comments.

2 See, for example, Susan Tallman, 'Tempest Over Slashed Newman,' *Art in America*, February 1992, 27.

3 There is a difference of opinion about whether Newman painted *Voice of Fire* expressly for Expo 67, as I and Brydon Smith in his piece for this volume contend, or whether he had already executed the work by the time he was invited to participate, as Thomas B. Hess contends (*Barnett Newman* [New York: Museum of Modern Art 1971], 141).

4 For an excellent analysis of Expo 67, see David Howard, 'Progress in an Age of Rigor Mortis,' MA thesis, University of British Columbia, 1986.

5 Walter Benjamin, *Charles Baudelaire* (London: Verso 1983), 165. For a remarkable video on shopping and social control, see Vera Frenkel's *This Is Your Messiah Speaking*, 1990.

6 For an analysis of how fairs have traditionally exerted control over their visitors, see Jonathan Crary, *Techniques of the Observer: On Vision and Modernité in the 19th Century* (Cambridge, MA: MIT Press 1990).

7 *Expo '67: Graphics Manual* (Montreal: Canadian Corporation for the 1967 World Exhibition 1963), n.p.

8 Howard, 'Progress in an Age of Rigor Mortis,' 61.

9 Quoted in Jeremy Baker, 'Expo and the Future City,' *Architectural Review* 142 (1967), 156.

10 André Picard, 'Plus ça change: Montreal, then and now,' *Globe and Mail*, 22 June 1992.

11 Alan Solomon, 'The Americans at Expo 67,' *American Painting Now*, exhibition catalogue (Boston: Institute of Contemporary Art 1967), n.p. The exhibition was remounted in the Horticultural Hall, Boston, from 15 December 1967 to 10 January 1968.

12 Paul and Percival Goodman, *Communitas* (New York: Vintage Books 1960).

13 Fuller, quoted in Kenneth Frampton, *Modern Architecture: A Critical History* (New York: Oxford University Press 1980), 239.

14 Solomon, 'The Americans at Expo 67,' n.p.

15 Buckminster R. Fuller, 'Prospects for Humanity,' in *Man and His Future*, edited by James E. Gunn (Lawrence: University of Kansas Press 1968), 165.

16 Barnett Newman, 'The First Man Was an Artist' (1947), republished in *Selected Writings and Interviews*, edited by John P. O'Neill (New York: Knopf 1990), 157.

17 See Hess, *Barnett Newman*.

18 Newman's reaction was reported to me by Robert Murray, who also had work at the fair, though not in the United States pavilion.

19 Fuller went to one of Newman's exhibitions at Betty Parson's Gallery, New York, in the early 1950s, and Newman and Fuller both undertook projects at Tatyana Grosman's lithographic press on Long Island.

20 Alan Solomon was director of the Jewish Museum in New York in 1962, when Newman participated in the exhibition *Recent American Synagogue Architecture*, organized by Richard Meier.

21 Brydon Smith, 'Some Thoughts about the Making and Meaning of *Voice of Fire*,' paper delivered at the symposium 'Other Voices,' National Gallery of Canada, Ottawa, 28 October 1990, republished in this volume.

22 The sailcloth panels, as well as the structures for the other interior exhibits, were all designed by Cambridge Seven Associates, Inc.

23 For an account of Newman's work that investigates the relationship between his imagery and titles, see Yve-Alain Bois, 'Perceiving Newman,' in *Painting as Model* (Cambridge, MA: MIT Press 1990). Brydon Smith has traced the phrase 'voice of fire' to Deuteronomy 5.

24 See, for example, *US News and World Report*, 22 May 1967, 96; *Time*, 2 June 1967, 9; and *Newsweek*, 6 May 1967, 54.

25 Quoted in *Maclean's*, June 1967, 143.

26 Michael Ballantyne, *Expo 67: Art* (Montreal: Tundra Books 1967), 54.

27 The precise date of the announcement was 7 March 1990.

28 *Globe and Mail*, 8 March 1990.

29 'MP Vows to Make Gallery Explain Why It Bought Costly U.S. Painting,' *Toronto Star*, 10 March 1990.

30 'Cabinet to Review $1.8M Art Purchase,' Ottawa *Citizen*, 10 March 1990, republished in this volume.

31 Greg Graham, director of CARFAC, quoted by Christopher Hume, 'National Gallery Criticized for Buying U.S. Work,' *Toronto Star*, 8 March 1990.

32 This insight was offered to me by students at Concordia University in a discussion following a lecture there in February 1993.

33 Among the critics commenting on Newman's professionalism and care with his medium were Meyer Schapiro and Thomas B. Hess. See Hess, *Barnett Newman* (New York: Walker 1969), 7 and 65.

34 On *Blue Poles*, see John Medlin, 'Cultural Imperialism,' *Broadsheet* 4 (September 1974), 3–11; and Ian Burn, 'Buying Cultural Dependency,' *The Fox* 1 (April 1975), 141–4. With respect to Andre's *Untitled*, it is worth noting that the controversy did not erupt until four years after the Tate Gallery purchased the work.

35 John Cruickshank, 'Newman: A Canvas of Strong Opinions,' *Globe and Mail*, 16 March 1990.

36 Brydon Smith, quoted in the *Globe and Mail*, 8 March 1990.

37 See John O'Brian, 'Where the Hell Is Saskatchewan, and Who Is Emma Lake?' in *The Flat Side of the Landscape: The Emma Lake Artists' Workshop*, edited by John O'Brian, 29–38. (Saskatoon: Mendel Art Gallery 1989).

38 Claude Tousignant, interviewed by Joan Murray, 22 April 1982, quoted by Denise Leclerc, in *The Crisis in Abstraction in Canada: The 1950s* (Ottawa: National Gallery of Canada 1992), 191.

39 Cruickshank, 'Newman: A Canvas of Strong Opinions.'

Voicing the Fire of the Fierce Father

1 Letter to the Editor. *Art Digest*, 15 February 1950, 5.

2 *Art Digest*, 15 March 1950, 5.

3 Lecture given by John O'Brian at the Barnett Newman Symposium at Harvard University in May 1992. See David Howard, 'Progress in an Age of Rigor Mortis,' MA thesis, University of British Columbia, 1986.

4 All of this started with the so-called kitchen debate between Nikita Khrushchev and then vice-president Richard Nixon in Moscow in 1959. For more on this important event see the wonderful book by Elaine Tyler May, *Homeward Bound: American Families in the Cold War Era* (New York: Basic Books 1988), particularly ch. 7.

5 Barnett Newman, interviewed by Dorothy Gees Seckler, *Art in America* 50 (Summer 1962), 87.

6 Harold Rosenberg, 'On the Fall of Paris,' *Partisan Review* (December 1940), 441.

7 See Michael Leja, 'Art for Modern Man: New York School Painting and American Culture in the 1940's,' PhD thesis, Harvard University, published as *Reframing Abstract Expressionism: Subjectivity and Painting in the 1940's* (New Haven: Yale University Press 1993).

8 Ibid., 66.

9 Barnett Newman, 'The Ideographic Picture,' published in February 1947 and republished in *Barnett Newman: Selected Writings and Interviews*, edited by John P. O'Neill (New York: Knopf 1990), 108. This was a major point in Newman's construction of the new modern painter. Man was in touch with metaphysical issues in a way that women could not be. See his text 'Northwest Coast Indian Painting,' ibid., 105–7, and 'The Plasmic Image,' ibid., 138–55. See also an interview with Pierre Schneider in which Newman said: 'If I am talking to anyone, I am talking to Michelangelo. The great guys are concerned with the same problems. Saying something about life and about man and about himself: That's what a painter is about. Otherwise he is a pattern-maker. That's why I am unsympathetic to Mohammedan art': *Louvre Dialogues* (New York: Atheneum 1971), 227.

10 May, *Homeward Bound*, 112.

11 It seems that after a trip to Ohio in 1949 Newman started to recognize the 'authority' of his earlier vertical formats. In a text called 'Ohio,' in which he describes his reaction in front of the Miamisburg mound and Newark earthworks, Newman writes of experiencing a new type of relationship with the land which translated in his mind into a different understanding of his 'primitive' models. The Mexican objects and Northwest Coast totem poles he previously cherished were transformed in his mind into, as he put it, 'hysterical,' 'overemphasized monsters.' The Ohio mound was a kind of a place created in order to express the sacredness of the moment, not the experience of space but of time. For Newman, space was experienced as an uninteresting 'communal fact'; 'Only time can be felt in private.' He declared that space could be 'understood,' which is common, contrary to time, which should be 'felt.' This was the lesson learned inside the Ohio mounds, which had a tremendous effect on Newman's painting strategy. His pictures never looked the same again. The verticality of totem poles (vertical, narrow formats) gave room to vast horizontal formats in which the vertical 'zips' served to give rhythm to the vast expanse of colour in order to bring the sensation of time to the attention of the viewer. *Selected Writings and Interviews*, 174–5.

12 For a positive discussion of this issue, see Jean-François Lyotard, *L'Inhumain: Causeries sur le temps* (Paris: Galilée 1988), 89–118.

13 See *Selected Writings and Interviews*, 202.

14 See 'The Plasmic Image' in ibid., 144.

15 Leja writes convincingly about the history of this ideological construction in *Reframing Abstract Expressionism*. See, in particular, ch. 2, pp. 49–120.

16 Newman answered in his typical outraged manner, reinforcing his male image by saying, not without humour, 'What is to be pitied in him [Crehan] is his love of impotence, his stupid fear of the creative man – man spelled masculine ... Mr. Crehan attacks my steadfastness, my "masculine" strength, by saying that it takes two to tango. To him this is the essence of real painting. Is the painting-dance *that* easy? I have a feeling that Mr. Crehan's two dancers are eunuchs. Some day, Mr. Crehan may learn that no matter how many it takes to tango, it takes only *one real man* to create a work of art': *Art News* 58 (April 1959), 12.

17 André Breton in Maurice Nadeau, 'Message d'André Breton,' in *Terres des Hommes*, 2 February 1946, 5.

18 Sammuel Beckett, 'La Peinture des Van Velde ou le monde et le pantalon,' *Cahiers d'art* (Paris, 1945–6), 349–56.

Tightrope Metaphysics

1 This already appears in the monograph by Harold Rosenberg, *Barnett Newman* (New York: Abrams 1978), 244–5; one year earlier, a French translation of this exchange of letters, done by Pierre Brochet, appeared in *Macula* 2 (1977), 147–9.

2 Robert Rosenblum, 'The Abstract Sublime – How Some of the Most Heretical Concepts of Modern American Abstract Painting Relate to the Visionary Nature Painting of a Century Ago,' *Art News*, 59 (February 1961), 38–41, 56–8. The text was reprinted in Henry Geldzahler, *New York Painting and Sculpture, 1940–1970* (New York: Dutton, in collaboration with The Metropolitan Museum of Art, 1969), 350–9.

3 *Art News*, April 1961.

4 Ibid. '... does Mr. Newman imply that he, as Aelfric says of God, is "above grammar"; or is it a misprint; or is it plain illiteracy?'

5 As early as 1933, he was already a public figure, running for mayor of New York on an artistic platform. He later published texts, wrote to newspapers, and appeared generally as a defender of American contemporary art.

6 *Art News*, May 1961.

7 Cited in Diane Waldman, *Mark Rothko, 1903–1970: A Retrospective* (New York: The Solomon R. Guggenheim Museum, in collaboration with Abrams, 1978).

8 Cited in E.A. Carmean, Jr, Eliza E. Rathbone, and Thomas B. Hess, *The Subjects of the Artist: American Art at Mid-Century* (Washington, DC: National Gallery of Art 1978), 15.

9 Reported in Maurice Tuchman, *The New York School: Abstract Expressionism in the 40s and 50s* (London: Thames and Hudson n.d.), 139.

10 Cited in Thomas B. Hess, *Barnett Newman* (New York: Museum of Modern Art 1971), 43.

11 The theme of the sublime recurs often in the writings of Newman, who, in December 1948, devoted an article to it entitled 'The Sublime Is Now,' *Tiger's Eye 1*, 51–3.

12 Beween 1943 and 1945 Newman wrote a whole series of short essays that he called monologues, in which he discussed the principal themes defining his aesthetic. Among the most important are 'The Plasmic Image,' 'The Problem of Subject Matter,' and 'The New Sense of Fate.' See Hess, *Barnett Newman*, 37.

13 We are referring to the concept developed by critic Harold Rosenberg and

used in numerous essays. See 'Les Peintres d'action americains,' in *La Tradition du nouveau*, translated by Anne Marchand, 23–8 (Paris: Minuit 1962).

14 'I therefore wish to call the new painting "plasmic," because the plastic elements of the art have been converted into mental plasma.' This definition is developed in the essay of the same name (see above, note 12).

15 Erwin Panofsky, *Studies in Iconology: Humanistic Themes in the Art of the Renaissance*, 4th ed. (New York: Harper Torchbook 1965), 8.

16 Ibid., 5.

17 The exhibition entitled *American Painting Now* was organized by Alan Solomon for the United States pavilion at the Cité du Havre in Montreal.

18 The allusive formula used by Newman can accommodate many other interpretive paths. We refer readers to the text by Brydon Smith for a reading that is more oriented towards the painter's anarchist sympathies.

19 The term is, of course, taken from Jacques Derrida, *La Verité en peinture* (Paris: Flammarion 1978).

20 Actually, Rosenberg's classification is somewhat different, in length and substance, from the few examples used here. But the principle of grouping by clusters of titles remains the same. See Rosenberg, *Barnett Newman*, 67.

21 See Hess, *Barnett Newman*, 69.

22 This question is particularly well treated in an article by Carter Ratcliff which combines the phenomenon with an expression of American-ness: 'Barnett Newman: Citizen of the Infinitely Large Small Republic,' *Art in America* 79/9, 92–7 and 146–7 (see especially p. 95).

23 On the *kouros* question see Nicolas Calas, 'Subject Matter in the Art of Barnett Newman,' *Arts Magazine*, November 1967, reprinted in Nicolas Calas, *Art in the Age of Risk* (New York: Dutton 1968), 208.

24 'When our Father Abraham came, he contemplated, meditated and beheld, investigated and understood and outlined and dug and combined and formed [that is, created], and he succeeded. Then the Lord of the World revealed Himself to him and took him to his bosom and kissed him on the head and called him His friend [another variant adds: and made him His son] and made an eternal covenant with him and his seed.' Scholem, writing of the Book of Yetsirah in Hess, *Barnett Newman*, 61.

25 The idea of the 'specific object' is at the core of minimalist theory. See Donald Judd, 'Specific Objects,' *Arts Yearbook* 8, 1965; reprinted in *Donald Judd: Complete Writings, 1959–1978* (Halifax: The Press of the Nova Scotia College of Art and Design 1975), 181–9.

26 Dore Ashton, 'Art,' *Art and Architecture* 83 (June 1966), 4. 'The fact is that almost all of Newman's writings have put forth an argument against the visible evidence of the painting. By removing himself from the realm of homo faber into an ethereal province where somehow there are only ends and never means, he removed himself from evaluation.'

27 This scandal was revived when *Voice of Fire* was acquired by the National Gallery of Canada, and it strongly motivated the current debate.

28 From a statement published in *Tiger's Eye* in 1947. See Ratcliff, 'Barnett Newman,' 96.

29 David Sylvester, interview with Barnett Newman in *Barnett Newman: Selected Writings and Interviews*, edited by John P. O'Neill (New York: Knopf: 1990), 257–8; reported by Ratcliff in 'Barnett Newman,' 95.

30 According to Thomas B. Hess, the experience evoked by the sculpture *Here I* recalls a visit Newman made in 1949 to the Indian mounds in Ohio: Hess,

Barnett Newman, 73. Hess points out that the meaning of place for Newman is inspired by the Jewish concept of *Makom* (place, site, location).

31 This reference to the throne is evoked by the painting *Cathedra* (1951).

32 Hess, *Barnett Newman*, 73.

33 Ratcliff, 'Barnett Newman,' 95.

34 Ibid., 96.

35 According to Thomas B. Hess, Newman had made this painting, which was difficult to exhibit because of its exceptional height, before Alan Solomon asked him to show it in Montreal (*Barnett Newman*, 141). Curator Brydon Smith suggests a different version of the facts in the prospectus that the National Gallery of Canada prepared for *Voice of Fire*. Smith implies that the work was done specifically for the United States pavilion. In either case, Barnett Newman did not violate his aesthetic choices in order to adapt his painting to a specific site (contrary to what he did, with less fortunate results, in the case of *Lace Curtain for Mayor Daley* in 1968).

36 The list of exhibitors includes, in addition to names already mentioned, Richard Anuszkiewicz, Edward Avedisian, Allan d'Archangelo, Jim Dine, Friedel Dzubas, Robert Indiana, Jasper Johns, Ellsworth Kelly, Roy Lichtenstein, Robert Rauschenberg, James Rosenquist, Frank Stella, Andy Warhol, Tom Wesselmann, and Larry Zox.

37 In *American Painting Now*, catalogue prepared for the presentation of the Montreal show at Horticultural Hall in Boston, 15 December 1967, to 10 January 1968, n.p.

38 Ibid.

39 Ibid.

40 Ibid.

Some Thoughts about the Making and Meaning of *Voice of Fire*

1 This paper was revised in February 1995 with thanks to John O'Brian and Germaine Koh.

2 Statement in *United States of America: VIII São Paulo Biennial* (São Paulo, Brazil, 4 September–28 November 1965).

3 These cross-sections were prepared by Anne Ruggles, Paintings Conservator in the National Gallery of Canada's Restoration and Conservation Laboratory.

4 Alan Solomon, *American Painting Now* (Boston: Institute of Contemporary Art 1967).

5 Solomon made an exception for Claes Oldenburg's *Giant Soft Fan*, which hung in the space like the paintings.

6 Barnett Newman, 'The True Revolution Is Anarchist!,' foreword to Peter Kropotkin, *Memoirs of a Revolutionist* (New York: Grove Press 1968), ix.

7 Ibid., ix–x.

8 Ibid., xvi.

Contributors

BRUCE BARBER, an artist and writer on culture, is a professor at the Nova Scotia College of Art and Design, Halifax, where he is the coordinator of the Intermedia Department. His work has been exhibited internationally since 1973. He is the author of *Reading Rooms* (1992) and the editor of *Essays on [Performance] and Cultural Politicization* for *Open Letter* (1983). He is presently at work on a forthcoming book, *Popular Modernisms: Art, Cartoons, Comics and Cultural Insubordination.*

THIERRY DE DUVE was a professor at the University of Ottawa at the time of the *Voice of Fire* controversy in 1990. He is the author of *Nomalisme pictural: Marcel Duchamp, la peinture et la modernité* (1984), *Essais datés* (1987), *Au nom de l'art* (1989), *Résonances du readymade* (1989), *Cousus de fil d'or* (1990), *The Definitively Unfinished Marcel Duchamp* (1991), *Faire école* (1992), and *Kant after Duchamp* (1996).

NICOLE DUBREUIL-BLONDIN is Professor of Art History at the Université de Montréal. A specialist in nineteenth- and twentieth-century art and art criticism, she has written on many topics, including American art and criticism of the 1960s, the art of the Russian avant-garde, French art writing between 1850 and 1900, and feminist criticism.

SERGE GUILBAUT is Professor of Fine Arts at the University of British Columbia, Vancouver. He edited the volumes *Modernism and Modernity* (1982) and *Reconstructing Modernism* (1990), and is the author of *How New York Stole the Idea of Modern Art* (1983) and a collection of essays, *Voir ne pas voir faut voir* (1993). He is currently at work on *The Spittle, the Square and the (Un)happy Worker*, a book about cultural relations in Paris, New York, and Montreal between 1945 and 1956.

ROBERT MURRAY is known primarily for his large painted steel and aluminum sculpture. He was born in Vancouver and grew up in Saskatoon, Saskatchewan, where he met Barnett Newman in 1959 at the Emma Lake Artists' Workshop. Following his move to New York in 1960, he and Newman became close friends. He assisted Newman with a number of projects and, prior to Newman's death in 1970, they built their sculpture in the same casting and fabricating facilities.

JOHN O'BRIAN is a professor of art history at the University of British Columbia, Vancouver. He edited *Clement Greenberg: The Collected Essays and Criticism* (4 volumes, 1986 and 1993) and *The Flat Side of the Landscape* (1989), and is the author of *David Milne and the Modern Tradition of Painting* (1983) and *Degas to Matisse: The Maurice Wertheim Collection* (1988). He is currently at work on *Ruthless Hedonism*, an institutional study on the American reception of Matisse. Since 1991 he has been an advisor on acquisitions to the board of trustees of the National Gallery of Canada.

BRYDON SMITH began organizing exhibitions and acquiring works of art for public institutions as the chair of the Student Centre Art Committee at McMaster University (1961-2). After completing his MA in art history at the University of Toronto, he continued to organize exhibitions and acquire works of art for the Art Gallery of Ontario as a curatorial assistant (1964-7) and for the National Gallery of Canada as Curator of Contemporary Art (1967-78), before moving into management asAssistant Director of Collections and Research (1978-93). He also acted as Project Director, New Building (1986-8). After a sabbatical year following the controversy over the acquisition of *Voice of Fire*, he returned to the National Gallery in 1994 as Curator of 20th Century Art.

Index

A **boldface** page number indicates an illustration.

John and Joan Czupryniak standing beside *Voice of the Taxpayer*, 1990.
Photograph courtesy of *The Citizen* (Ottawa)